# GRACE

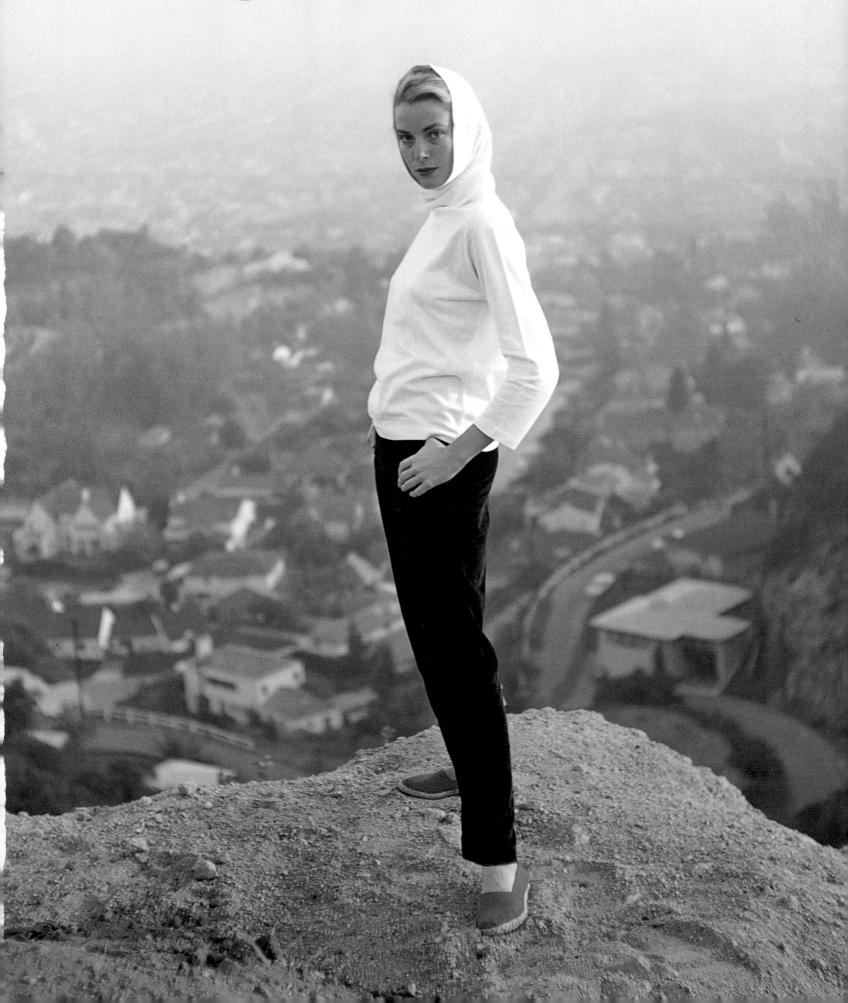

# GRA

INTRODUCTION BY TODD BREWSTER
DESIGN BY MARY K. BAUMANN & WILL HOPKINS
A BOB ADELMAN BOOK

Random House New York

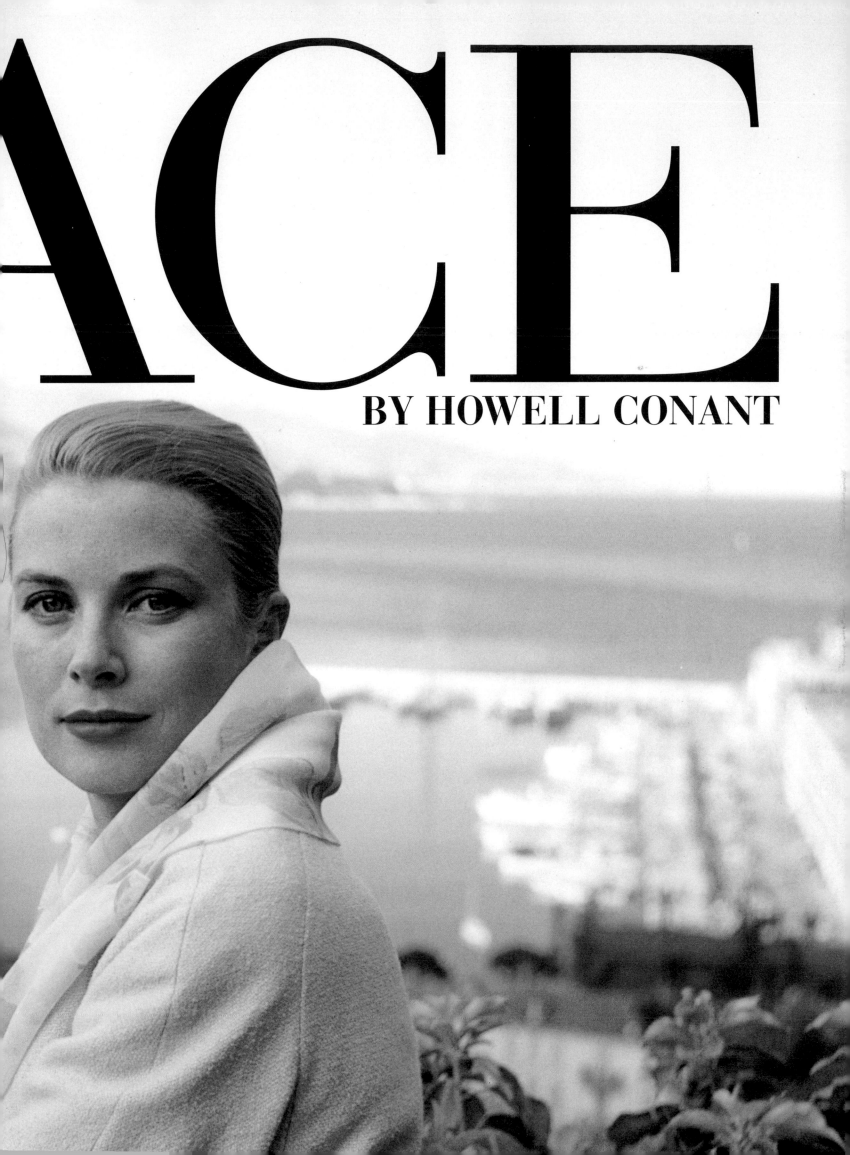

# ACE

## BY HOWELL CONANT

# To the memory of H.S.H. Princess Grace

Copyright © 1992 by Howell Conant and Bob Adelman

All rights reserved under International
and Pan-American Copyright Conventions.
Published in the United States by Random House, Inc.,
New York, and simultaneously in Canada
by Random House of Canada Limited, Toronto.

Library of Congress Cataloging-in-Publication Data
Conant, Howell
Grace: an intimate portrait of Princess Grace
by her friend and favorite photographer
Howell Conant.—1st ed.
p.  cm.
ISBN 0-679-41803-2
1. Grace, Princess of Monaco, 1928-1982.
2. Monaco—Princes and princesses—Biography.
3. Motion pictures actors and actresses—
United States—Biography.
I. Title.
DC943.G7C66  1992
944.9'49—dc20

Manufactured in Japan
24689753
First Edition
All photographs and captions are by Howell Conant
Producer: Bob Adelman
Editor: Todd Brewster
Copy Editor: David Frederickson
Proofreader: Emily Garlin

Design: Mary K. Baumann & Will Hopkins, Hopkins/Baumann
Photography Editor: John Durniak
Photographic Prints: Michael Macioce

Acknowledgments: The Producer wishes to thank Walter Weintz,
Myron Miller, Stephen Brewer, Dorthea Cherington, Dorothy Conant,
Steve Metz, Andrew Dechet, Paige Dickinson, and Junichi Iwama
for their help in making *Grace* possible.

**Captions**

Page 1: Grace Kelly in the hills above Hollywood, 1955.
Title page: Princess Grace overlooking the harbor in Monaco, 1959.
Opposite: Princess Grace on her throne, Monaco, 1962.

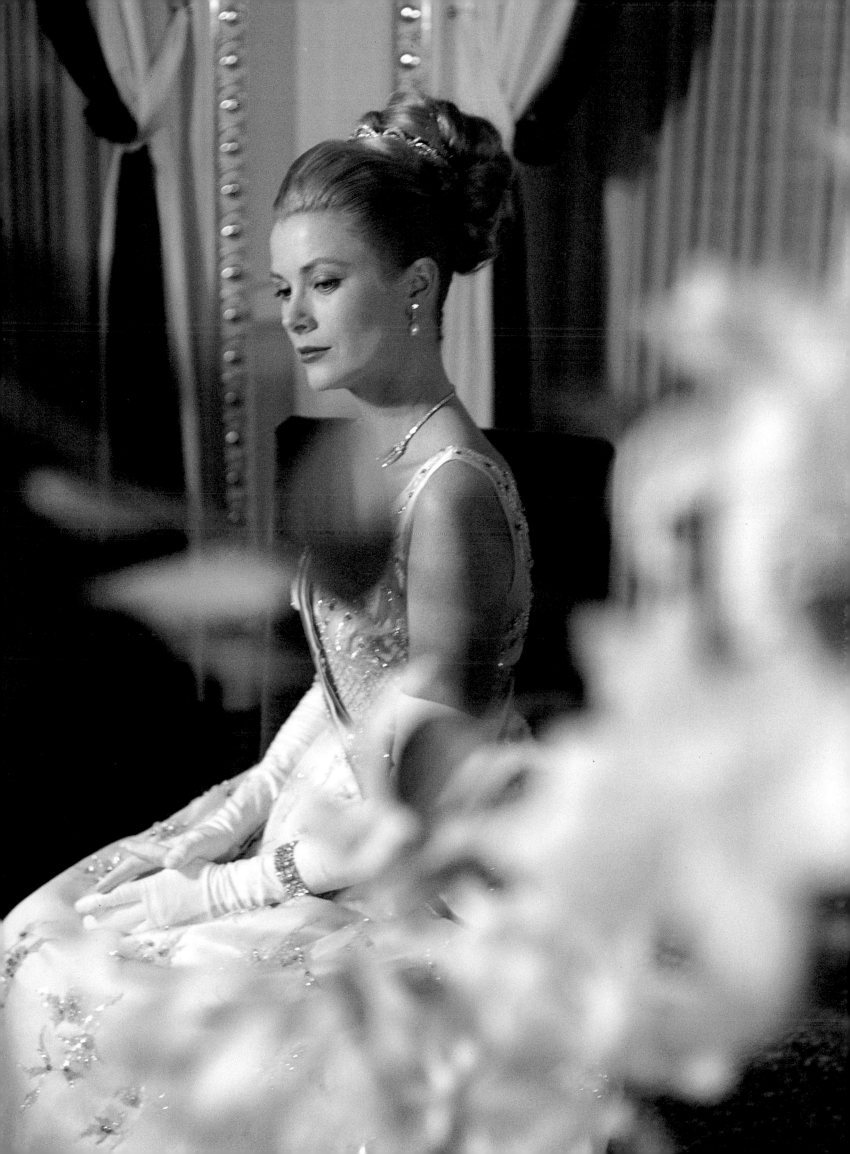

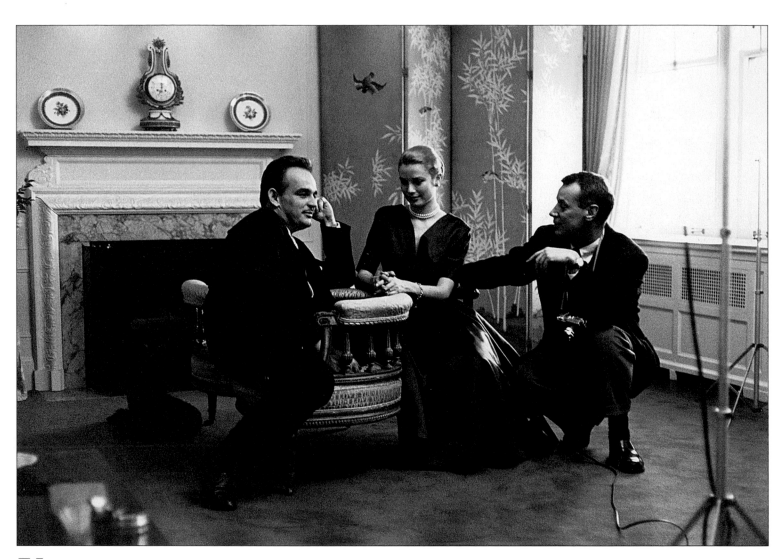

**Y**ears after my assistant snapped this picture of me with the newly engaged Grace and Rainier, the couple inscribed it and returned the print as a gift. Rainier wrote, "It would look better underwater"— a reference to our mutual interest in scuba-diving and undersea photography.

To the World's Greatest Photographer our fondest regards — Grace & it would look better under water *Rainier*

# Portraits
of a
Lady

ONE OF THE GREATEST collaborations of modern photography began awkwardly, when *Photoplay* assigned Howell Conant to shoot Grace Kelly shortly before she won an Oscar in 1955. Conant was one of New York's leading fashion photographers, but had little experience with Hollywood actresses—and Kelly was one of the most popular stars of the day. He was nonplussed, unsure how to proceed. Finally, Kelly herself took charge. "This is my good side," she said sympathetically, turning her face a bit to the right. "Now light it as you know how, and we'll be done with it." He did, and they were, but not before an emboldened Conant cooked up a plan to get the actress back again.

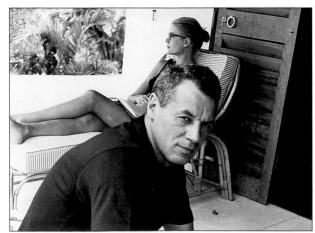

Conant on assignment in Jamaica in 1955 to photograph Grace Kelly for *Collier's*.

Late for an interview with columnist Earl Wilson, she asked to borrow a headband from Conant's working collection of costume jewelry. "There's just one condition," said Conant. "You have to return it in person."

No one who makes his living with a camera had greater access to Grace Kelly than Howell Conant. No one spent more hours studying that classic face. Over the twenty-seven years between their meeting and Princess Grace's tragic death, Conant photographed her in thousands of situations, compiling a record that includes some of the most private family moments. Yet it all began with that unpromising *Photoplay* session. When Kelly returned to his East Forty-Eighth Street studio, holding the precious headband, her eyes widened at the sight of some underwater photography Conant was doing at the time, and a lifetime friendship had begun.

Soon, Conant was off on a Jamaican vacation with Grace and her sister Peggy, shooting for *Collier's*. Some months later, when she decided to accept the proposal of Prince Rainier

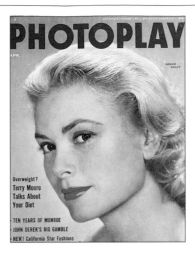

Howell Conant's first picture of Grace Kelly: the April 1955 *Photoplay*.

of Monaco, Conant was there to take the official engagement picture. Conant was the only photographer who traveled with the wedding party aboard the S.S. *Constitution* as it steamed across the Atlantic, the only photographer who had entree to the palace once they arrived in Monaco, and the only photographer who enjoyed a personal relationship with Monaco's royal family throughout Princess Grace's reign.

Grace Kelly trusted Conant; indeed, they worked like partners. Early on, they discovered that they shared a desire to create a new kind of Hollywood image, to break the mold of the stereotypical airbrushed movie-star photograph, and, one by one, as Conant's pictures of her appeared in the world's top magazines—*Life, Look, Collier's*—they broke it. The traditional studio publicity shot had represented the actress as an untouchable icon, an image of pure fantasy; what Conant and Kelly now produced was an image of the actress as a living, breathing human being. Before, no Hollywood star would have dared to

pose with her hair wet, rising out of the water, as Grace did on a now-famous *Collier's* cover. No actress would have appeared wearing eyeglasses, as Grace did on the cover of *Look*. Conant shot Grace Kelly without makeup, wearing a boy's shirt. He shot her lounging with a pillow and eating an orange. The Grace Kelly of these photographs

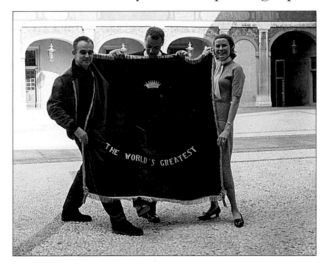

The prince and princess ceremoniously bestow a royal focusing cloth on Howell Conant, 1957.

looks proper, even elegant, today; back then, when the great picture magazines carried the power that television carries now, the candid image they gave to one of Hollywood's top stars made them positively revolutionary.

When Grace Kelly became Princess Grace, Conant was able to create a new image of royalty. Grace, he says,

became an entirely different kind of photographic subject once she married Prince Rainier, conforming as best she could to her conception of what a princess should be. Though she was always dignified, she never thought being royal meant being rigid. Just imagine Queen Elizabeth pictured lounging with Prince Philip at the end of a long day or bouncing on a trampoline and you will realize what a truly stunning accomplishment these pictures represent.

Not that there wasn't at least some fantasy involved. Conant refers to his style in these photographs as "semi-

Conant mugs with Princess Grace in the Swiss chalet, 1959.

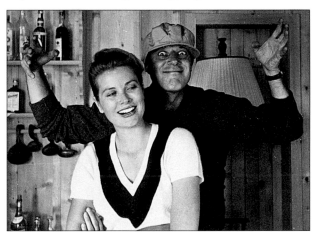

candid," and that's just about right, because he and Grace explored the narrow area between the sometimes sloppy truth of photojournalism and the outright lie of the glossy cliché. His unwritten, unstated agreement with her was that he would never photograph her when she didn't want to be photographed. He would never publish a picture that she didn't first see. When editors strapped for copy asked Conant to interview the princess as well as take her picture, he reported only the words she approved. If that didn't raise the hackles of journalistic purists at the time, it was only

because the pictures were so interesting, even if Grace herself had okayed them. Together, photographer and subject had found the tantalizing place where she appeared both real and unreal, one of us and not one of us. And, of course, the story of the Philadelphia girl turned princess was precisely that—both real and unreal.

For Conant, whose father and grandfather were portrait photographers in Wisconsin, this was a job well done. Though he published in the top outlets for photojournalism at the time, he never considered himself a journalist. He prefers to say he was "a people-picture-taker" who carried the mentality of the small-town photo studio into the world of big-time magazine work. Conant never forgot the few tricks his father had employed over many years of photographing Polish-American weddings. Is the man bald? Shoot him with a shadow on his head. Does the woman have a double chin? Focus from above. Even a face as nearly perfect as Grace Kelly's had to be photographed with a careful eye on its flaws. Conant says he always worked to hide her square jaw by photographing her with her head turned or her collar up. Shooting her with young Caroline, he would have her hold the baby against her chin. Conant worked from a simple credo that good pictures are the pictures that make people look good. With Grace—Grace Kelly and Princess Grace—Howell Conant took many very good pictures.

As simple as that sounds, it should take nothing away from the impres-

sive document that Conant has assembled here. The family pictures (many of which have never before been seen) are private: comparable to what you would have in your family photo album if you could hire a photographer of Conant's talents to come live with you, go on vacation with you, and watch your children grow up. The more public material, such as Conant's photographs of the crowds at the wedding, are so artfully executed that they rise above anything done by any of the hundreds of photographers with whom he was competing. And the material on Grace and Rainier alone betrays a closeness rarely achieved between photographer and subject. The couple really appear happy to be around the photographer, smiling not for a picture alone, but for the man behind the camera, too.

Conant was preparing to go to Monaco to shoot yet another story on Princess Grace in 1982 when his editor at *Good Housekeeping* called with the bad news: Grace had died. Conant jumped on the Concorde and flew to Monaco for the funeral, for the first time leaving his cameras behind. Like a biographer who devotes his life to a single subject, the photographer felt part of himself expire as he watched the procession that bade goodbye to this remarkable American woman and consummate European princess.

Though Prince Rainier was by now as close a friend to Conant as Grace had been (even today, the two correspond regularly), Conant never took another picture in Monaco. Appropriately, his last session with Grace

Kelly had contained a touch of Hollywood: in 1981, on the couple's twenty-fifth wedding anniversary, Rainier had taken the family to Palm Springs for a visit with Frank Sinatra and asked Conant to come along. The gathering was warm, just a meeting among old friends celebrating an event of great

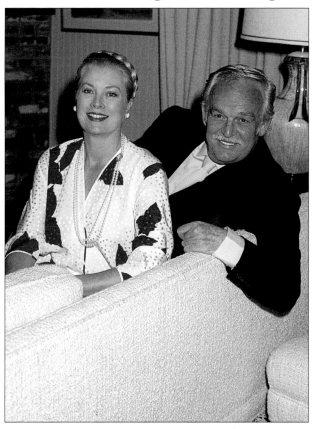

At the last session: Grace and Rainier in Frank Sinatra's Palm Springs home, 1981.

happiness. Grace, reports Conant, still had an extraordinary beauty, still the beguiling glimmer in her eyes that he had noticed the first day he photographed her. She and Rainier shared memories with Sinatra and then posed for one more family portrait. Though Conant had no way of knowing it, their photographic collaboration was now complete. In a few short months, Monaco, Hollywood, and the rest of the world would lose the rare spirit that was Grace Kelly. Yet, like her distinguished performances in a too-short list of films, she lives on, in the pages that follow.        — *Todd Brewster*

# Grace in Jamaica

**C**OLLIER'S WANTED A behind-the-scenes look at Grace Kelly, "the white-gloved Philadelphia Main-Liner," when they assigned Conant to do these pictures in 1955. He first suggested following her around New York or watching her go horseback-riding, but the actress thought such plans too ordinary. The project was put on hold while Grace and her sister Peggy went to Jamaica for a much-needed vacation—she had done five films the previous year, and she needed a rest from some difficult negotiations with MGM. Once in Jamaica, she suggested that *Collier's* send Conant down to do the story, while she gathered rocks and shells, went snorkeling, read books (Rachel Carson's *The Sea Around Us* and Jacques Cousteau's *The Silent World*), and took more than a few pictures of her own. Even this re-laxed regimen had its rigors: in order to take the famous head-in-the-water photo, both Kelly and Conant had to be careful to avoid stepping on the pincushiony sea urchins littering the bottom of the bay.

Eight times Grace dove underwater and came up dripping before we got this shot. I was stand-ing next to her, knee deep in the Caribbean, trying to keep my cameras dry. This picture was Grace's idea. She had done a water scene in a recent movie (I think it was *The Bridges at Toko-Ri*) and liked the way she looked with wet hair.

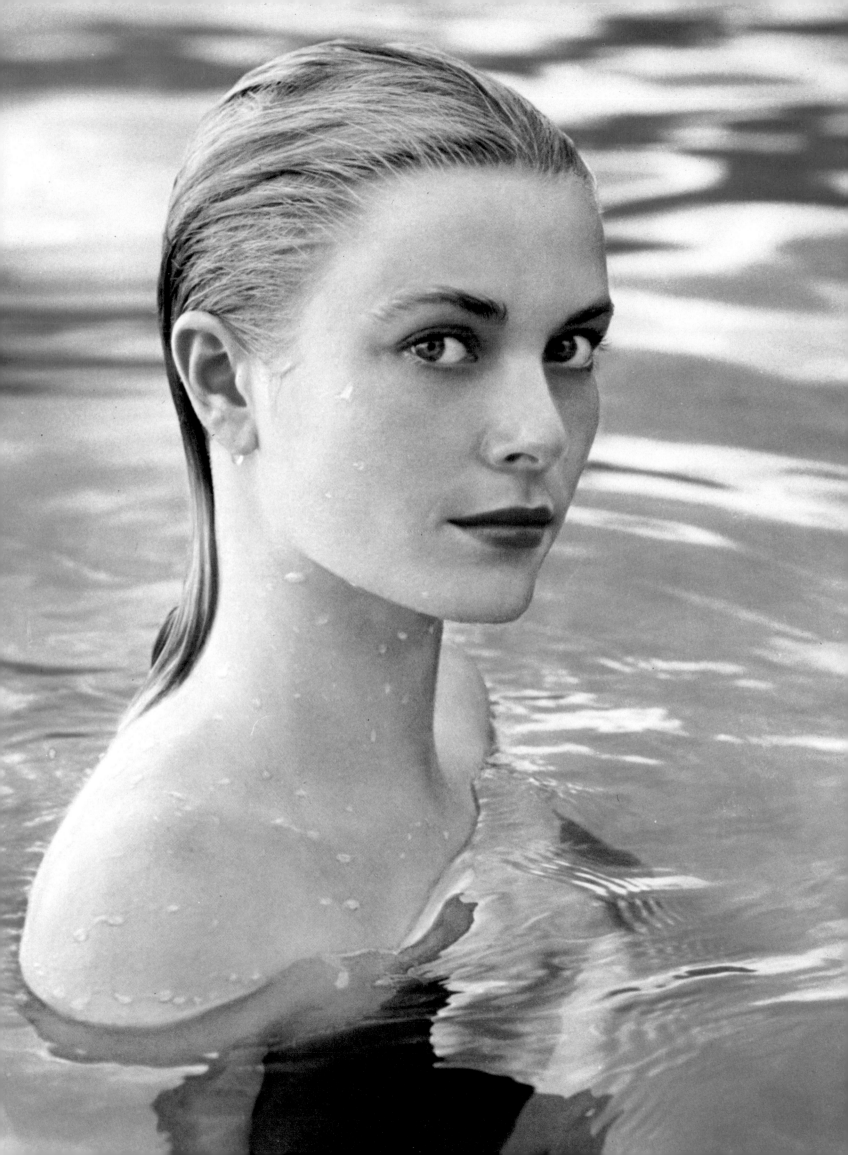

The raised hand meant "Don't take my picture now." We were just getting to know each other on this trip, and I hadn't yet learned how far I could go with her. Grace had definite ideas about how she wanted to look. Though she rejected the traditional studio image, she disliked the sloppiness of candid photography, too. In time, we found a middle ground.

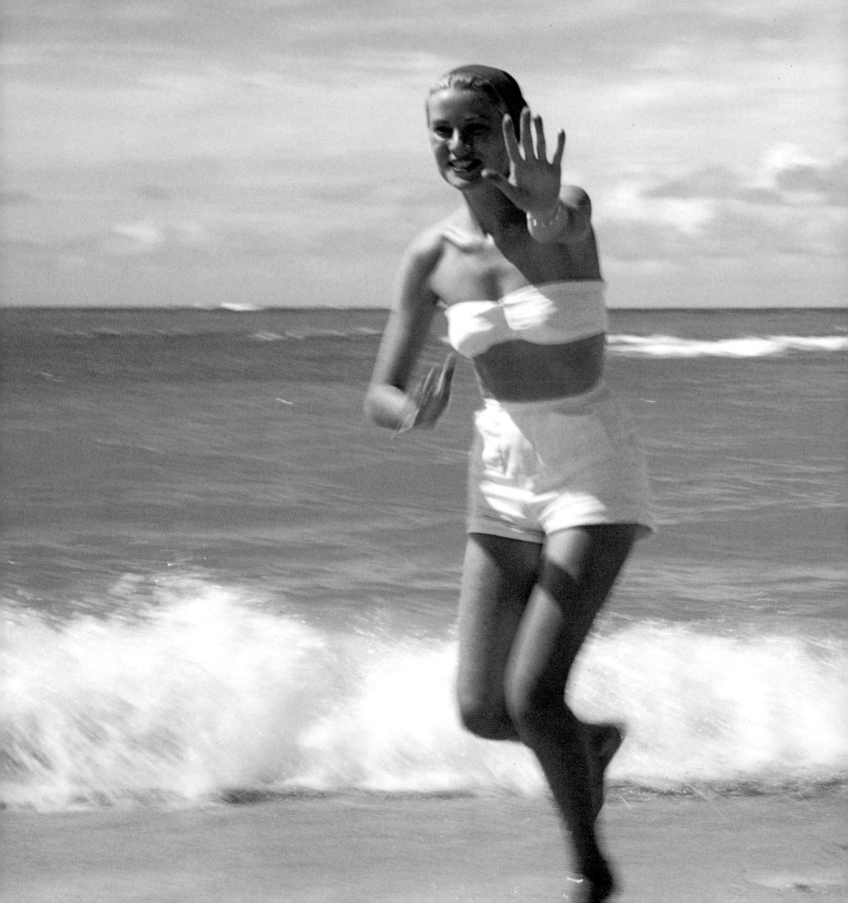

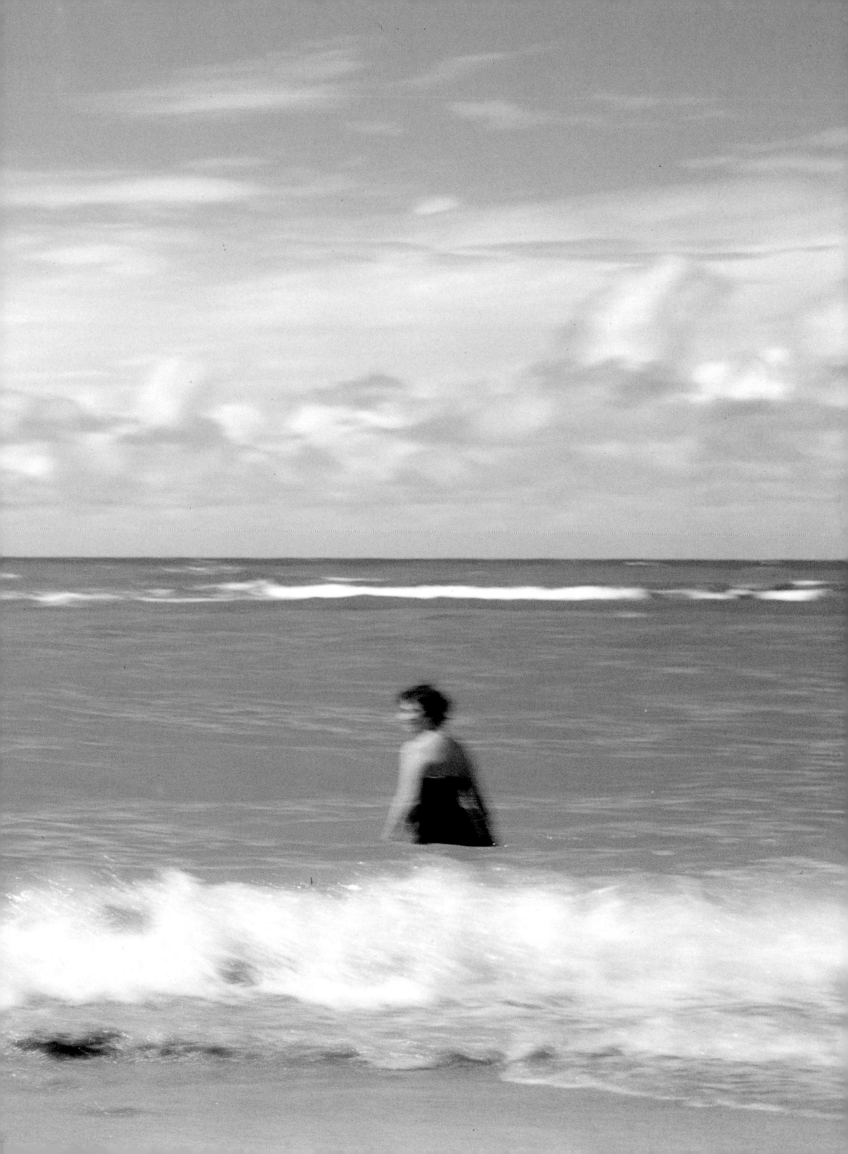

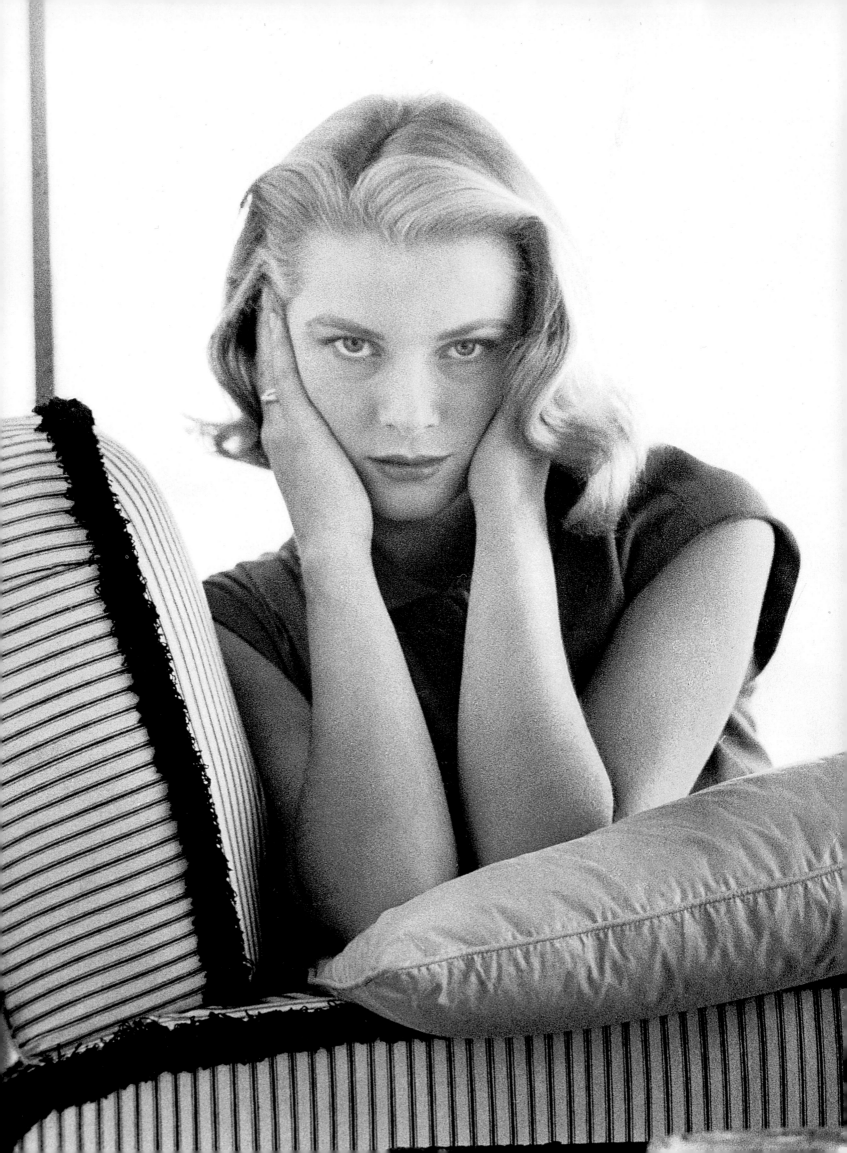

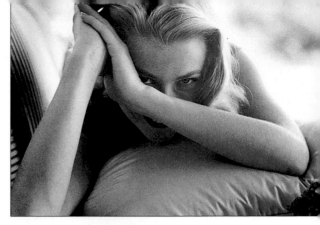

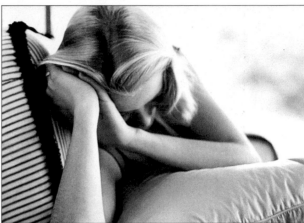

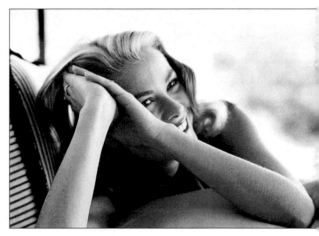

I'll never forget this series. Once, when I complained that actors and actresses always fell into cliché poses, Jimmy Cagney suggested that I should get them to act, shoot motion pictures, and then select stills from the film. So, when Grace began playing with a pillow, I grabbed the next best thing—my 35mm motor-drive—and started shooting. Grace was so myopic she couldn't see ten feet in front of her, so she followed the sound of my voice as I "directed" her. "Beautiful," I said over and over again. The more the camera hummed, the more she reacted. "Beautiful. Beautiful."

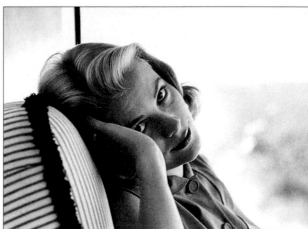

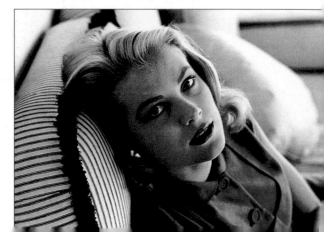

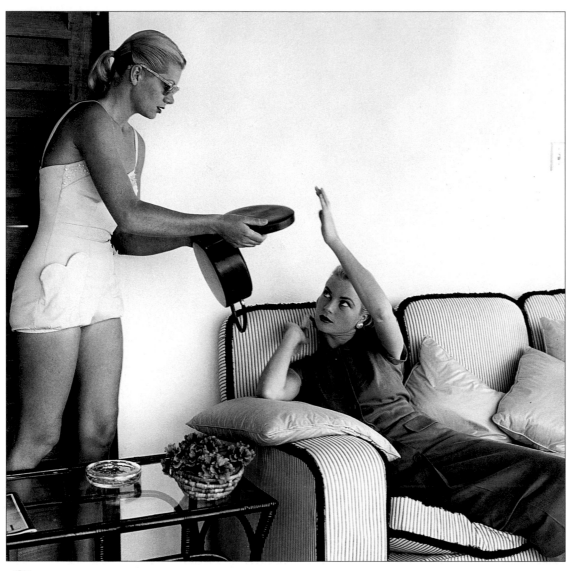

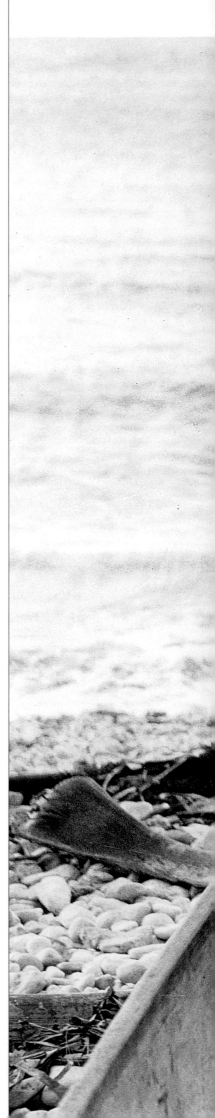

Grace was a consummate actress. With her on that sultry spring vacation, I noticed that she had a dancer's awareness of her body; her every movement was a telling gesture. Whether she was checking her makeup with the help of her sister Peggy or relaxing on the stern of a boat we happened upon on a quiet walk by the water, Grace's arms and legs were as expressive as her face.

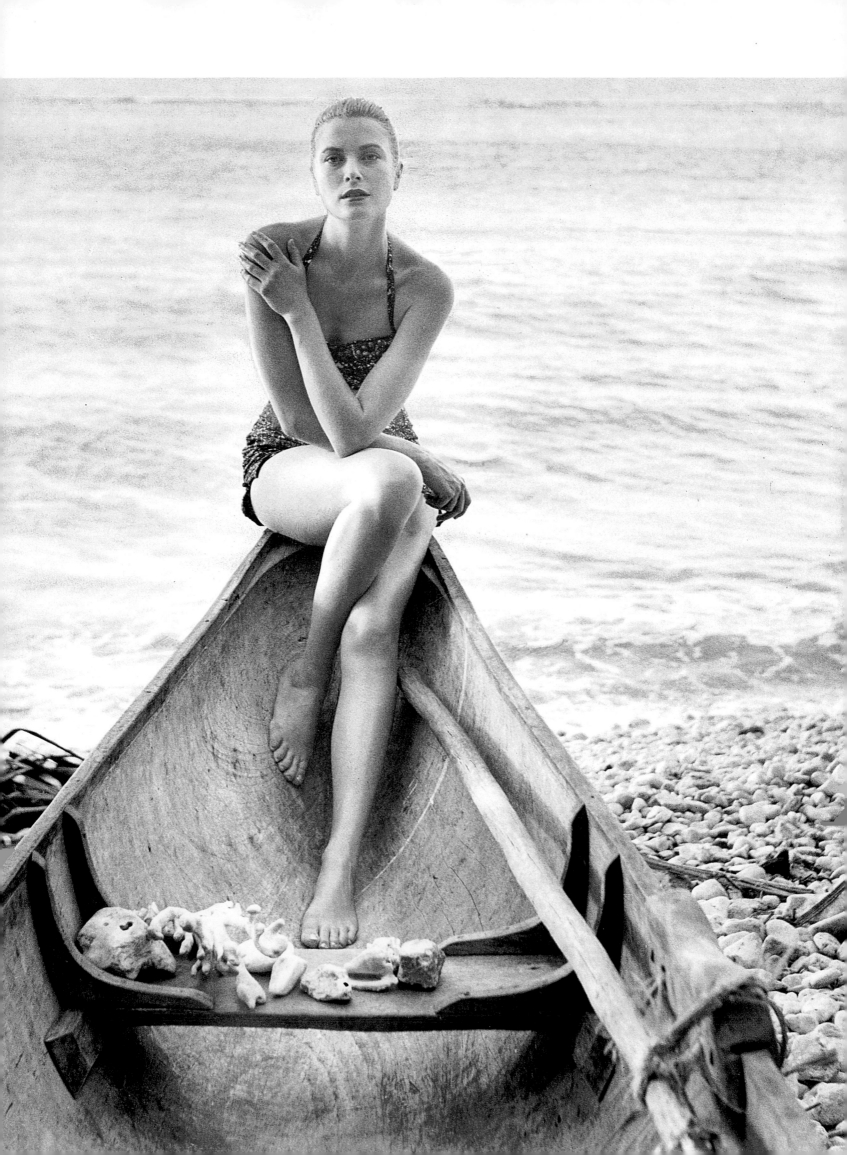

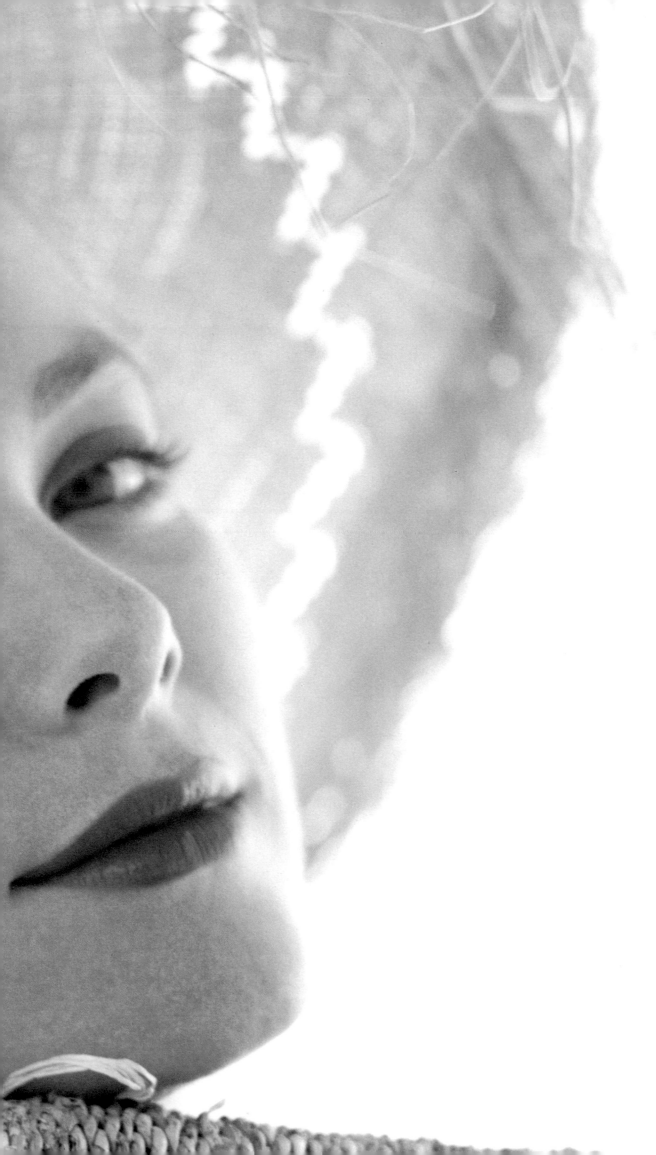

If Grace's face had one flaw, it was her jaw, and she knew it. Every time I shot her picture, I would have her turn her face so that it didn't look quite so square. Sometimes a collar would cover it; at other times I would tilt her chin to show more of the cheek.

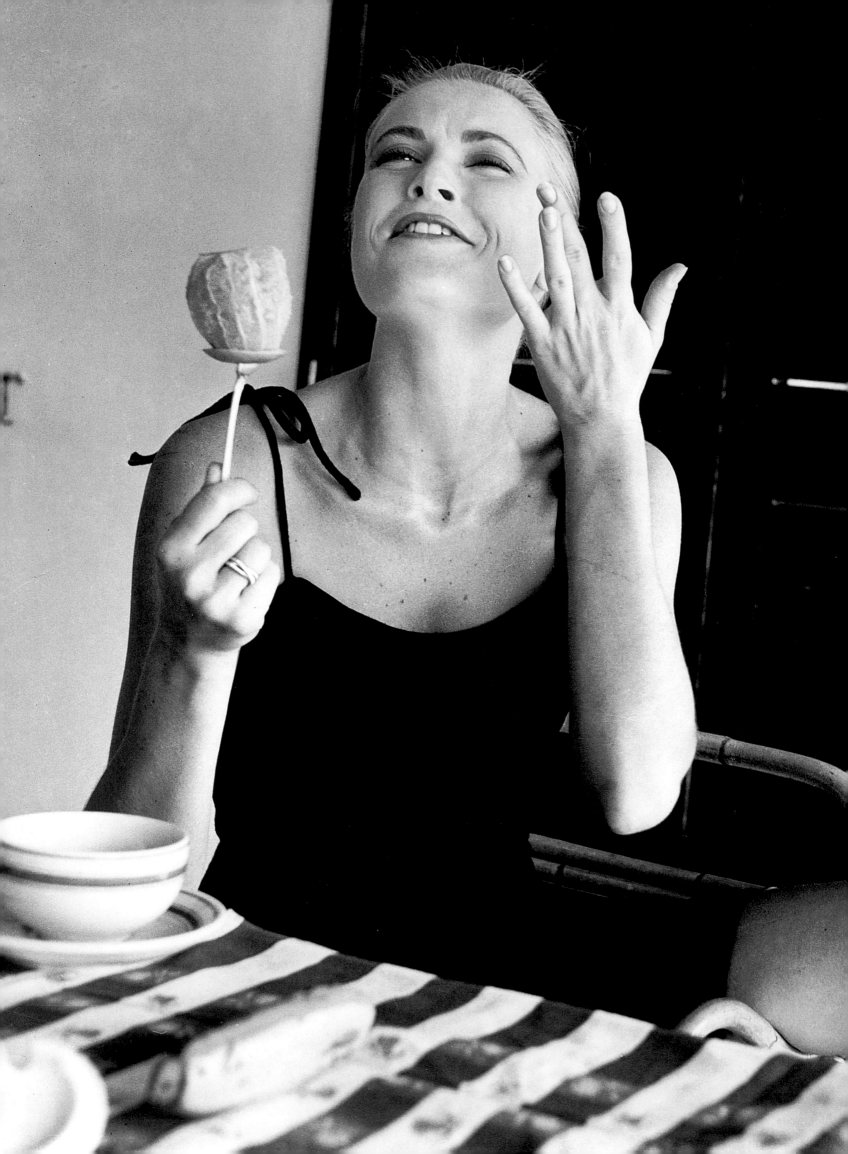

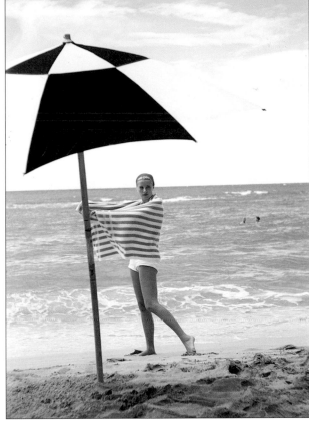

O̲ur time in
Jamaica was the
most relaxed I
ever saw her—
this was one place
where Grace
could let down
her guard and not
worry about fans,
MGM executives,
or critics. Here
I was telling her
some ridiculous
story when she
broke down
laughing. As
usual, I had my
camera ready.

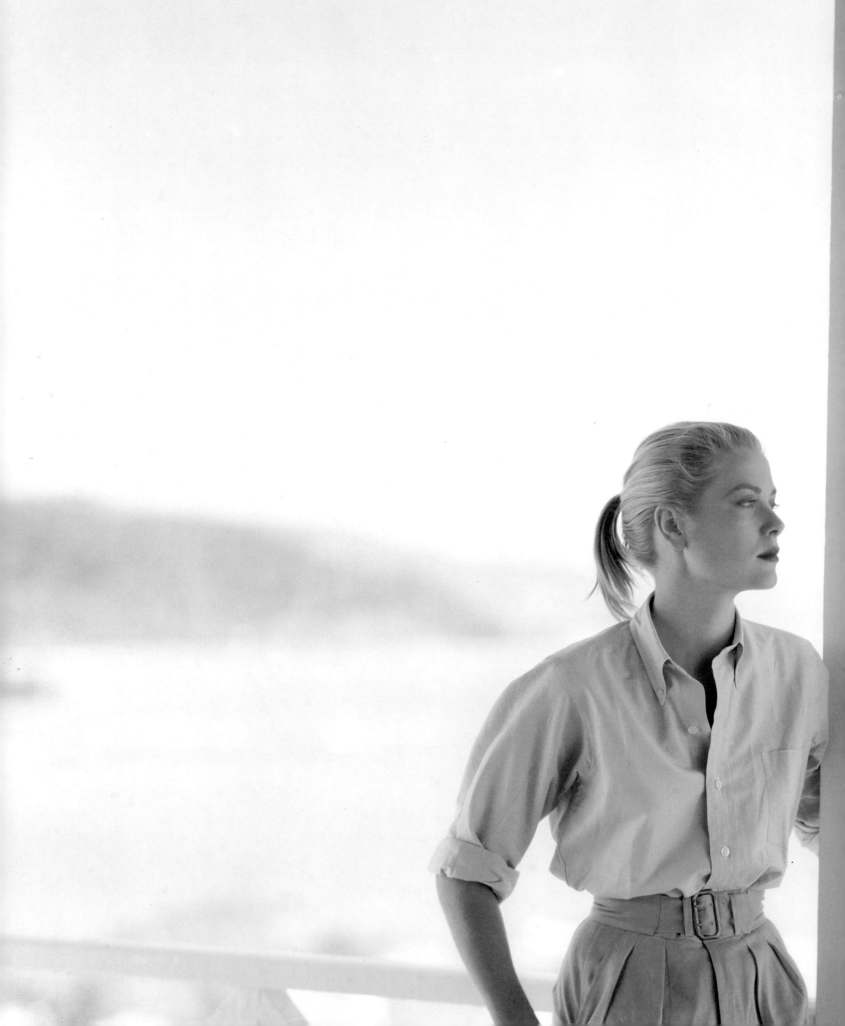

You trusted Grace's beauty; you knew it wasn't built from clothes and makeup. In New York, Grace would come over to my studio dressed in a sweater, a skirt, and loafers. In Jamaica, she was no different: her hair pulled back, dressed in a simple boy's shirt. This was Grace: natural, unpretentious.

# The Swan
# and
# the Prince

IT'S HARD TO BELIEVE THAT MGM's executives didn't know what was in store for Grace Kelly when they offered her the role in what would be her next-to-last movie. *The Swan* was a period piece in which the actress who was soon to marry a prince played, of all things, a princess who was contemplating marriage. Grace

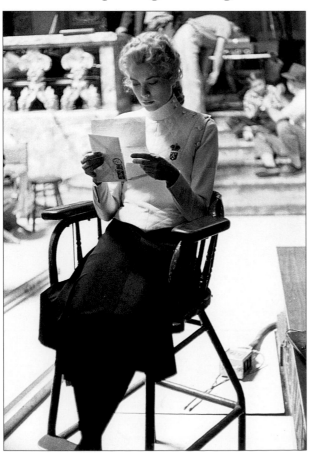

had accepted the role in April 1955, then met Prince Rainier for the first time in May. That summer, as she prepared for the role of Princess Alexandra, Kelly pondered a possible future with a real-life prince.

Conant came along on the filming to shoot pictures for *Collier's*. Yet neither he nor anyone else on the set knew what was on Grace's mind. Between scenes, he photographed her around Biltmore House, a replica of a French Renaissance château that George Vanderbilt had constructed in North Carolina in the 1890s.

Then, back home in New York, she invited Conant up to meet and photograph the man she would soon marry. As he took pictures, Conant engaged Rainier in conversation about their mutual love of skin-diving. The couple examined newspaper clippings of their wedding announcement and chuckled over the pictures of them. They held hands and whispered to each other. "I don't believe I've ever seen two people who looked more in love," reports Conant.

Though none of us knew why at the time, Grace seemed preoccupied throughout the filming. Whether waiting on the grand staircase of the Asheville, North Carolina, château that served as the set or reading a letter (is that letter written in French?), Grace often had her mind on other things, far away.

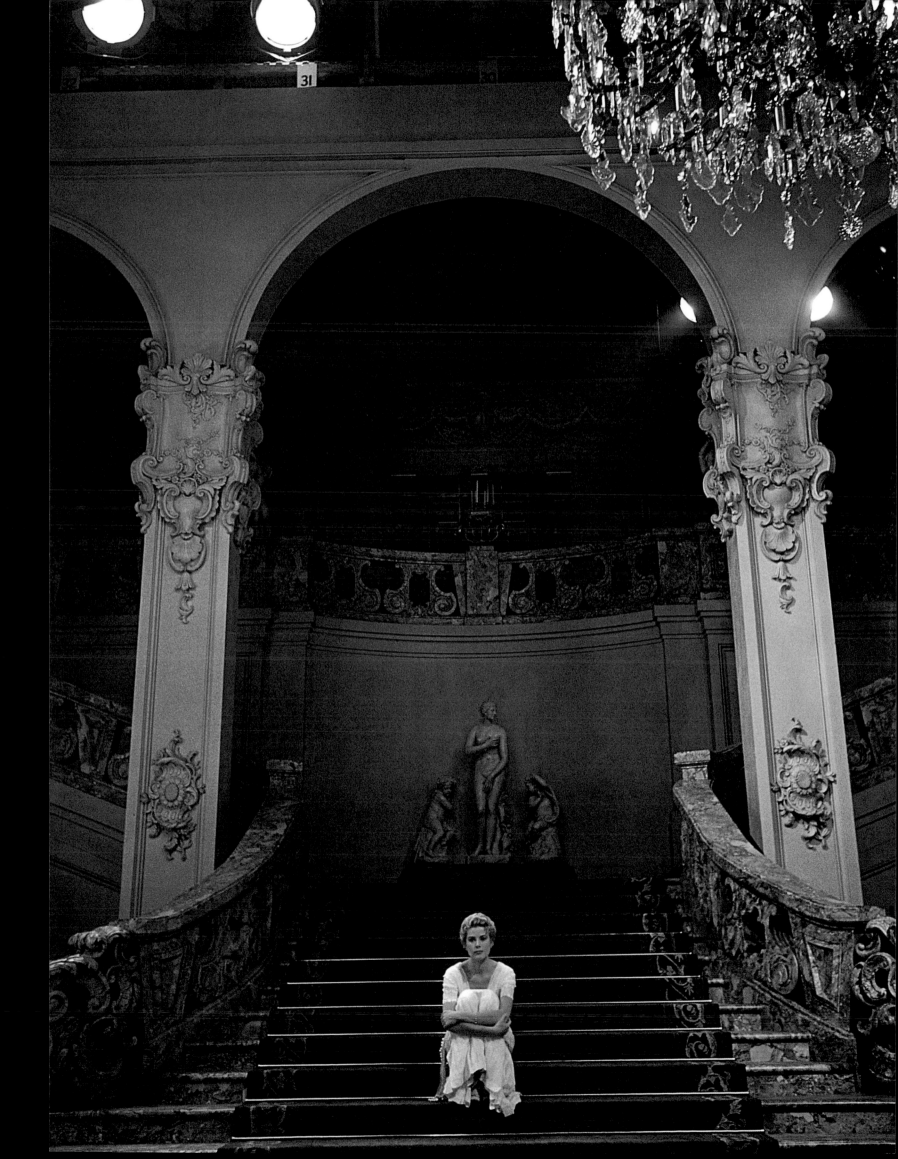

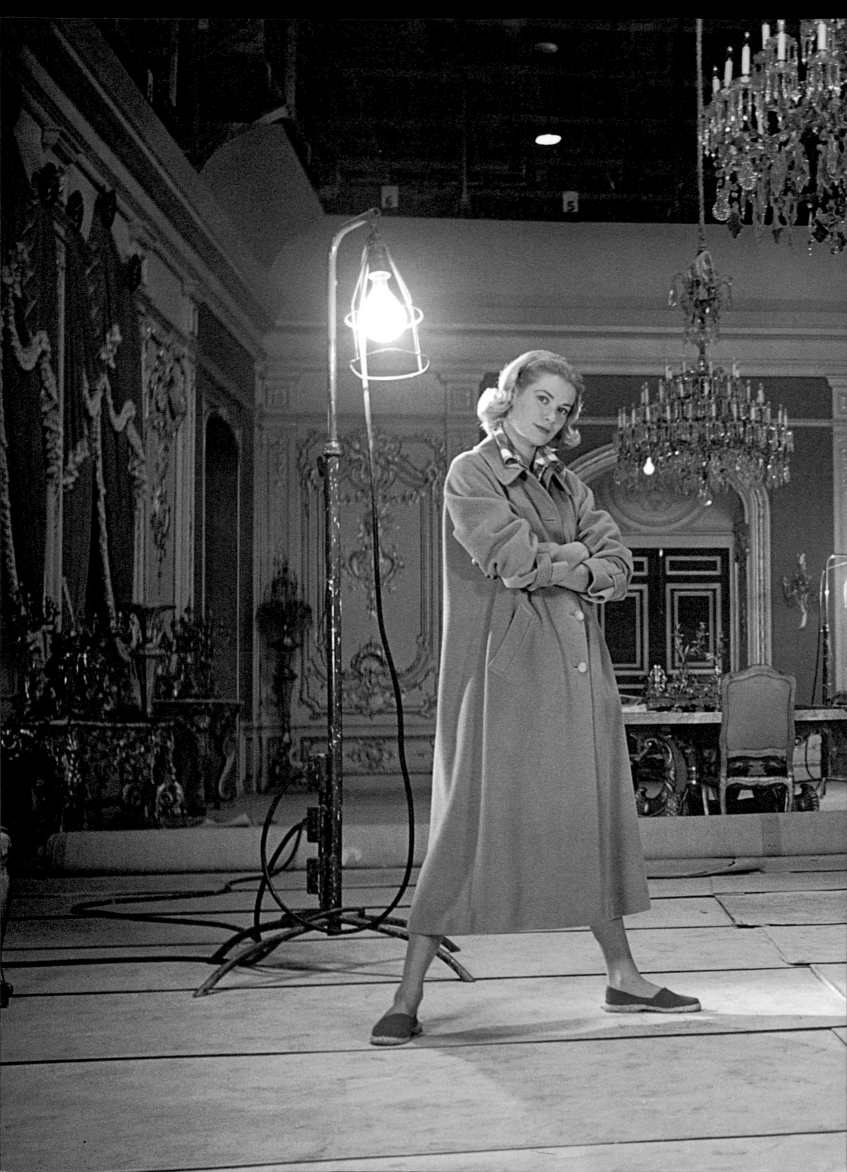

There is a lot of waiting in movie-making, and that gave her a lot of time to think. She remained remote on the set: quiet, pensive. Wrapped in a camel's-hair overcoat, she stood next to this incongruous-looking stage light and I snapped away. For me, this was a new side of Grace, a hard-working actress.

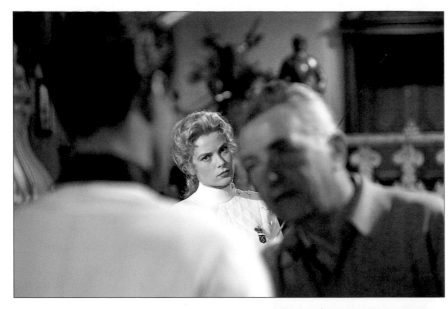

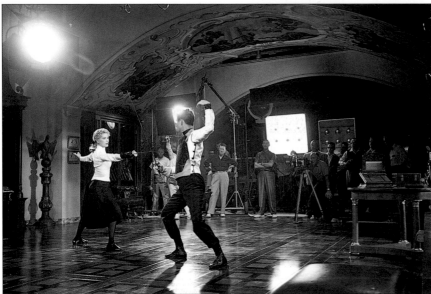

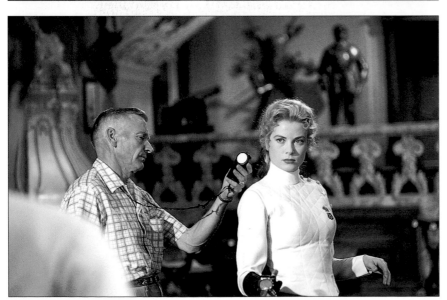

At twenty-six, Grace had reached the top of her profession. *The Swan* was the first picture in which she received top billing, yet her costars were Louis Jourdan, Alec Guinness, and Agnes Moorehead. That's Jourdan at left getting a few pointers from director Charles Vidor before his dueling scene with Grace. A studio technician, below, checks the lighting before they shoot.

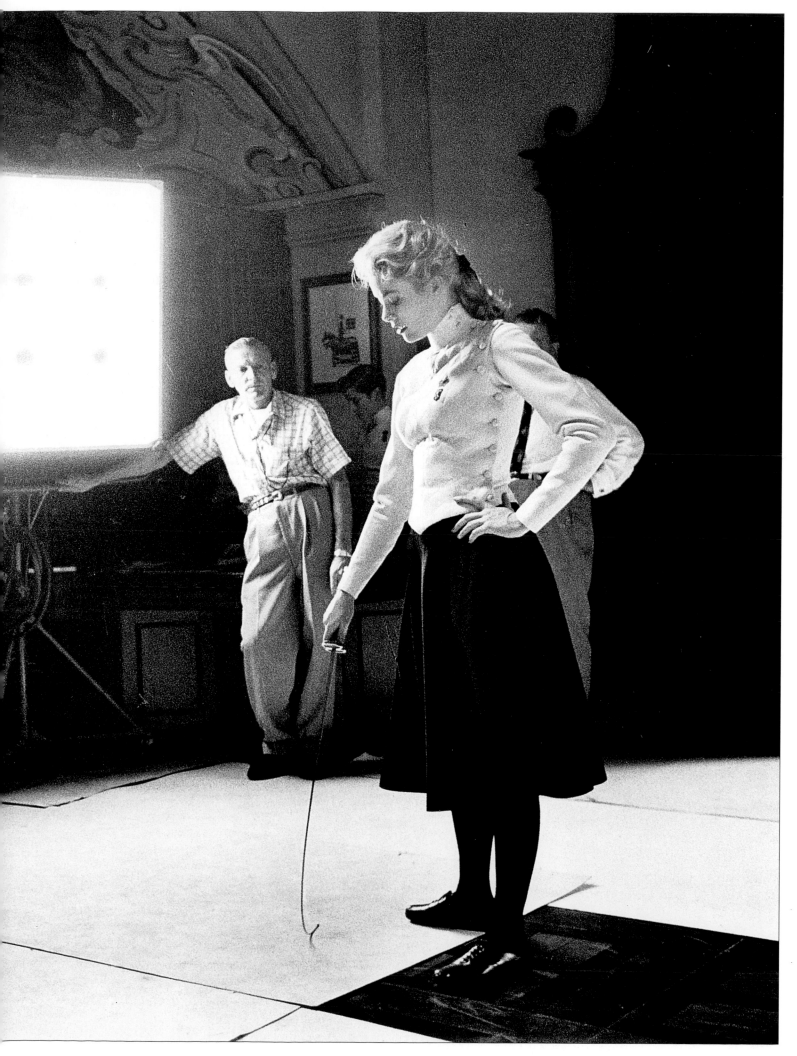

The distractions prompted Grace to keep her hands busy. Between scenes, she would return to her dressing room and crochet or knit (here, while listening to her sister Peggy). I would always stay near Grace; my access to the film set depended upon everyone knowing that I wasn't just any photographer, that I had Grace's full cooperation.

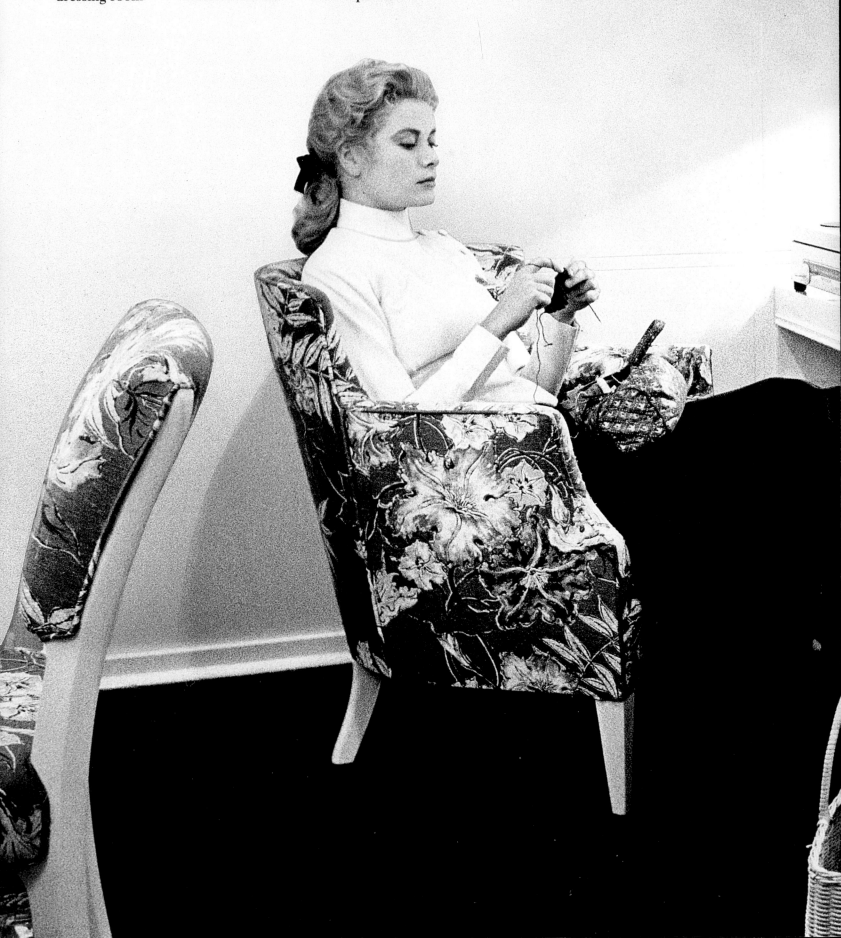

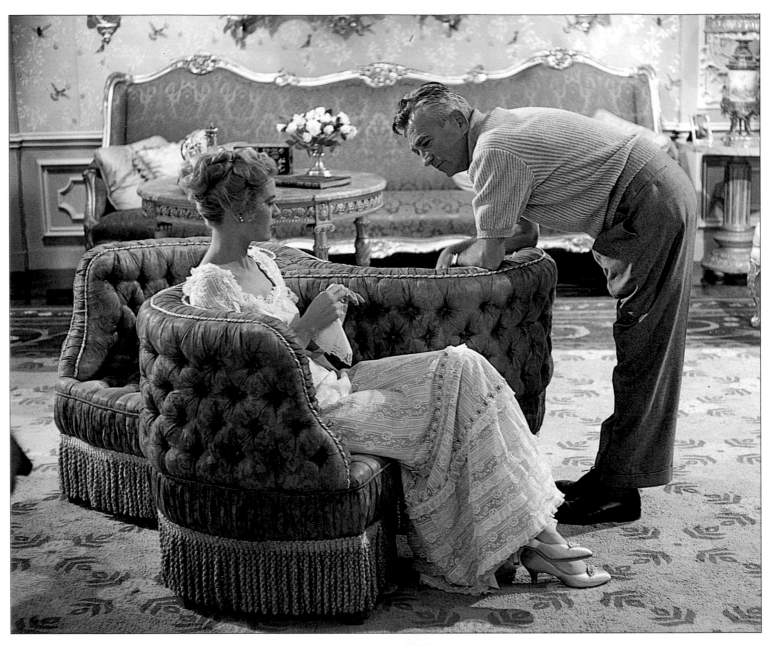

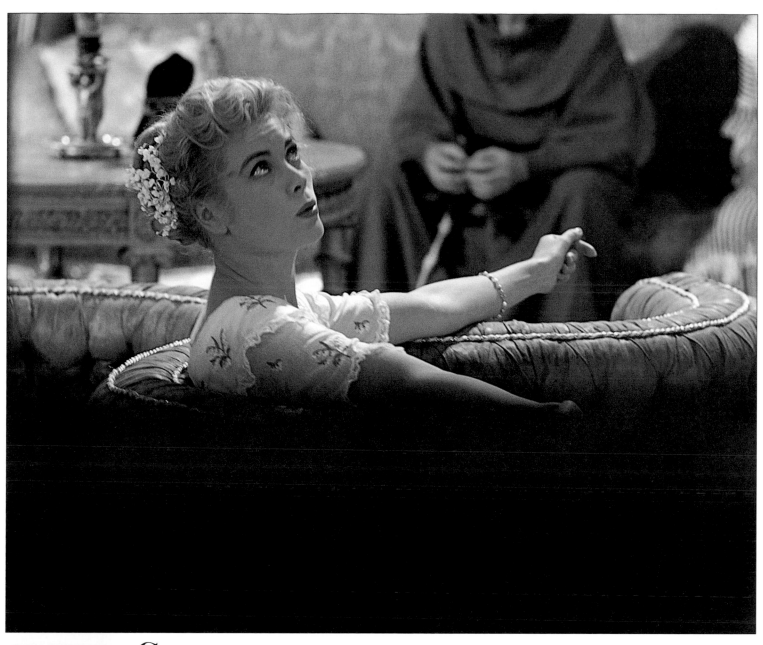

Grace, Vidor, above left, and Guinness got along famously. Grace and Guinness even took to playing pranks on each other. Aware that he had received a rather forward letter from a fan named Alice, she would have "Alice" page him periodically from the hotel lobby. For his part, the famous English actor had the hotel porter place an Indian tomahawk he had been given in Grace's bed. (She didn't acknowledge it until years later, when she delivered it anonymously to the bed at Guinness's English cottage.)

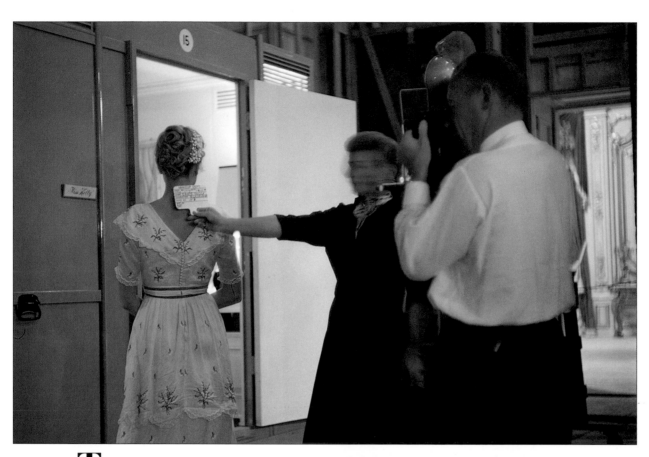

There was plenty of time for photographic experimentation, and Grace was always game. She had a wonderful profile, rarely seen. So, noticing the big square lighting panel on the set (visible on page 31), I had her step in front of it and shot her with backlighting. Above, a studio photographer takes a picture to document Grace's costuming and makeup, as he did for every scene. At right, Virginia Darcy, who always dressed Grace's hair, and a makeup man fix her up for the next scene.

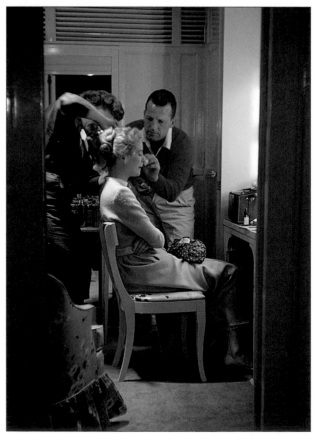

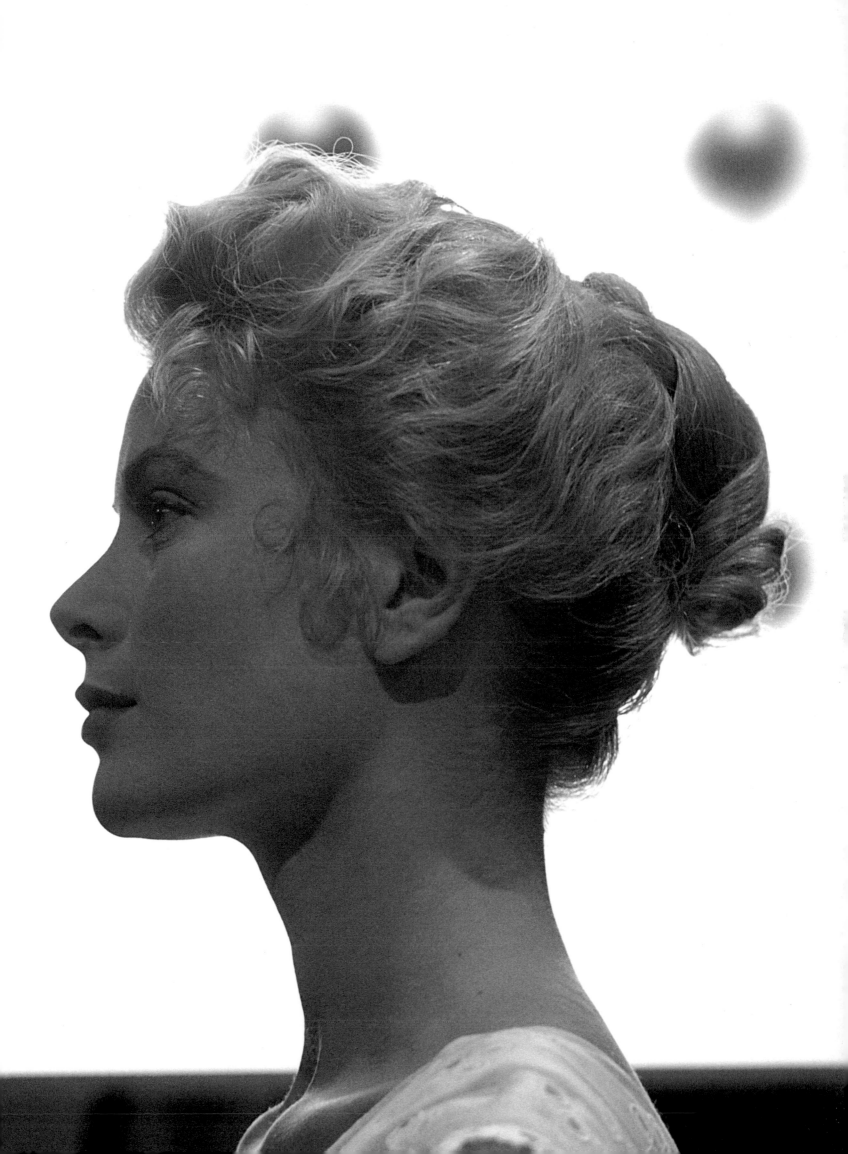

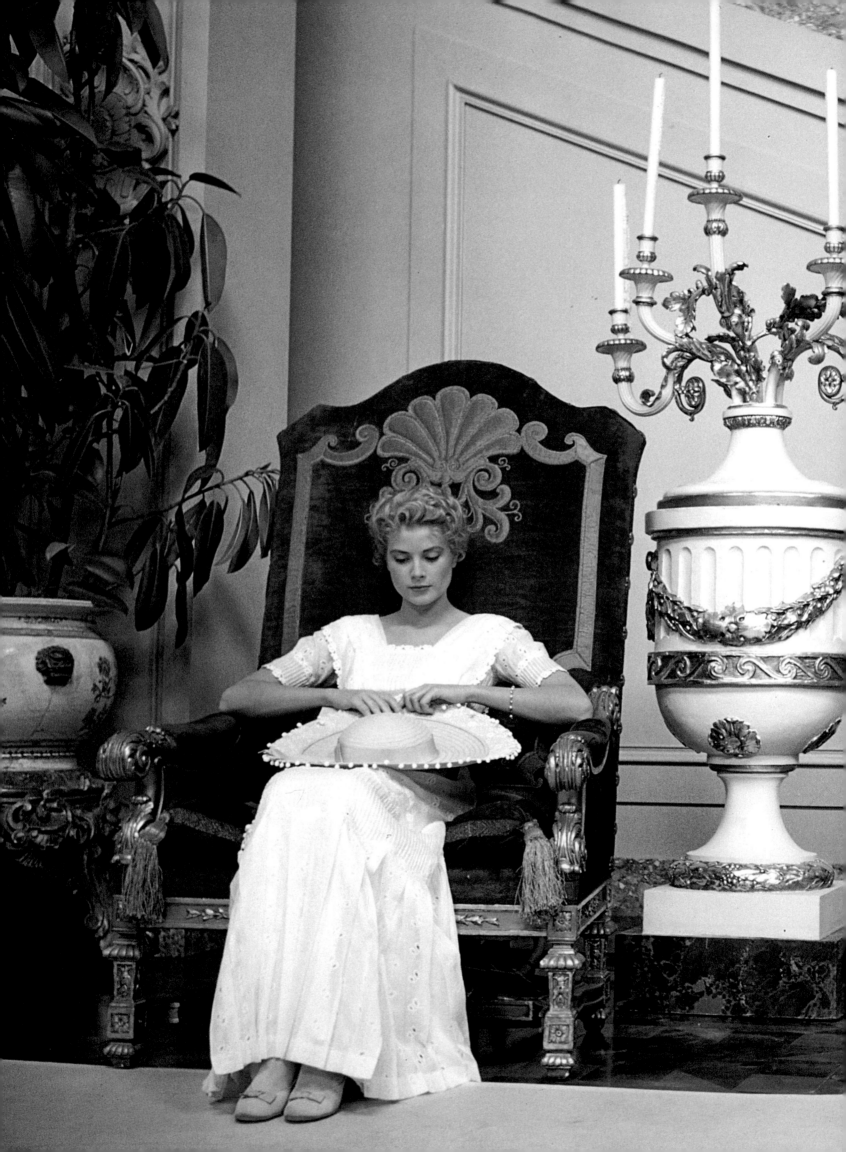

**I** don't think Grace even knew I was taking this picture. Here she was in this grand setting, a top star in a major film, yet she was oblivious to all she had, thinking her own thoughts.

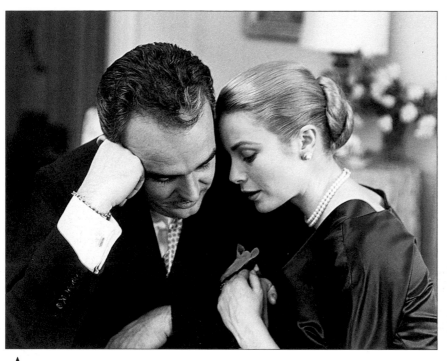

A few weeks after we returned from filming *The Swan*, she called to announce that she was going to marry this Prince So-and-So, and asked if I would take their engagement picture. I hurried over to her Park Avenue apartment and saw a Grace Kelly I had never seen before. Jamaica had introduced me to the playful Grace, and *The Swan* to the thoughtful, inward Grace; now I found, standing arm in arm with Prince Rainier of Monaco, Grace Kelly Number Three, a woman in love. I was so nervous I forgot to thread my film and shot only four good frames before we quit. Then the couple walked quietly over to the window for a few private words.

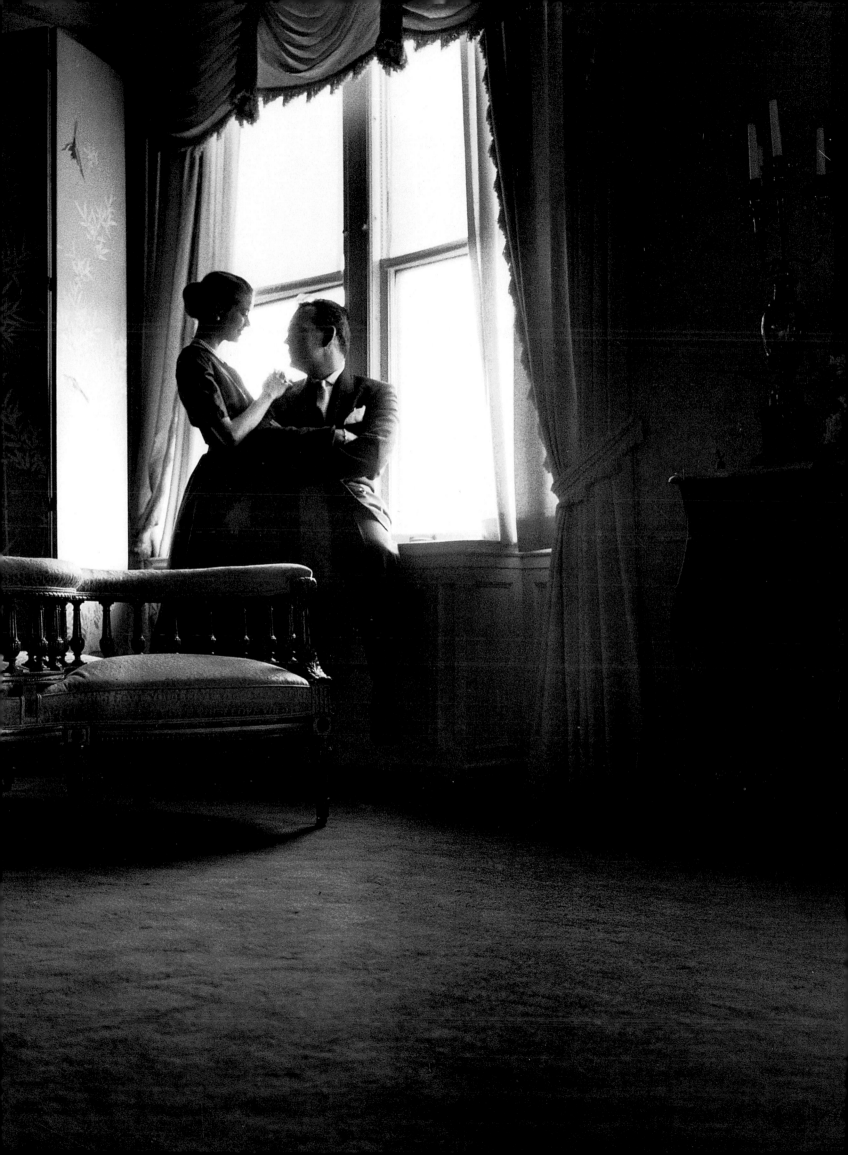

# The Voyage
# to
# Monaco

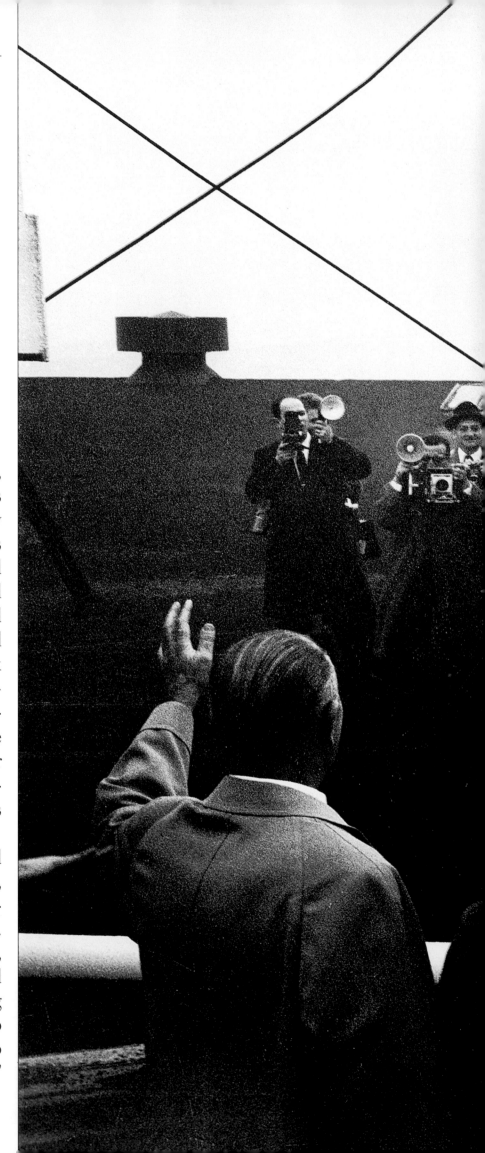

On April 4, 1956, Grace Kelly began her voyage across the Atlantic to a new name and a new life. Seventy-two friends and relatives joined her and her parents, John and Margaret Kelly, on the trip; so did more than a hundred reporters and photographers looking for stories and pictures to satisfy avid readers back home. From the moment the S.S. *Constitution* set off from Pier 84 in Manhattan until it arrived at the Côte d'Azur eight days later, Grace and her wedding party were besieged by journalists trying all kinds of shenanigans to one-up the competition.

Despite the ruckus, Grace found moments for reflection on the trip, even admitting later to a bit of nervousness as she set out on the journey. "The day we left," she told a friend, "our ship was surrounded by fog, and that's the way I felt, as if I were sailing off into the unknown. I couldn't help wondering, 'What's going to happen to me? What will this new life be like?'"

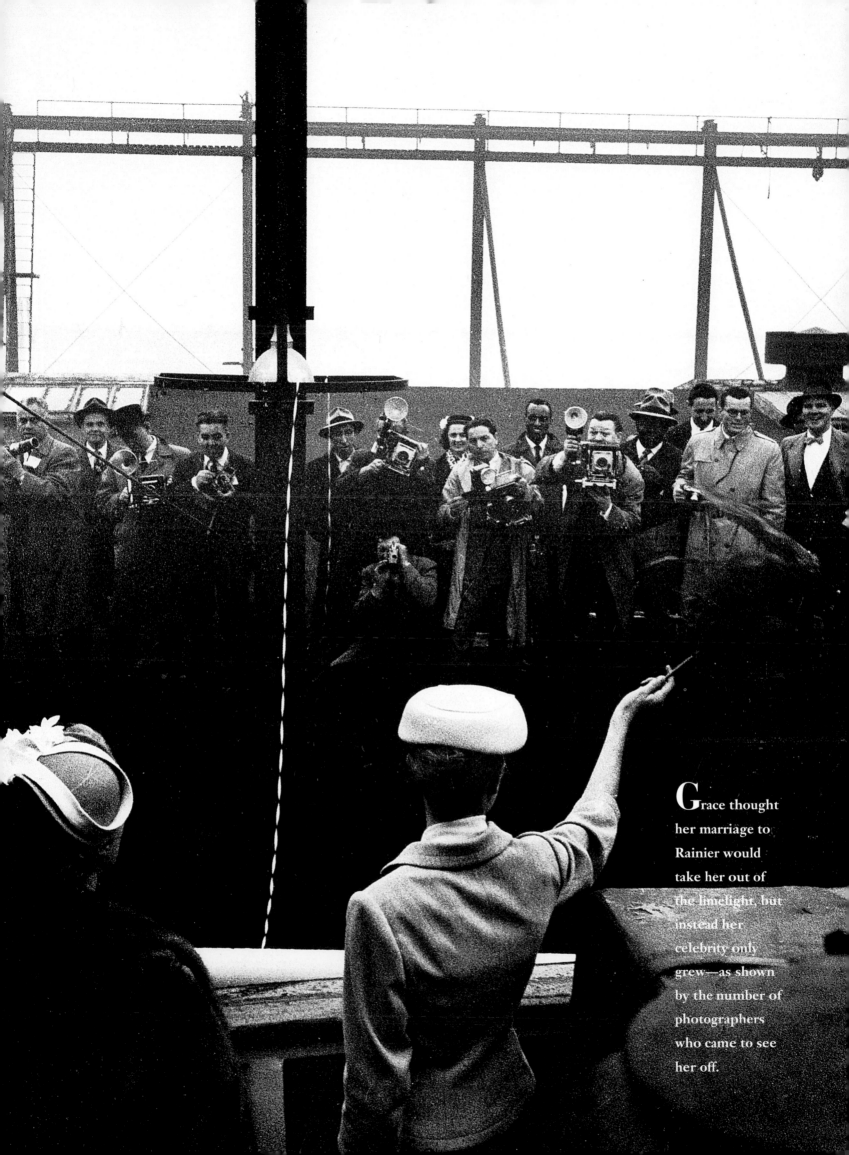

**G**race thought her marriage to Rainier would take her out of the limelight, but instead her celebrity only grew—as shown by the number of photographers who came to see her off.

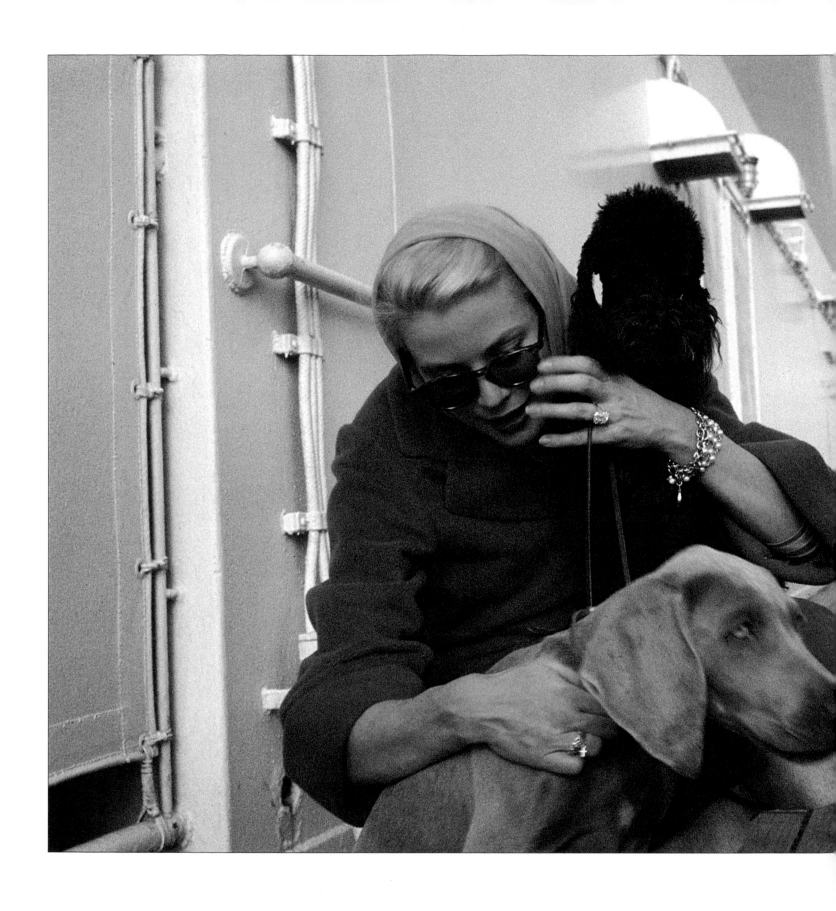

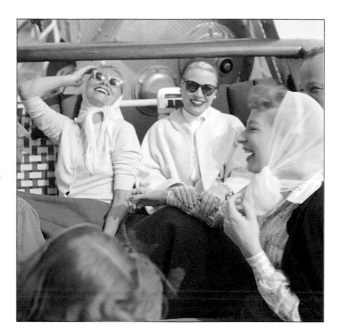

Life on the boat was crazy. The press made it seem like a zoo. We cordoned off an area outside Grace's stateroom to protect the wedding party from all the reporters and photographers; at right, Grace and Peggy take advantage of their own private bit of deck. I was lucky—as Grace's photographer, I had access to her when the others didn't. I was working for *Life*, yet Grace, Rainier, and I had struck a deal to keep that a secret.

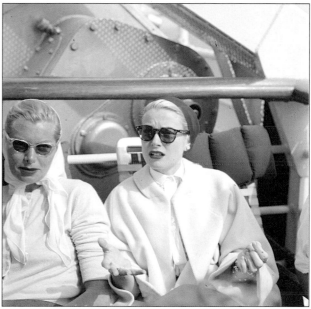

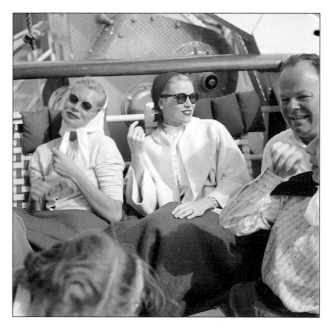

Each day, Grace would walk her prized poodle, Oliver, around the deck. The Weimaraner was the gift of some friends, who put it in her state-room with the other bon-voyage presents. Of course the dog lost control; when Grace opened the door, the state-room smelled like a zoo.

To satisfy the demands of the press, Morgan Hudgins (Grace's MGM publicist) and I concocted a plan. Each day, we arranged an event to give reporters what they needed: words and pictures to send home. Grace's shuffleboard game with a few shipboard kids was one such setup.

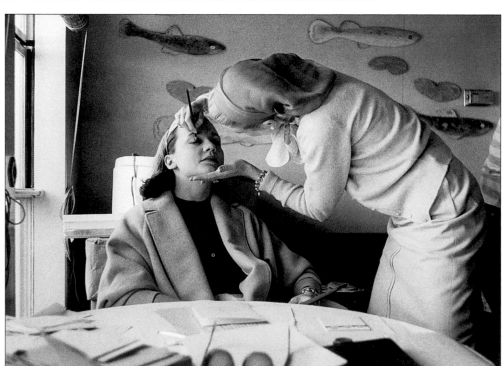

But even I needed a few staged events for my *Life* story, so I convinced Grace to pretend she was giving makeup lessons to one of her bridesmaids, Maree Pamp.

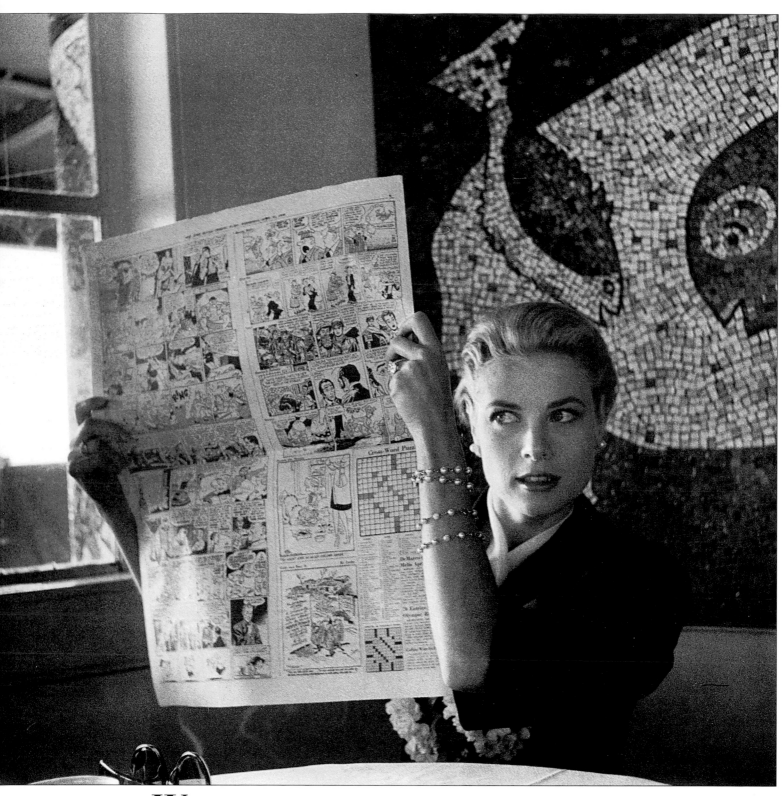

While the rest of the press followed each other around, I was able to store my cameras in Grace's stateroom. Photographers lurked around every corner and peered through every window, hoping to grab a picture of Grace unawares. Above, she shields herself with a newspaper.

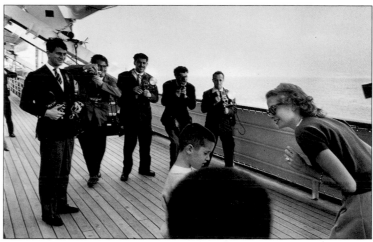

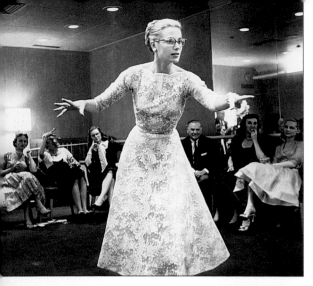

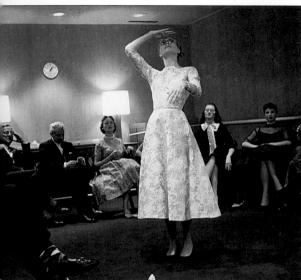

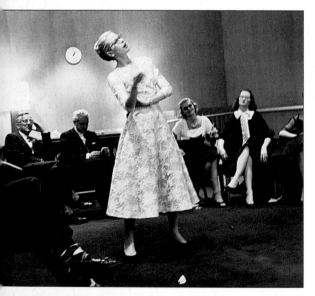

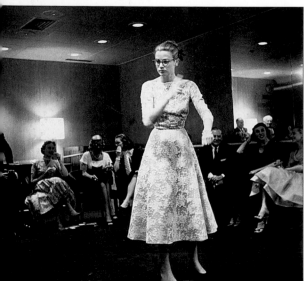

Charades was a popular shipboard game, and Grace loved to play. In the series at left, she tries her hand at dramatizing the phrase "watch the danger line"; at right, along with other members of the wedding party, she tries to guess as agent Jay Kanter (the shadow at far right) acts out "heat transfer and thermodynamics." *Paris Match* photographer Walter Carone is sitting just behind Grace's right shoulder. We let him play on one condition: no cameras.

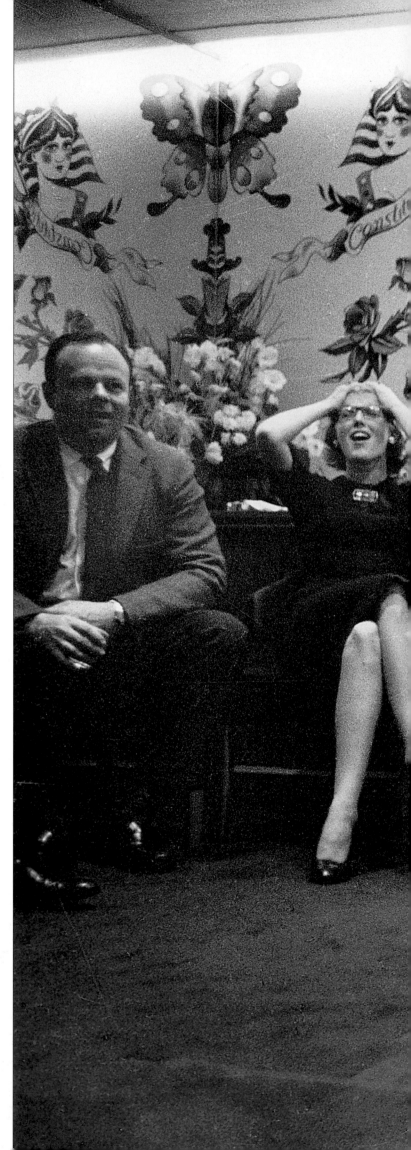

For her arrival in Monaco, Grace donned a wide-brimmed white hat, and while waiting for her prince and his yacht, she asked me how it looked—she had come to trust my eye. I thought the hat looked great and said so; I was pretty embarrassed when the waiting Monégasques complained that they couldn't see her face.

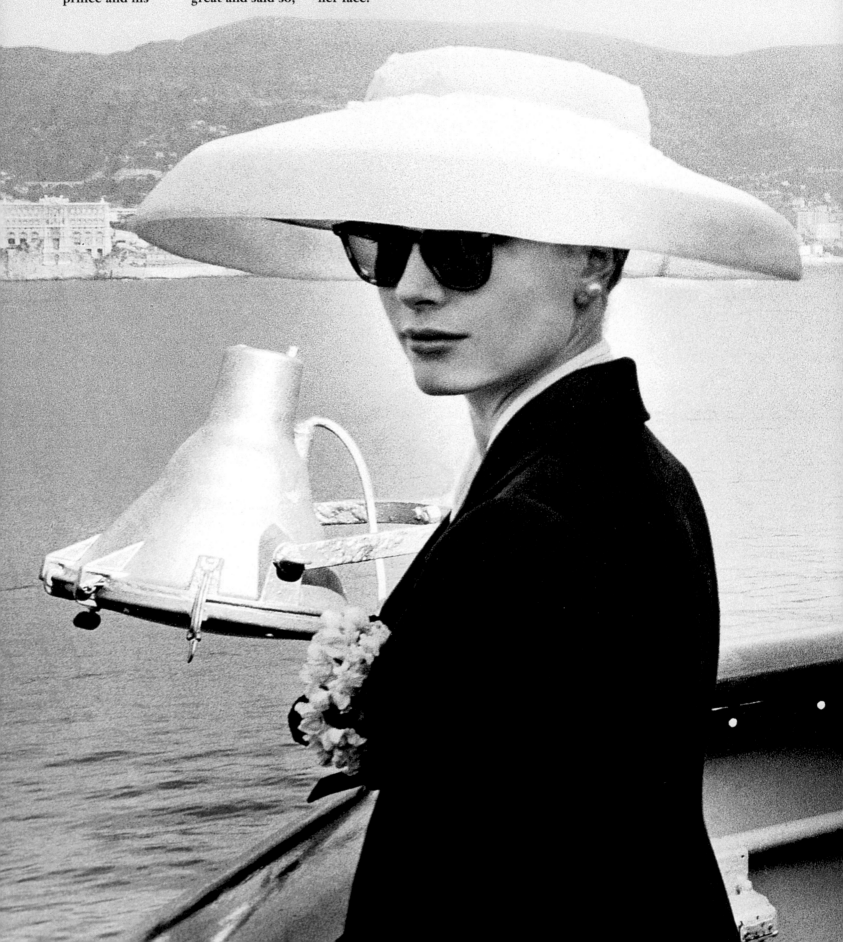

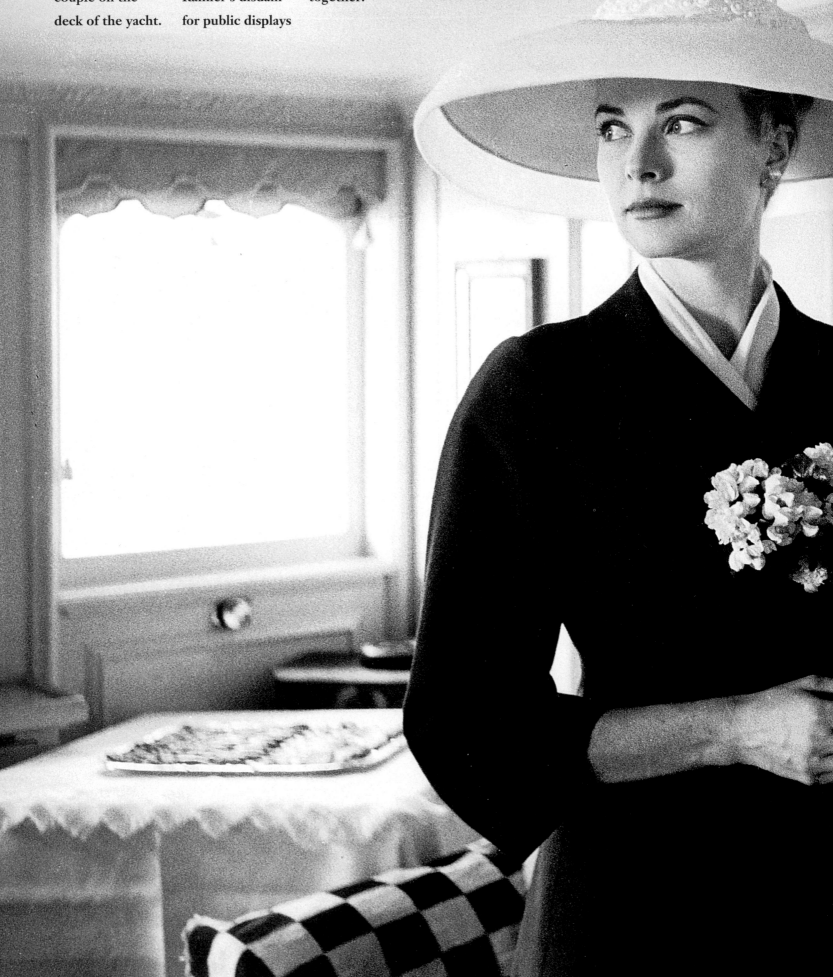

Only a polite handshake marked the greeting of the couple on the deck of the yacht. Though Grace was much more excited than that, she respected Rainier's disdain for public displays of affection. Even here inside, the couple seemed a little nervous together.

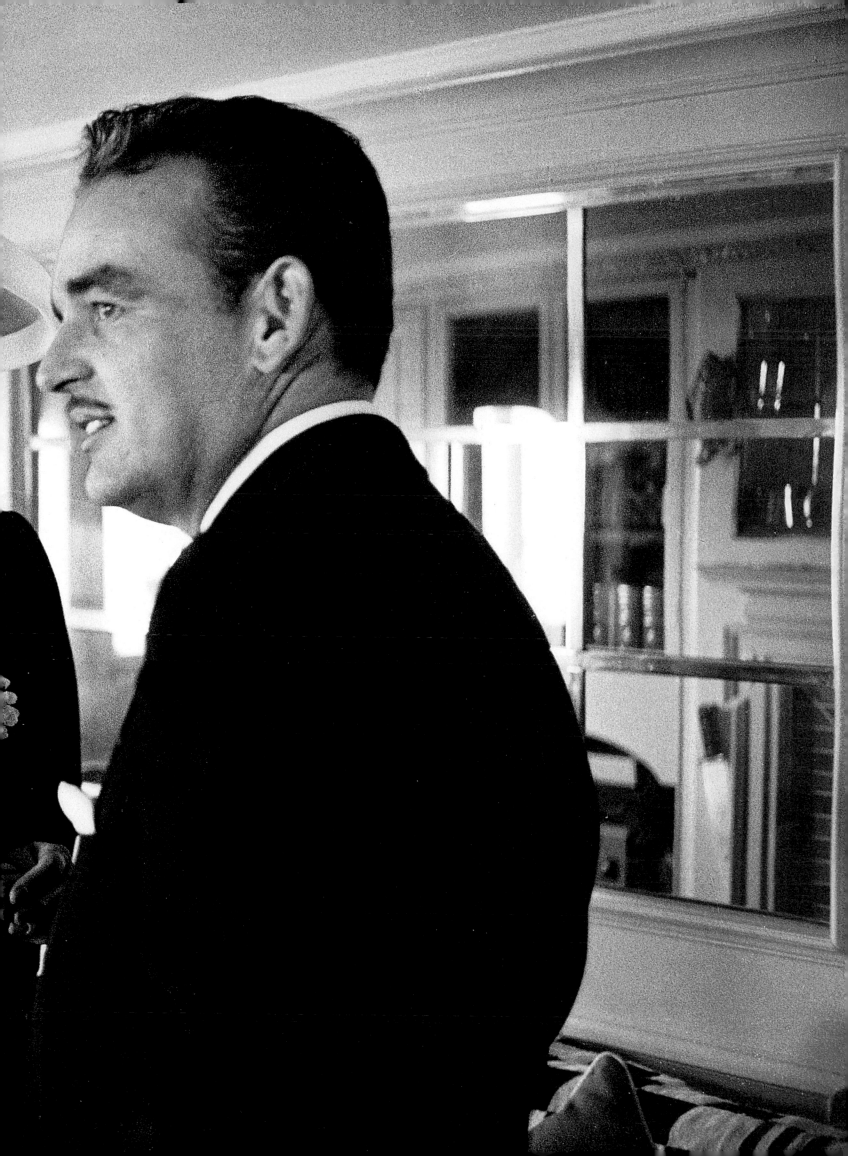

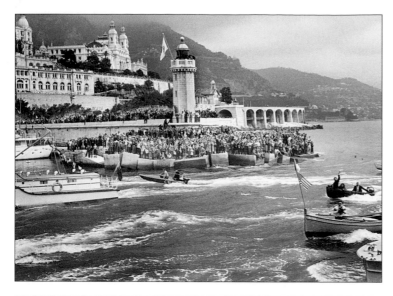

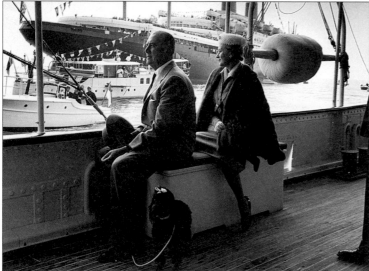

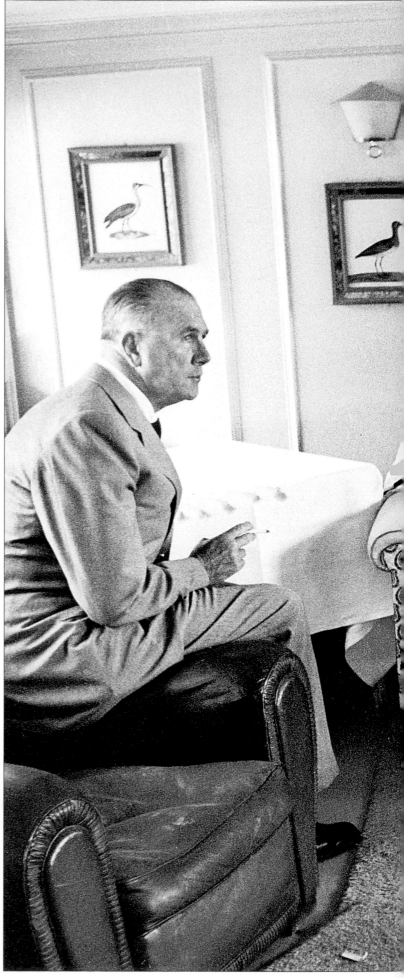

The *Constitution* didn't dock in Monaco, so most of the press had to disembark early, in Cannes. *Paris Match*'s Walter Carone stayed aboard, wrapped his cameras in plastic, slipped through a porthole, and dropped into the sea, where a small boat sent by his magazine picked him up. Only her parents and I had been allowed to join Grace and Rainier on the yacht; after a chat in the saloon, the couple stood at the bow and looked out at the thousands of people waiting to greet them, top. The elder Kellys (above with Oliver) waited somewhat impatiently themselves.

Once they were ashore, overleaf, Monsignor Gilles Barth, who would later marry the couple, and Father Francis Tucker, the man who had introduced them, escorted Grace and her mother into Rainier's 220-room pink palace.

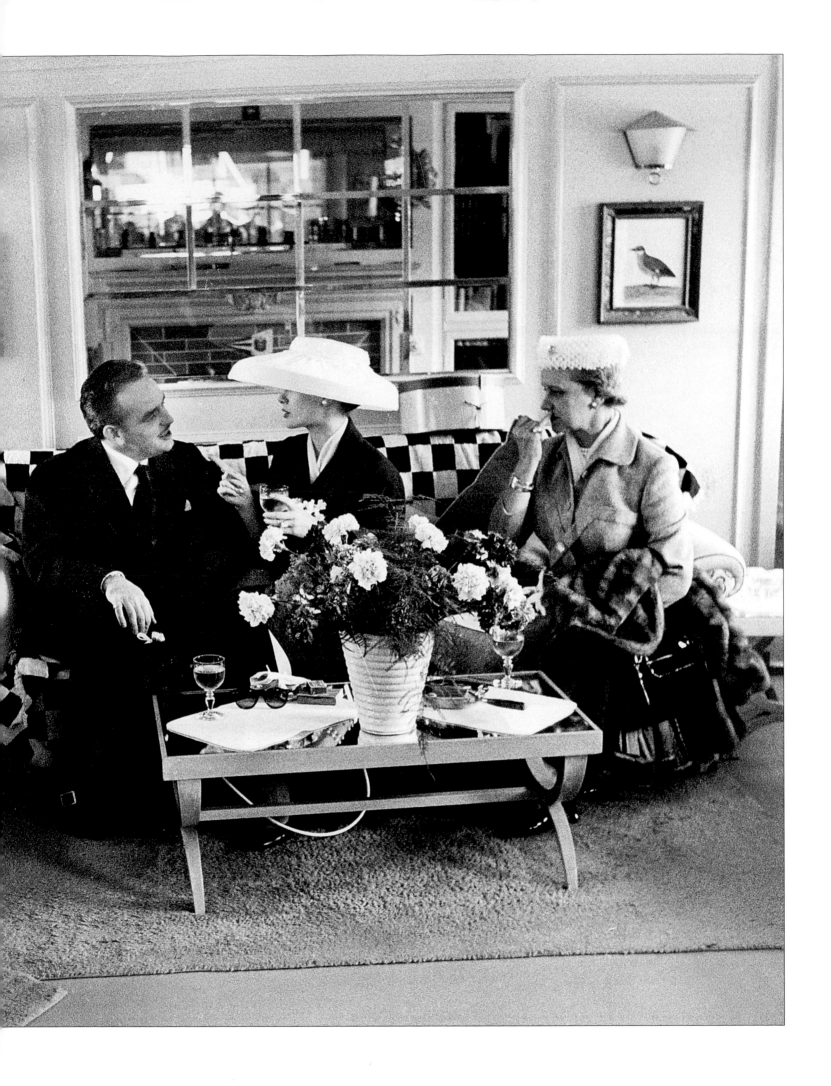

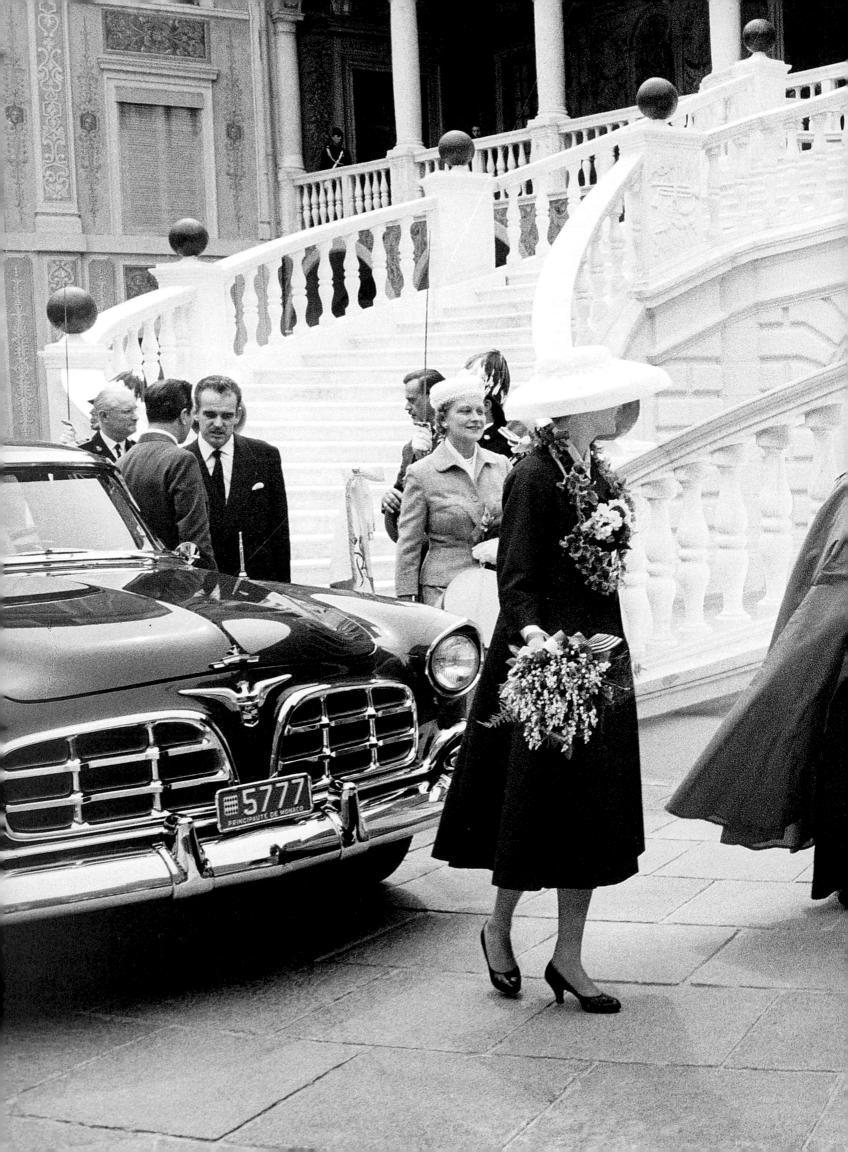

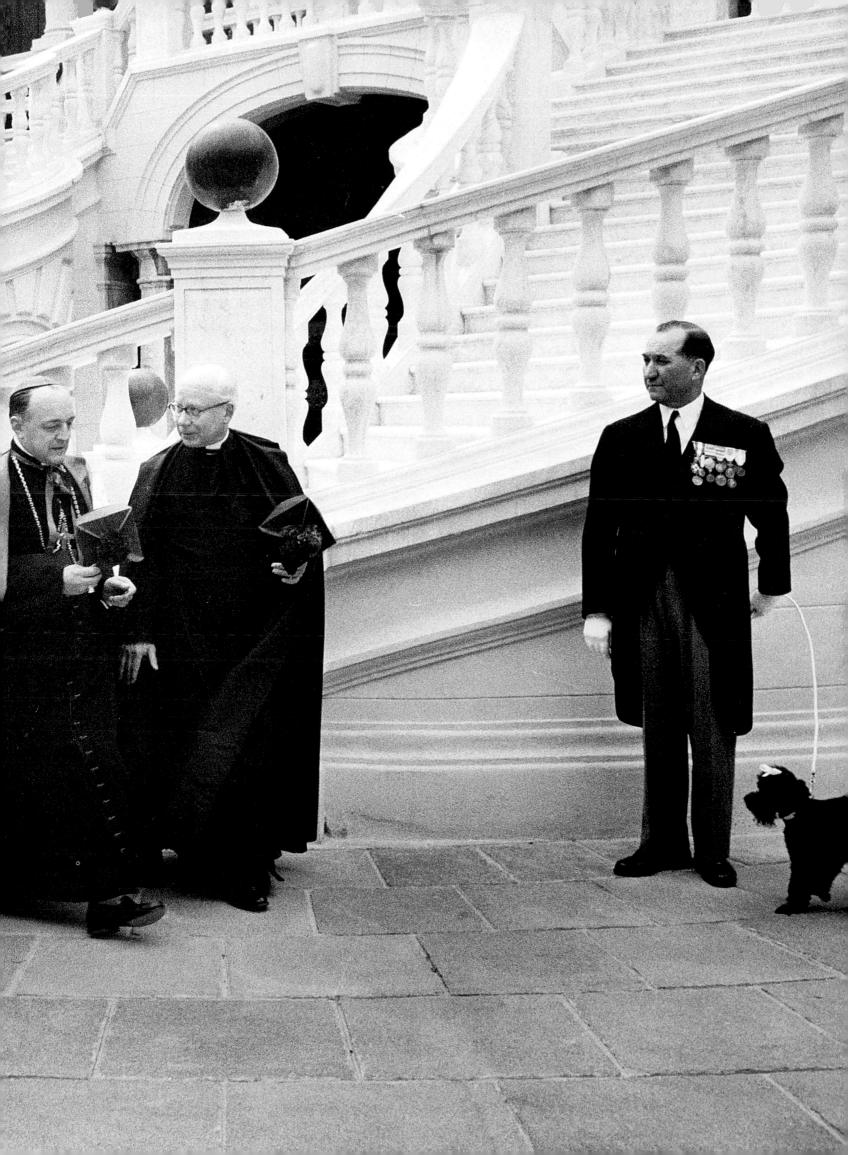

# The Wedding

Chaotic as the trip over had been, it was a mere prelude to what followed. The press contingent, having already ruined Grace's hopes for a calm ocean journey, now turned its attention to overpowering the wedding, too. More than fifteen hundred reporters from all over Europe and America crammed into the tiny 370-acre principality, joined by crowds of Monégasques eager to lay eyes on their new American princess. Perhaps it was naïve of her to have thought otherwise, but as the crowds and the cameras followed her every move, Grace quickly realized that her wedding was to be shared not just with her new husband and her proud family, but with all of Monaco and much of the rest of the world as well.

The event involved two ceremonies. The first was a civil one (after which Grace referred to herself as "half-married"), held in the throne room of the palace while rain poured down outside. The next day, April 19, came a religious ceremony at high mass in the Cathedral of Saint Nicholas, while sun bathed the rocky coast. Thereafter, Monégasques called any sunny day "Princess Grace weather."

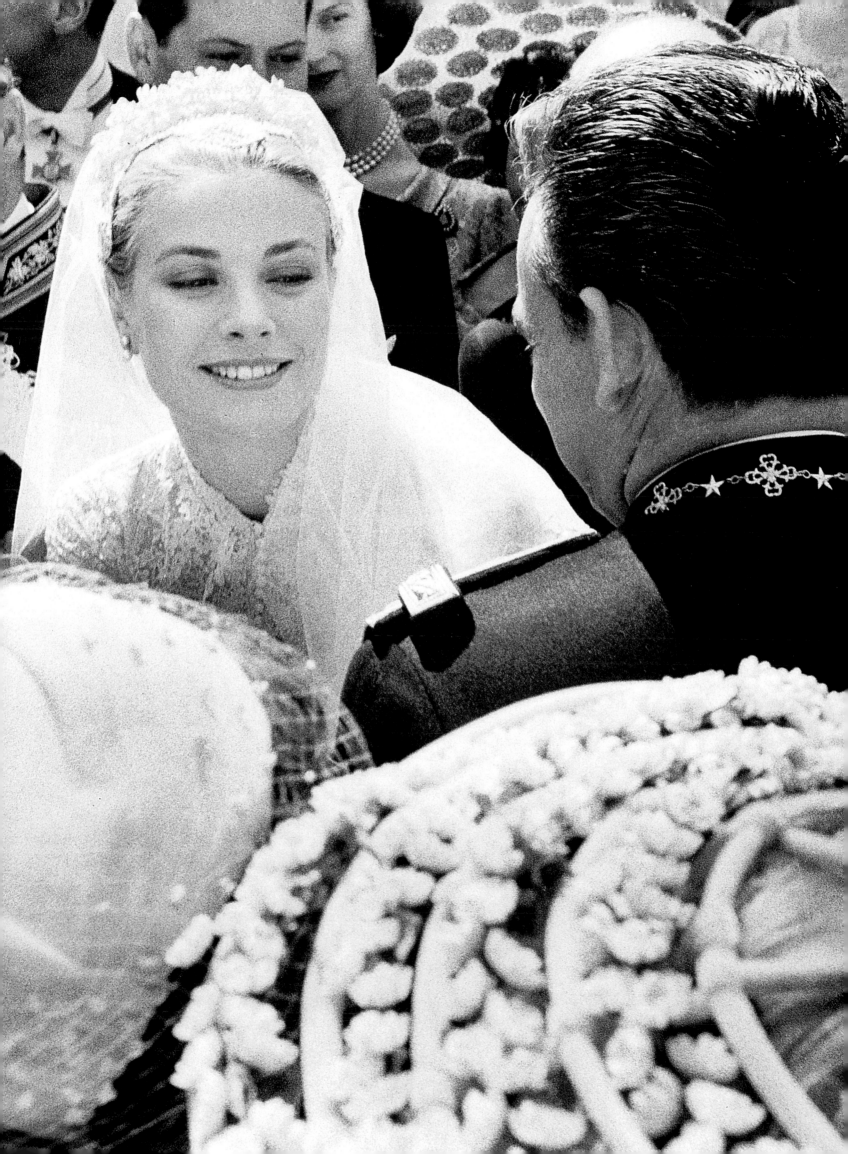

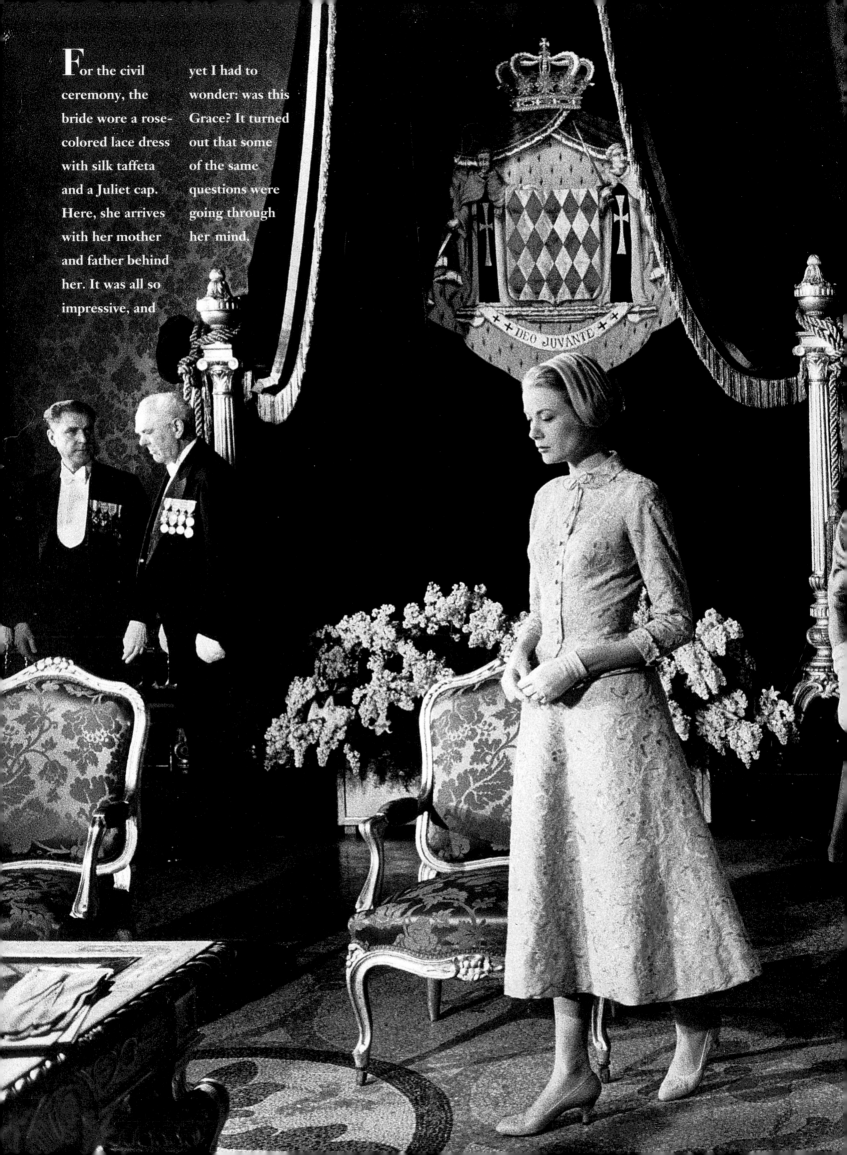

For the civil ceremony, the bride wore a rose-colored lace dress with silk taffeta and a Juliet cap. Here, she arrives with her mother and father behind her. It was all so impressive, and yet I had to wonder: was this Grace? It turned out that some of the same questions were going through her mind.

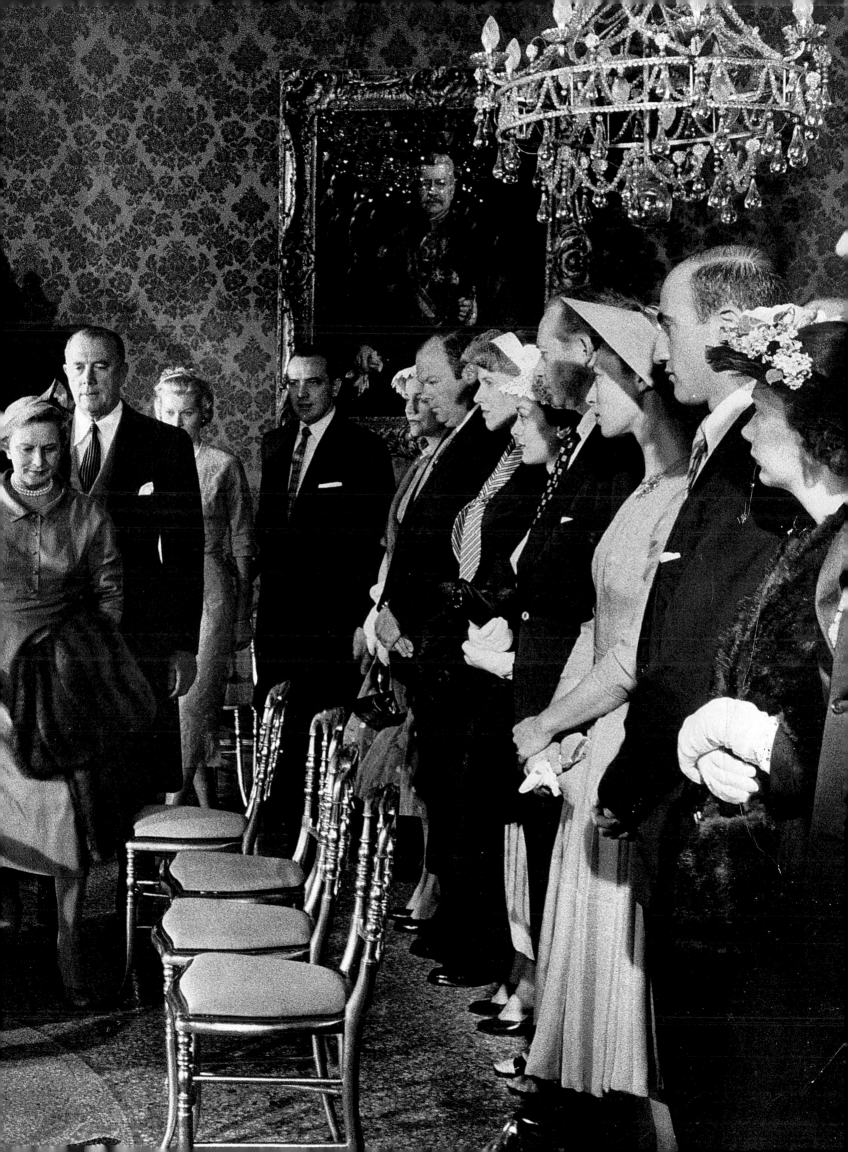

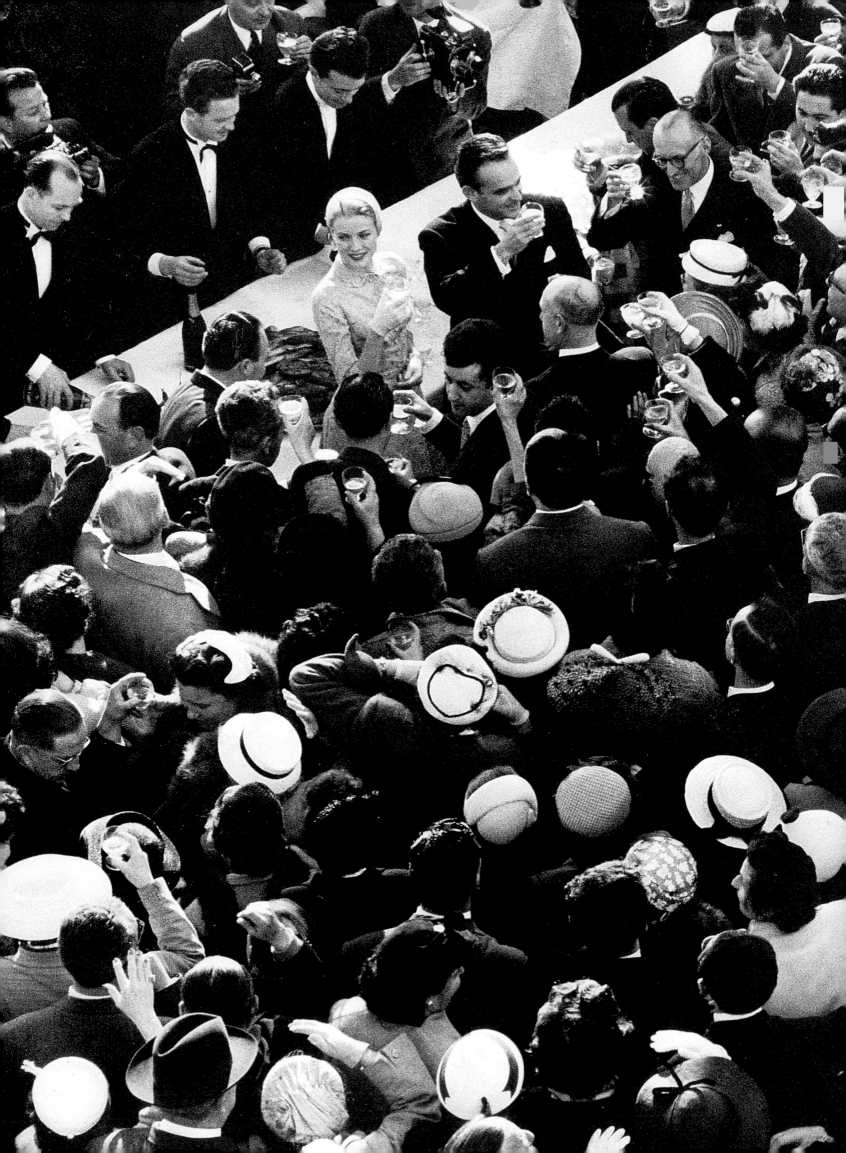

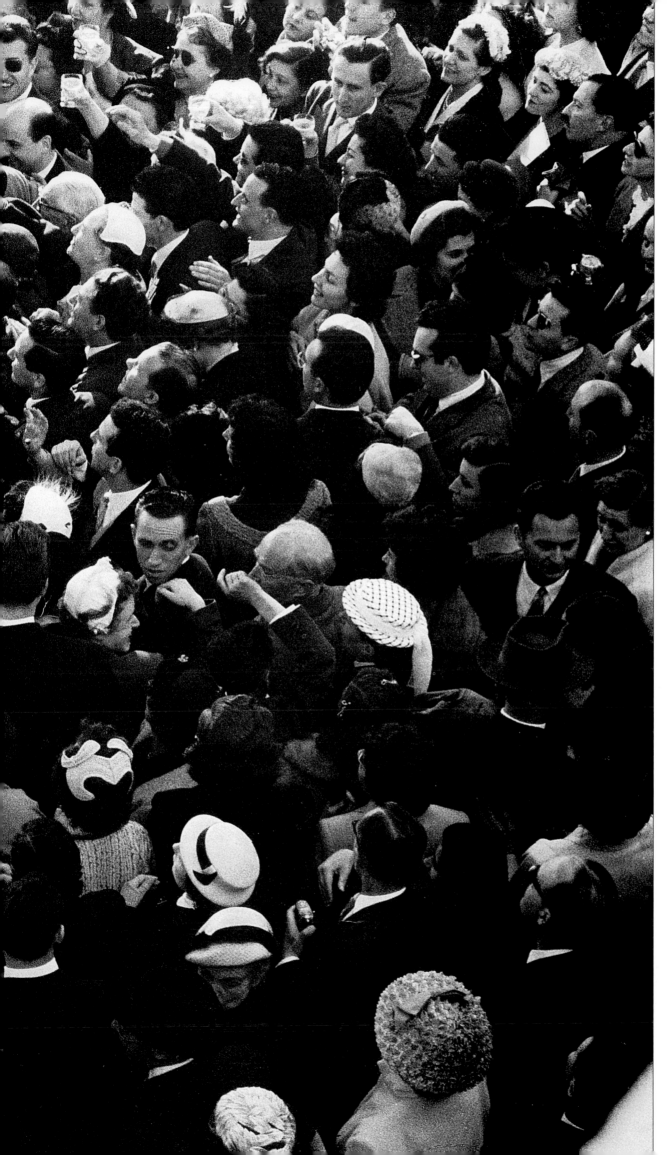

After the civil ceremony, about three thousand of Grace's new subjects were treated to cake and champagne in the palace courtyard. Now Grace Kelly was a princess, coping with all the glamour and responsibility that went with the title.

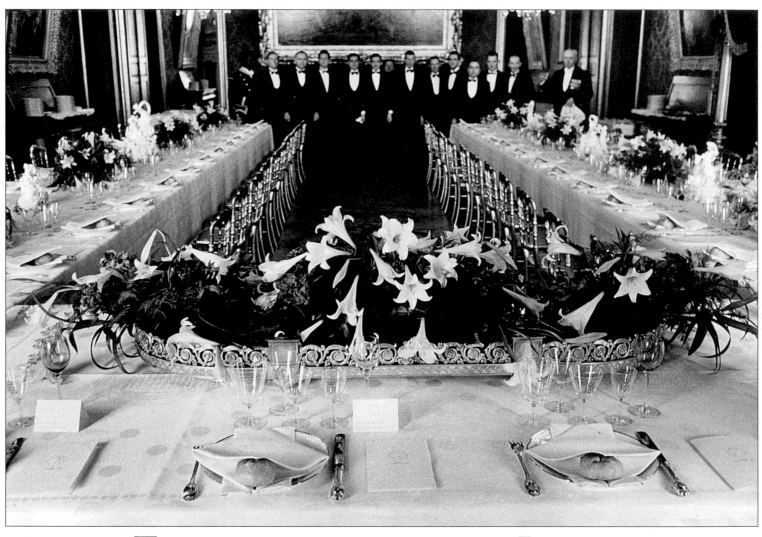

This is the table set for lunch after the civil rite; at right, Rainier and his princess acknowledge the crowds of Monégasques from their palace window that evening. The fuss around the event had made things unpleasant for both of them, yet Grace's innate sense of dignity allowed her to keep up a good appearance.

I was sorry to miss the mass. But had I been setting up there, I wouldn't have gotten one of my favorite shots, the casual grouping of Grace and her bridesmaids, overleaf. They had just finished their preparations and were on their way to the cathedral when I happened upon them and asked them all to strike a quick pose.

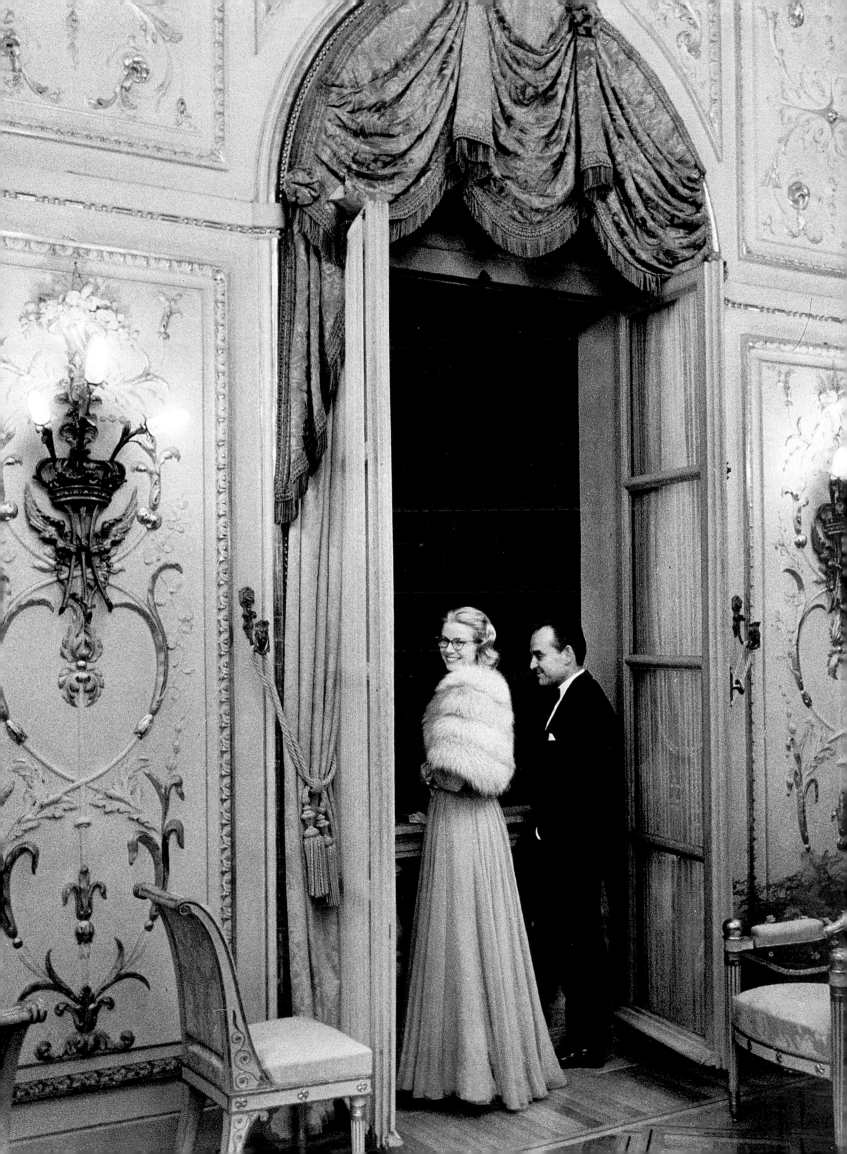

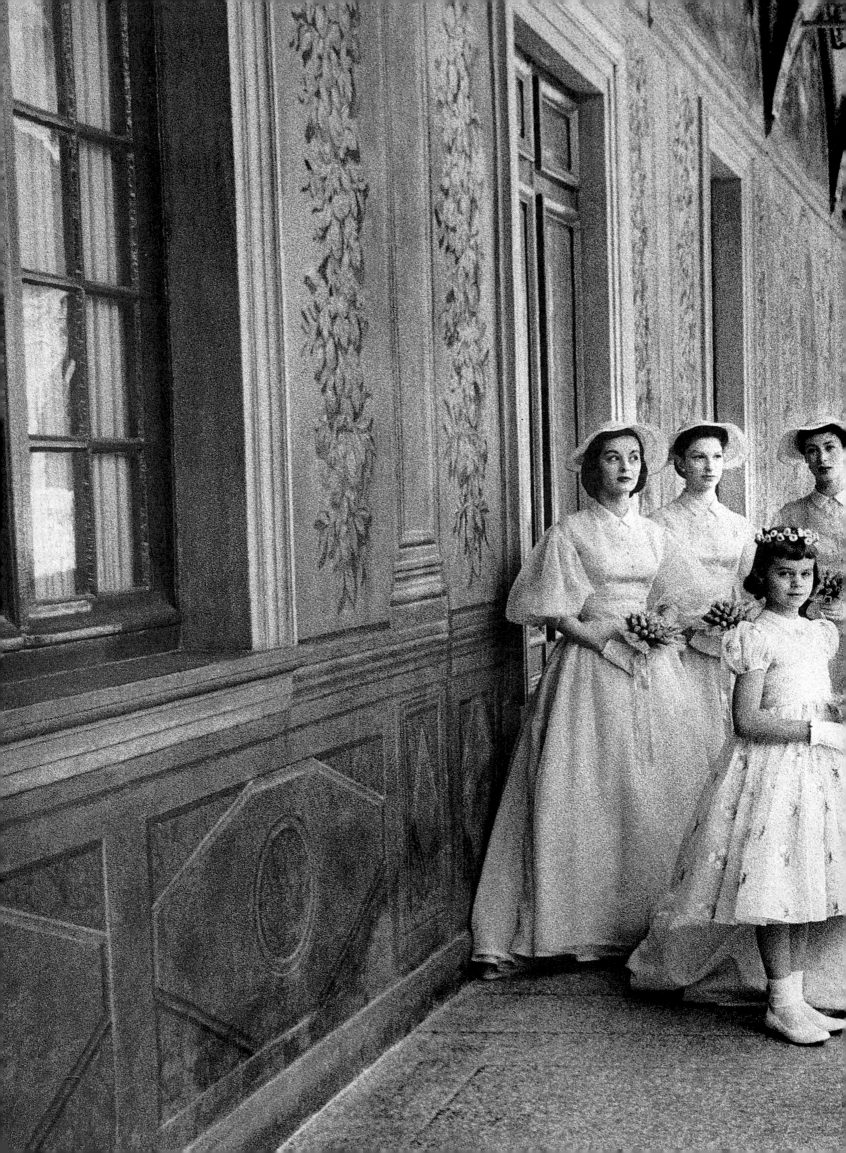

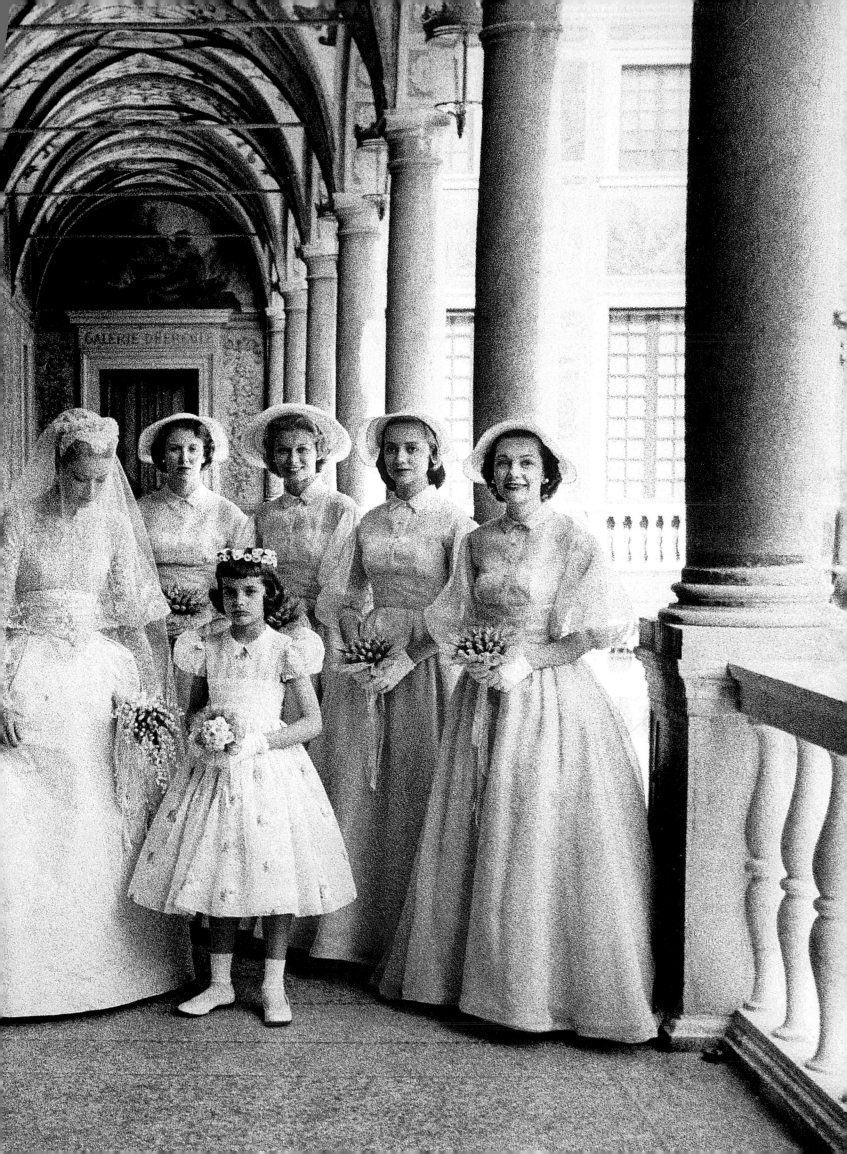

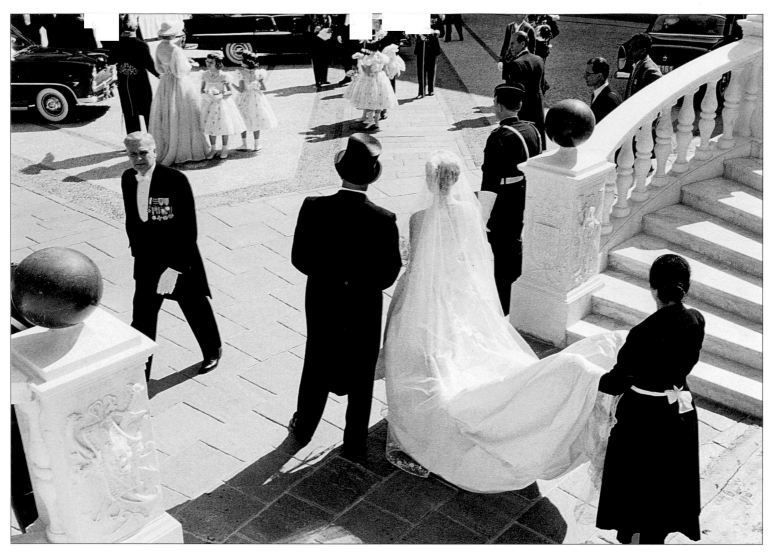

Despite the prevailing circus atmosphere, there were many quiet moments to record: Grace and her father waiting in the courtyard to be taken to the cathedral, above, and the baker putting the final touches on a beautiful wedding cake, which Rainier, at the right moment, deftly cut with his sword.

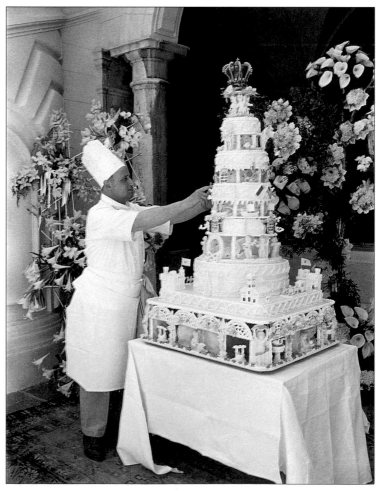

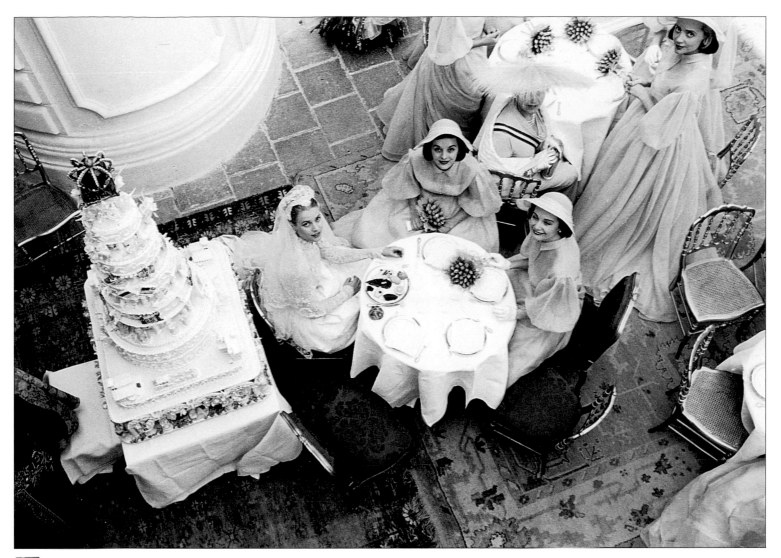

The reception included six hundred guests, but Grace stayed close to the wedding party, above. Though polite, both she and Rainier were spent from their ordeal and ready to sail off on their honeymoon (they planned to cruise along the Riviera and the coast of Spain). Ava Gardner, who had starred with Grace in *Mogambo*, asked me if I could get her into the private area to see the bride. When I did, it created a huge fuss from everyone else who wanted to get near. Prince Rainier was annoyed with me for this breach of protocol, but kept his sense of humor. "Hey, Howell!" he called out. "Have you got a brother?" When I said yes, the prince replied, "I hope he's nicer than you are!"

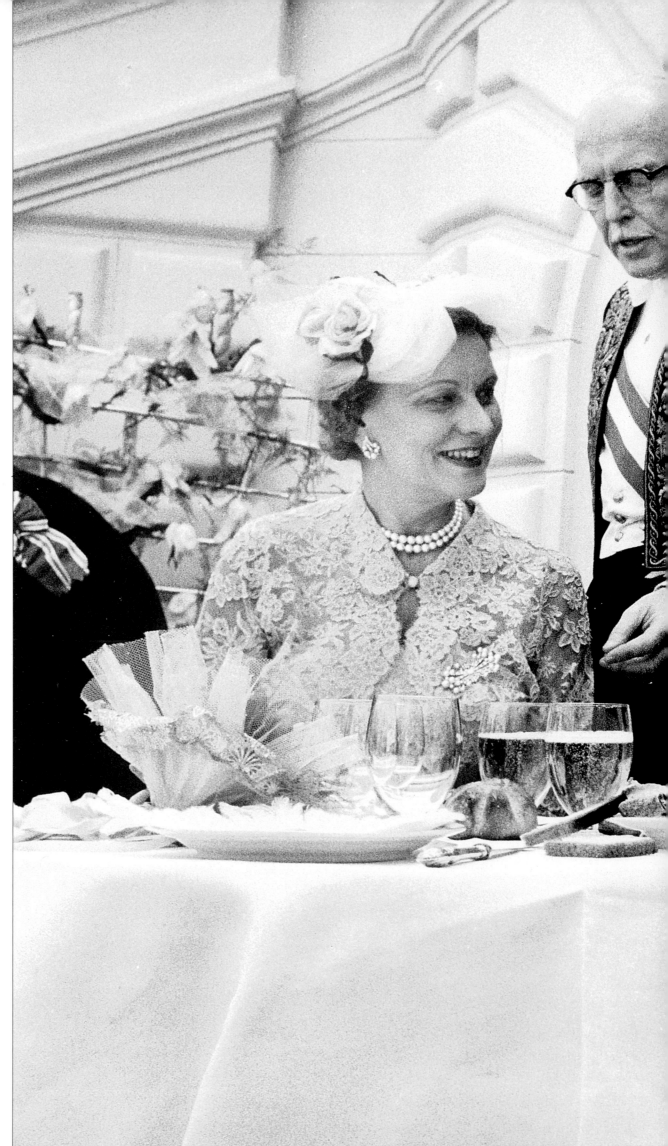

Grace's wedding gown drew a lot of attention. Designed by Helen Rose (who had done the actress's costumes for *The Swan*), it featured 125-year-old Brussels lace, twenty-five yards of silk taffeta, and a veil sewn with tiny pearls. Rainier had designed his own wedding uniform, blending symbols of French and Italian military history (he is wearing the French equivalent of the Medal of Honor). Here they dine at the reception with Grace's mother and Rainier's father, Prince Pierre.

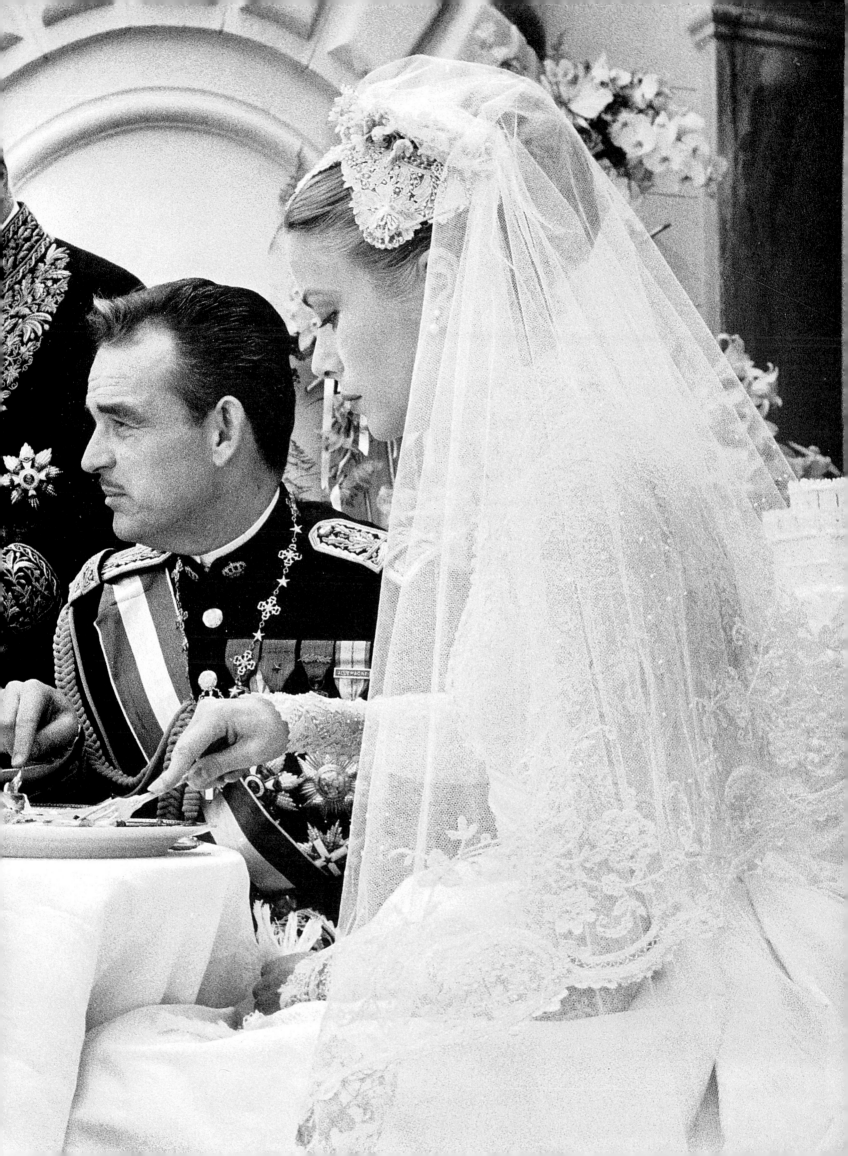

# Life
# with
# Rainier

M ARRYING
Rainier Louis Henri Maxence
Bertrand de Grimaldi was not like
marrying any other man; he was a
prince, the reigning monarch in a long
family line stretching back to 1297.
Tiny Monaco had once been a more
substantial state; in the nineteenth
century, one of the prince's ancestors
ceded some of it to France in a deal
that assured the Grimaldis' sover-
eignty. Since then, its income had
come largely its thriving casino. As-
cending to the throne in 1948 on the
death of his grandfather, Rainier hoped
to change that; and over time, he
attracted foreign investment, encour-
aged light manufacture, increased
tourism—all of which decreased the
dependency on income from the ca-
sino—and even, through landfill, in-
creased the size of the country. When
she met him, Grace admired his great
family pride and his ambitions for his
country. As the couple got to know
each other, she grew to value his intel-
ligence, humor, and sensitivity as well.

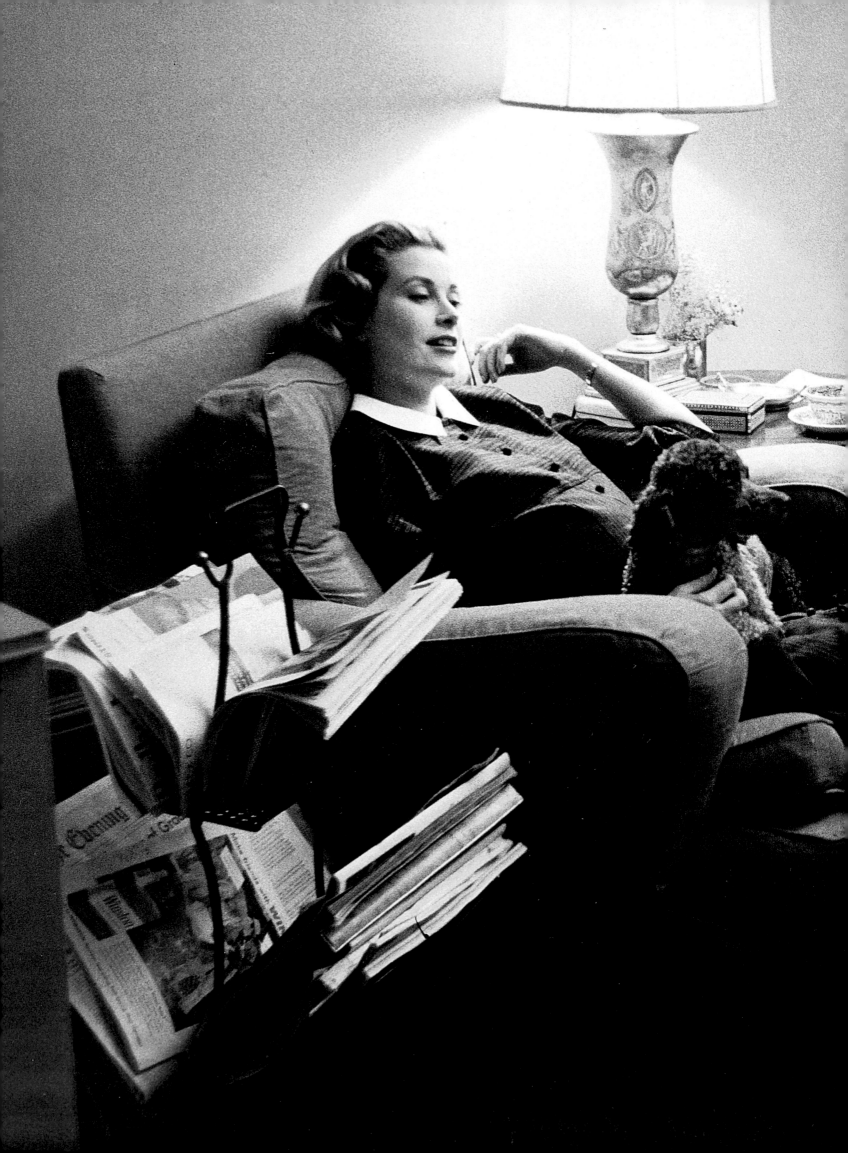

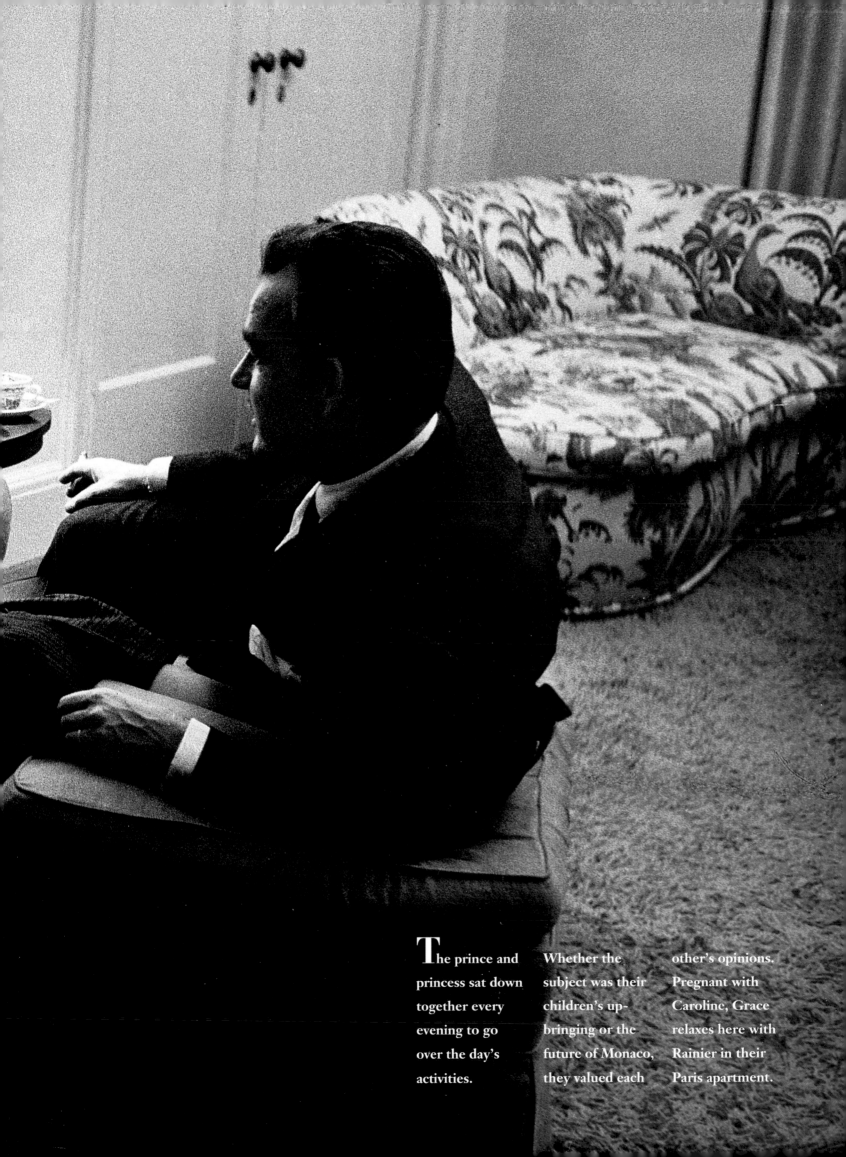

The prince and princess sat down together every evening to go over the day's activities. Whether the subject was their children's upbringing or the future of Monaco, they valued each other's opinions. Pregnant with Caroline, Grace relaxes here with Rainier in their Paris apartment.

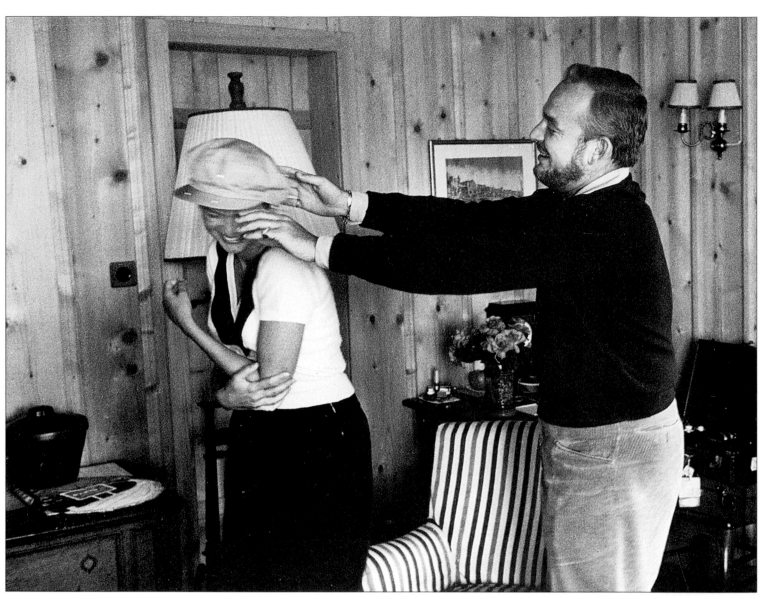

**T**heir early years together were filled with playfulness. In this series, Grace tries on one of Rainier's hats and strikes a sultry pose before they collapse in laughter. It was 1957, baby Caroline was a year old, and they had asked me to accompany them on vacation in the Swiss Alps. The chalet they rented was in Schönried, near Gstaad. "Shtad, Howell! Shtad!" Grace would admonish me whenever I tried to say it. "You don't pronounce the G." But I never could get it right.

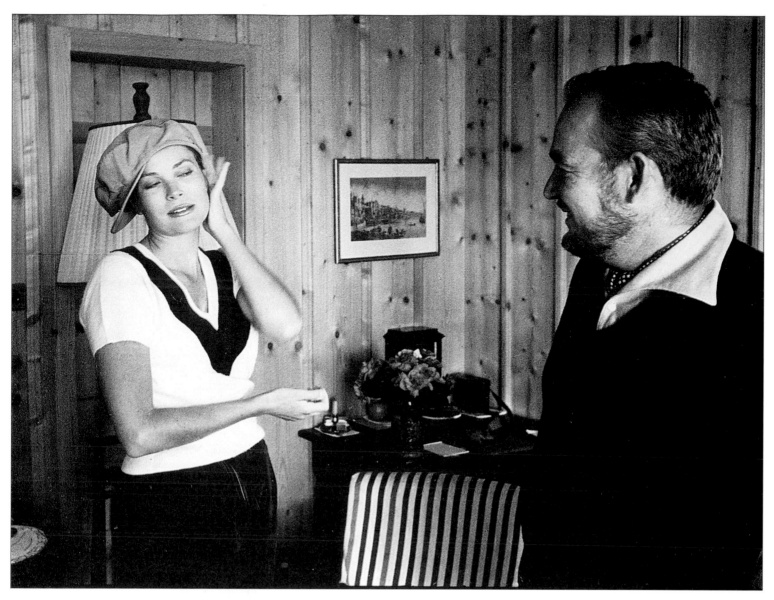

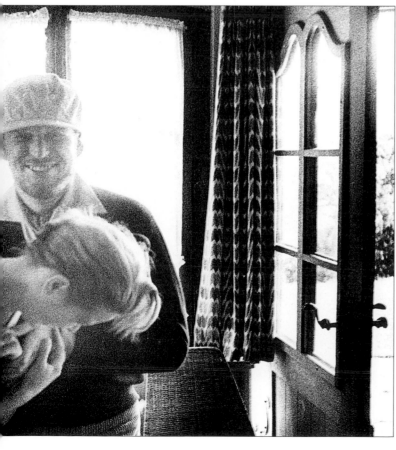

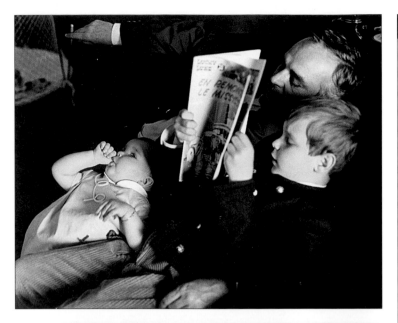

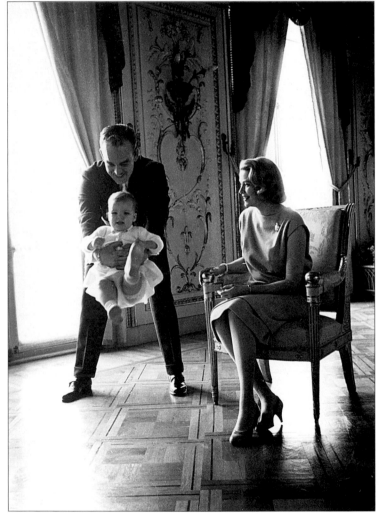

A workaholic (yes, this prince works hard on the business of his realm), Rainier eased up on his schedule after Caroline's birth; by the time Albert and Stephanie had arrived, he was the quintessential family man. He reads to the two younger ones at top, and, above, swings Caroline around, interrupting a formal portrait session with Grace and her baby in the palace's Gold Room.

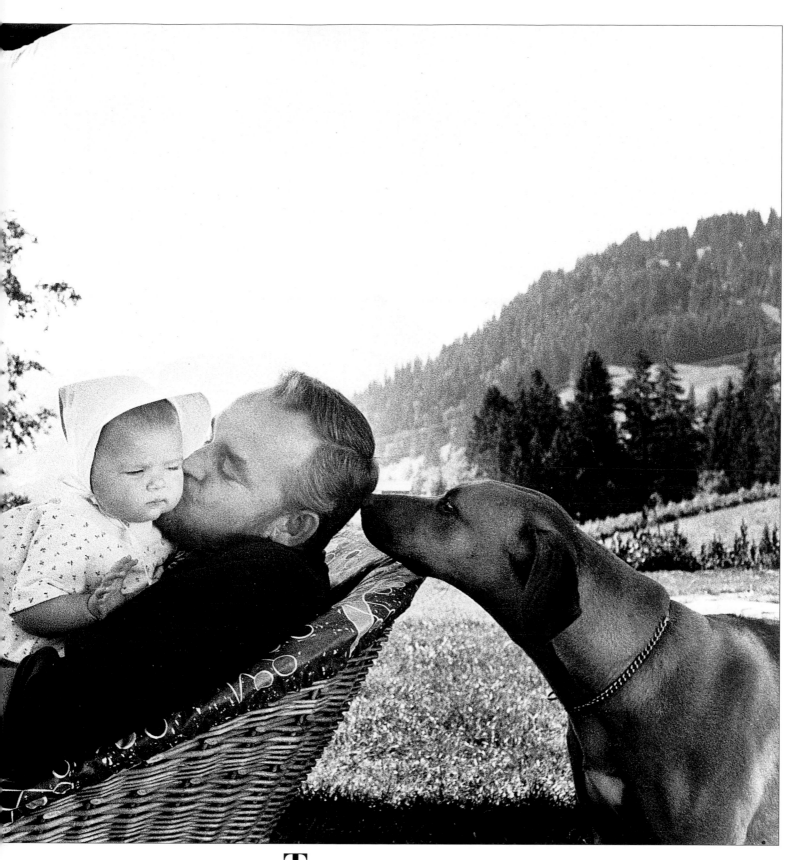

The prince's own lonely childhood may have been the driving force behind his determination to have a solid family life. Though it shocked Monaco as one of Grace's "American" notions, he joined her in centering their life around their children, insisting that they not be "strangers relegated to the other end of the house," as they are in so many European homes. He nuzzles Caroline in Switzerland, above, as Fanny, the family's Rhodesian ridgeback, does the same to him.

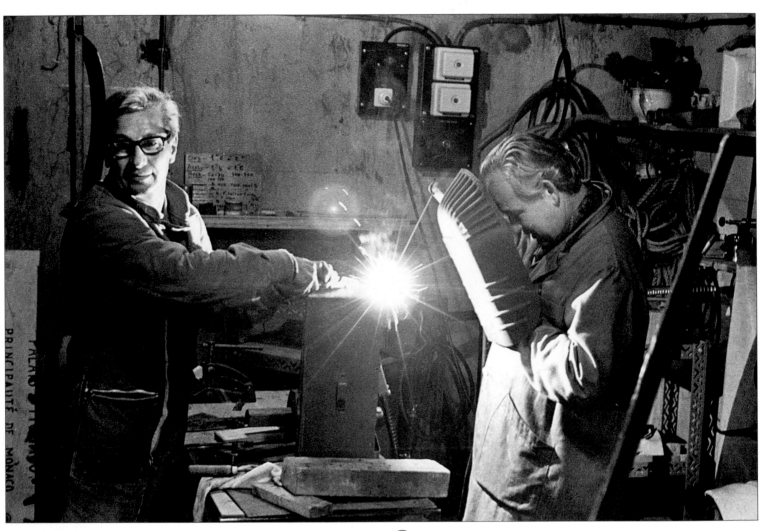

Of course Rainier had his own interests, too. He loved welding and spent hours at a time in his workshop. He collected antique cars, buying many as wrecks and then fixing them up in a well-equipped mechanic's garage he built on the palace grounds. He even had an old Ford pickup stowed there. But Rainier's greatest love—not shared by Grace—was his menagerie. He kept many live animals—elephants, chimpanzees, tigers—at the palace zoo, and when the family went away to Roc Agel, their summer home in the mountains above Monaco, he would bring a few kittens along, right, to entertain the children.

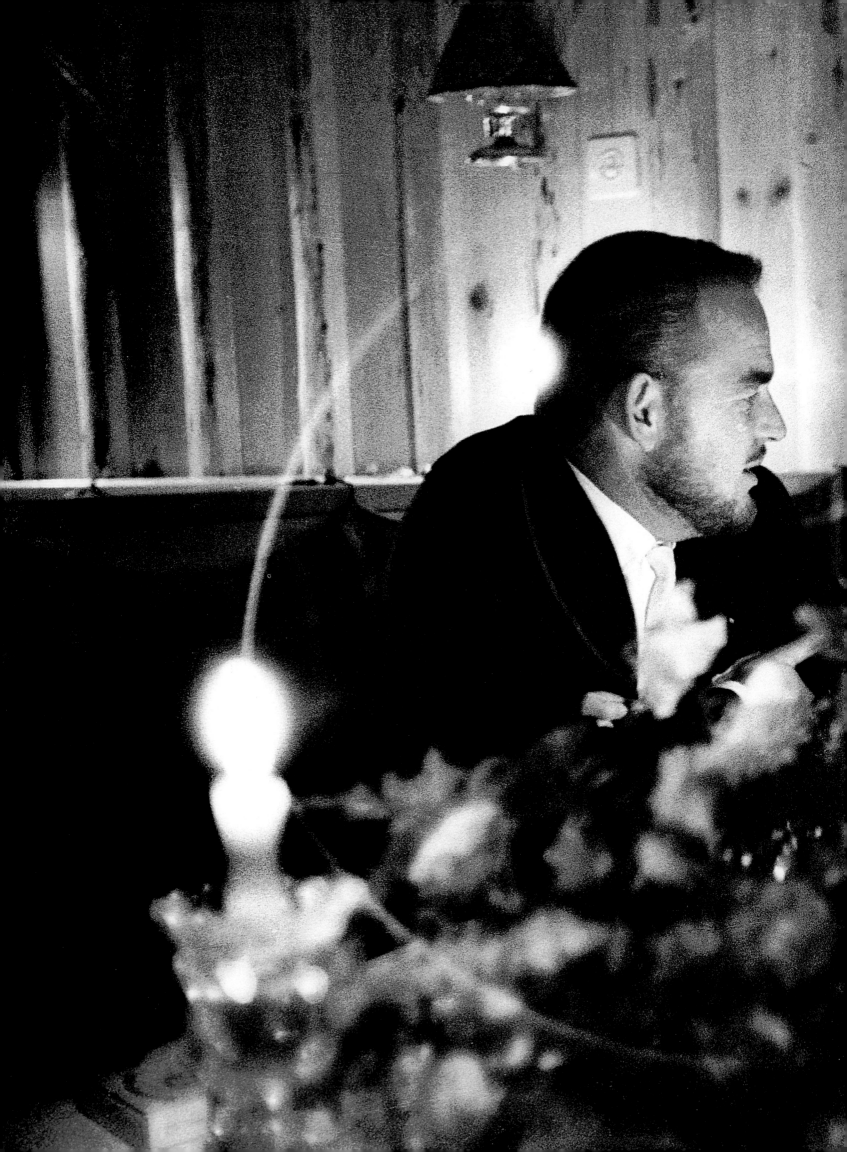

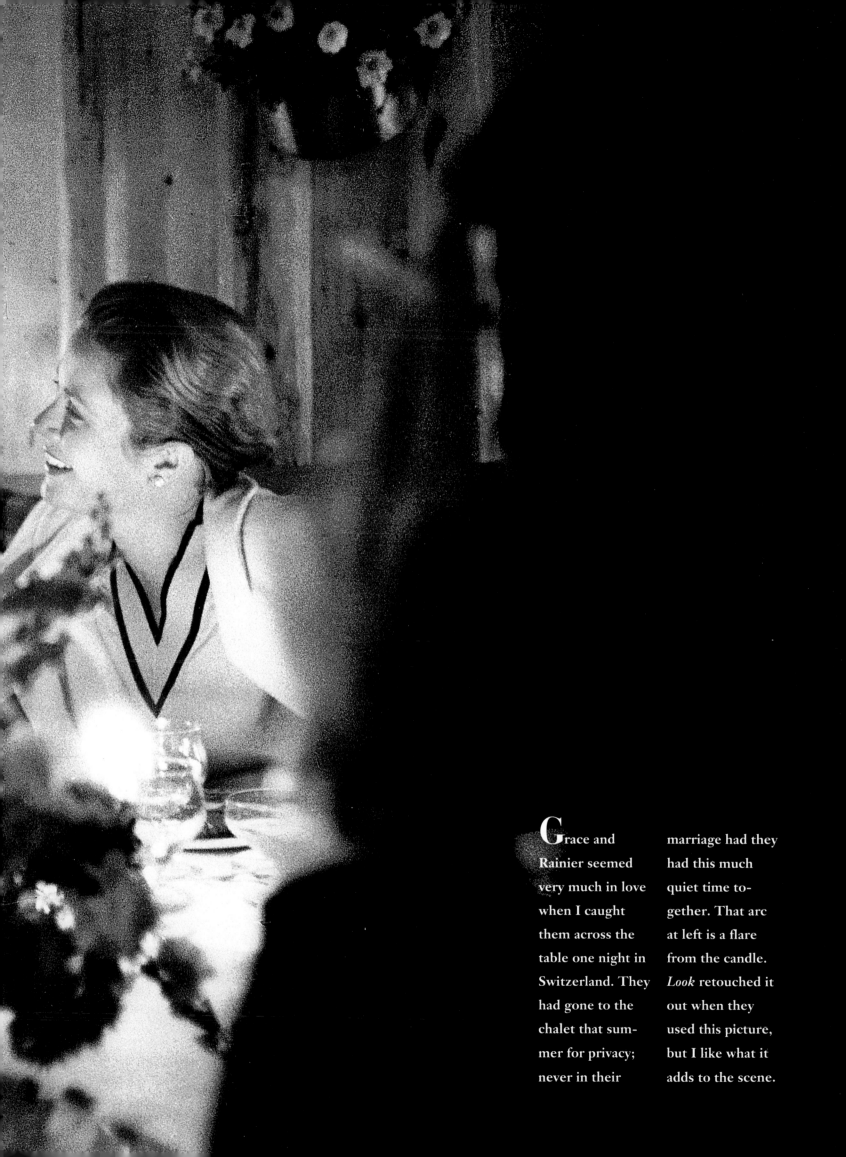

Grace and Rainier seemed very much in love when I caught them across the table one night in Switzerland. They had gone to the chalet that summer for privacy; never in their marriage had they had this much quiet time together. That arc at left is a flare from the candle. *Look* retouched it out when they used this picture, but I like what it adds to the scene.

# Starting
## a
# Family

**B**EFORE HE CHOSE GRACE Kelly as his bride, the prince of Monaco had announced in an interview with *Collier's* that he was looking for a wife who would be "pretty," "natural," and "charitable," not "flashy" or "spoiled"—and, of course, able to bear him an heir. Monaco needed an heir. In a 1918 treaty, the country had agreed that should the reigning member of the Grimaldi family die without a natural successor to the throne, the country would revert to French control. But Grace didn't need a treaty to be convinced on that subject. She had always wanted a family, and said so publicly.

Then, on January 23, 1957, the couple got their wish. Grace gave birth, without anesthetic, to their first child, Caroline. Grace wept quiet tears of joy as she held her newborn. Greeting the press, the doctor described the baby's first sounds as "like a melody resounding through the palace." Two more children followed—Albert a year later and Stephanie in 1965—before the family was complete.

For Grace, this was a magical time. Asked if winning an Oscar (for *The Country Girl*) was the most exciting thing that had ever happened to her, she said, "No, it was the day when Caroline, for the first time, began to walk. She took seven small steps by herself, one after the other, before reaching me and throwing herself into my arms."

**G**race with the newborn Albert in the spring of 1958.

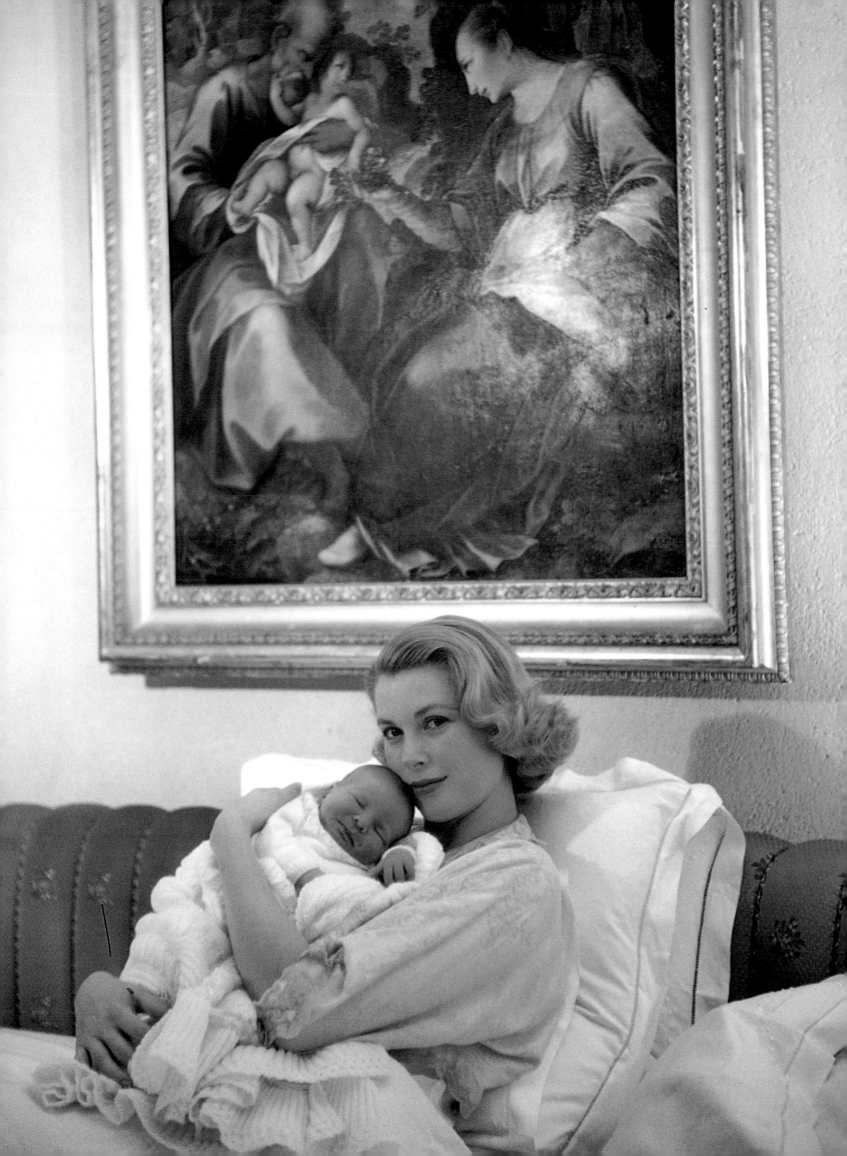

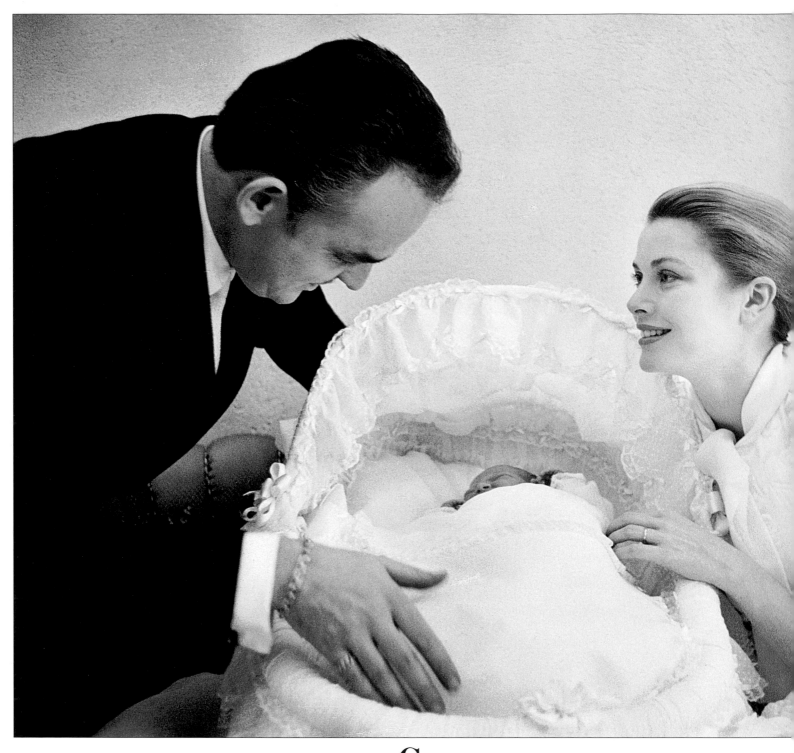

**C**aroline was one hour old when I took this picture. On January 23, 1957, at 9:27 A.M., all 8 pounds, 3 ounces of her arrived. The palace library had been converted into a delivery room and draped in Irish green silk for good luck. The bassinet, which once carried baby Rainier, had been dragged out of storage. Grace looked radiant, if a little bleary. Outside, twenty-one cannon shots rang out at the news (tradition says twenty-one for a female, a hundred and one for a male) followed by church bells, and horns from the Monégasques' cars and boats.

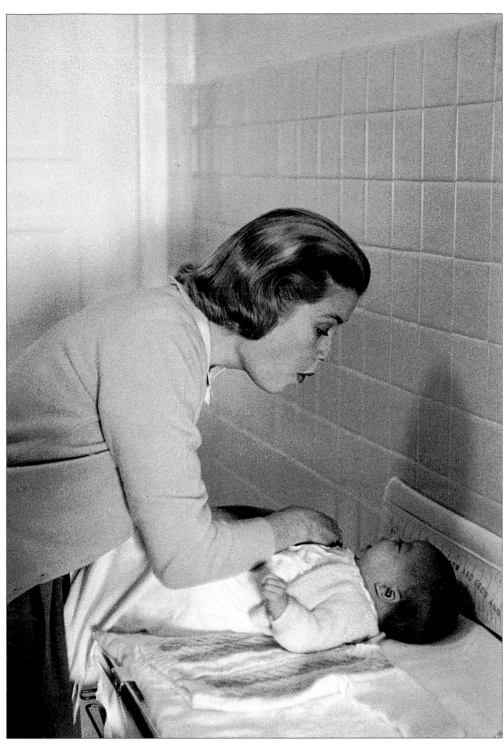

**M**onaco was a little taken aback at how involved Grace got with her kids, but her unpretentious side—some would say her American, egalitarian side— just wouldn't allow her to give the child-rearing over to someone else. Still, it was hard to raise the children of a royal couple to think of themselves as ordinary kids— little Caroline's closet held about two dozen dresses.

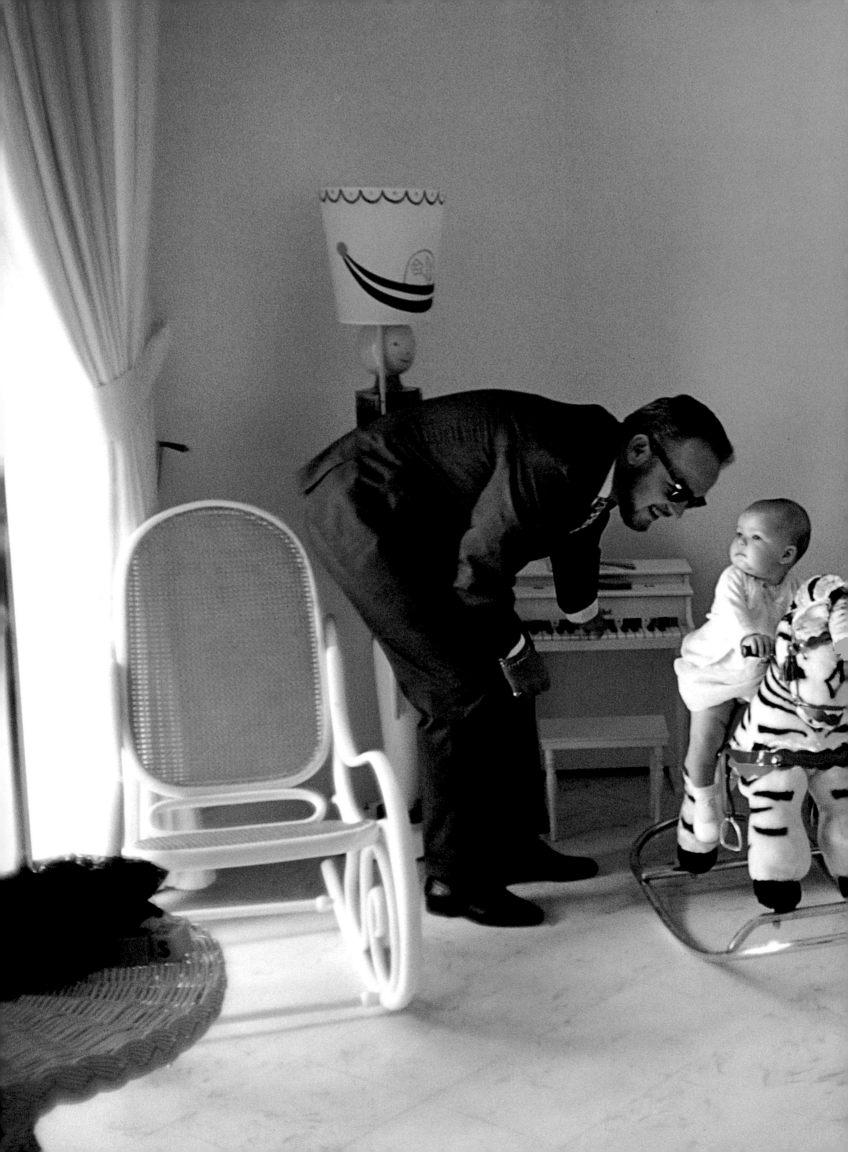

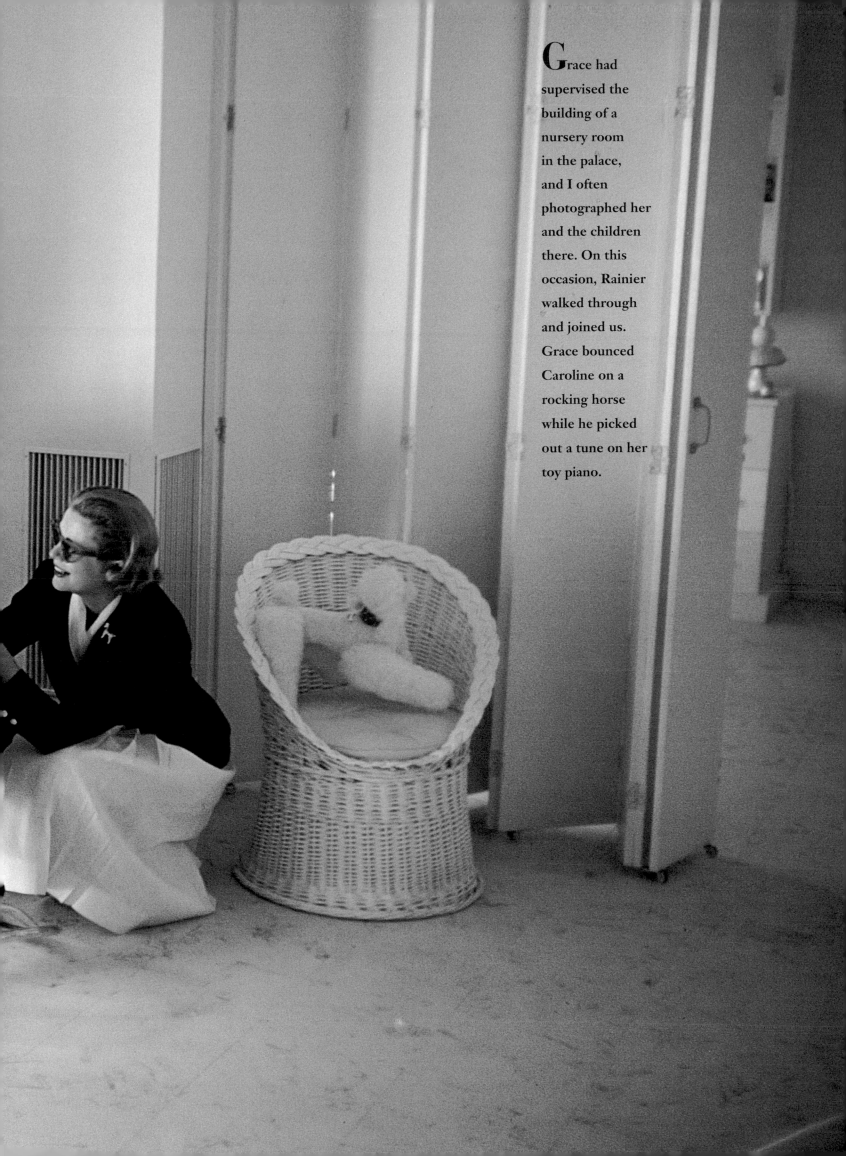

**G**race had supervised the building of a nursery room in the palace, and I often photographed her and the children there. On this occasion, Rainier walked through and joined us. Grace bounced Caroline on a rocking horse while he picked out a tune on her toy piano.

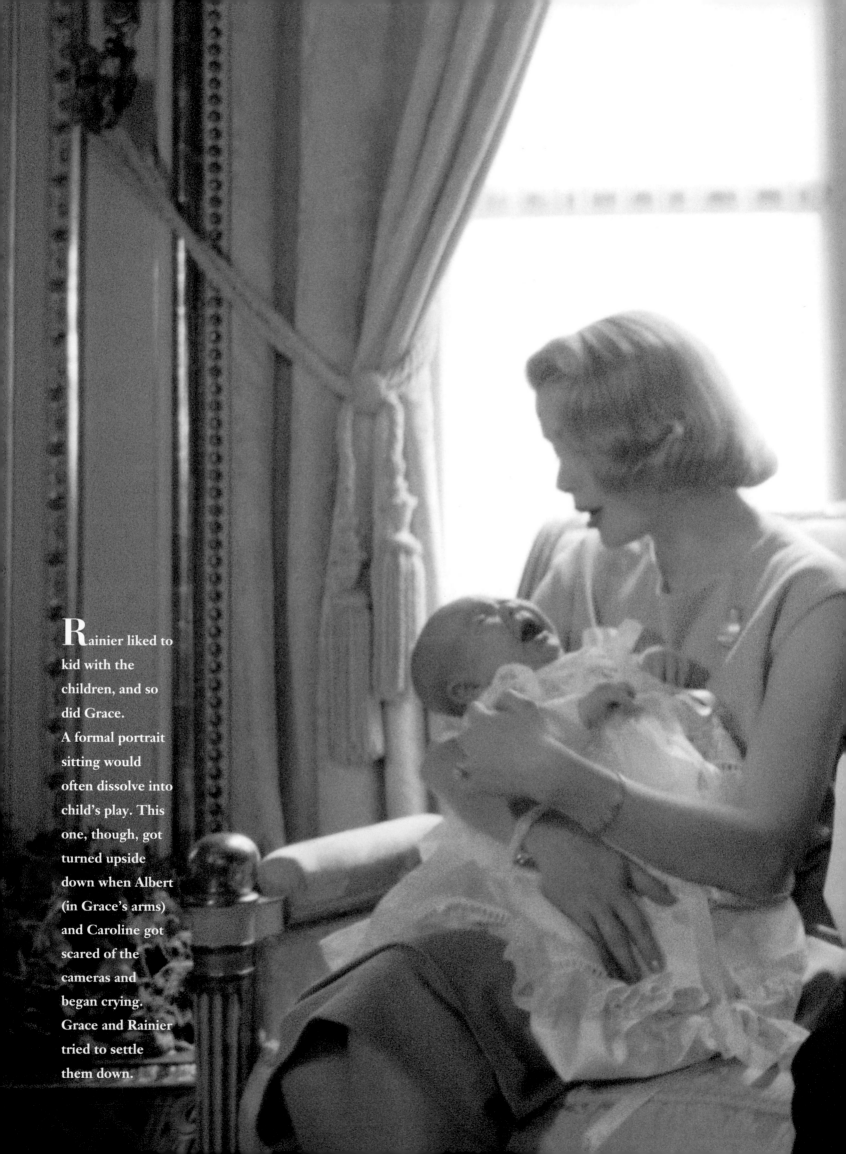

Rainier liked to kid with the children, and so did Grace. A formal portrait sitting would often dissolve into child's play. This one, though, got turned upside down when Albert (in Grace's arms) and Caroline got scared of the cameras and began crying. Grace and Rainier tried to settle them down.

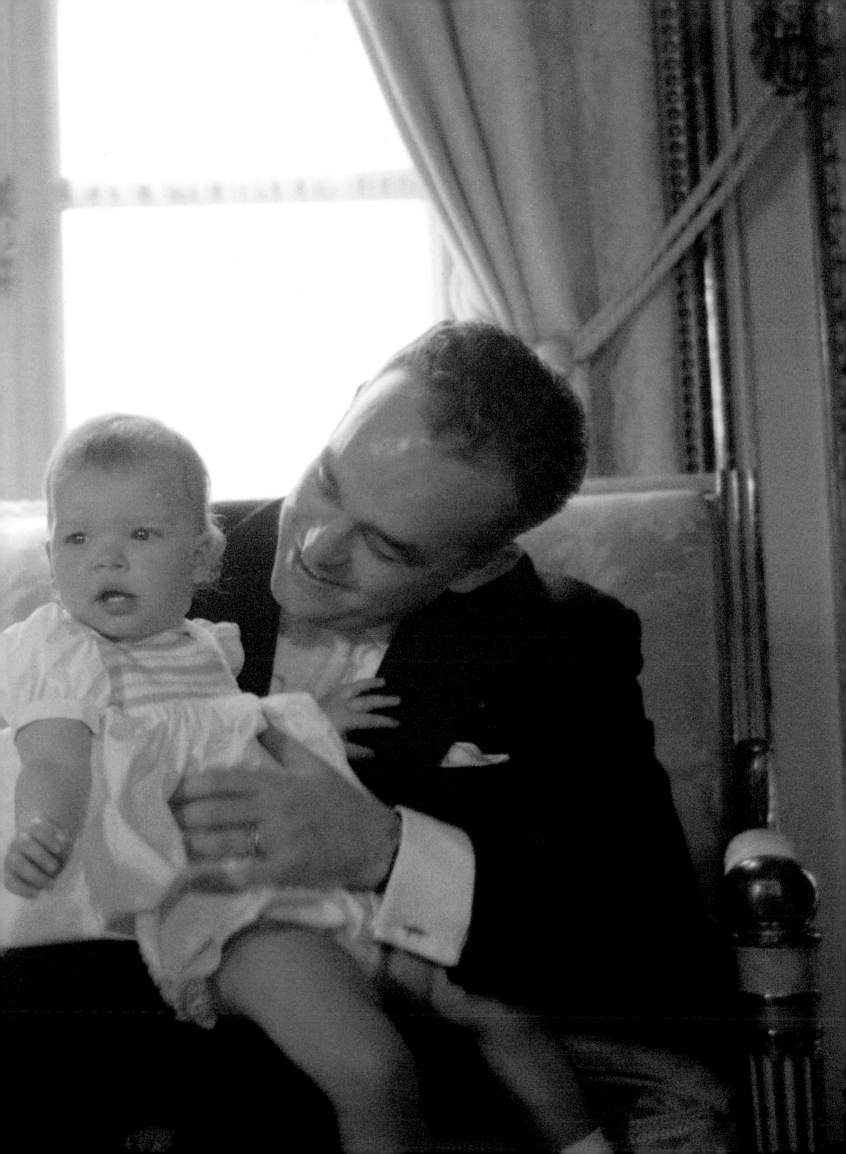

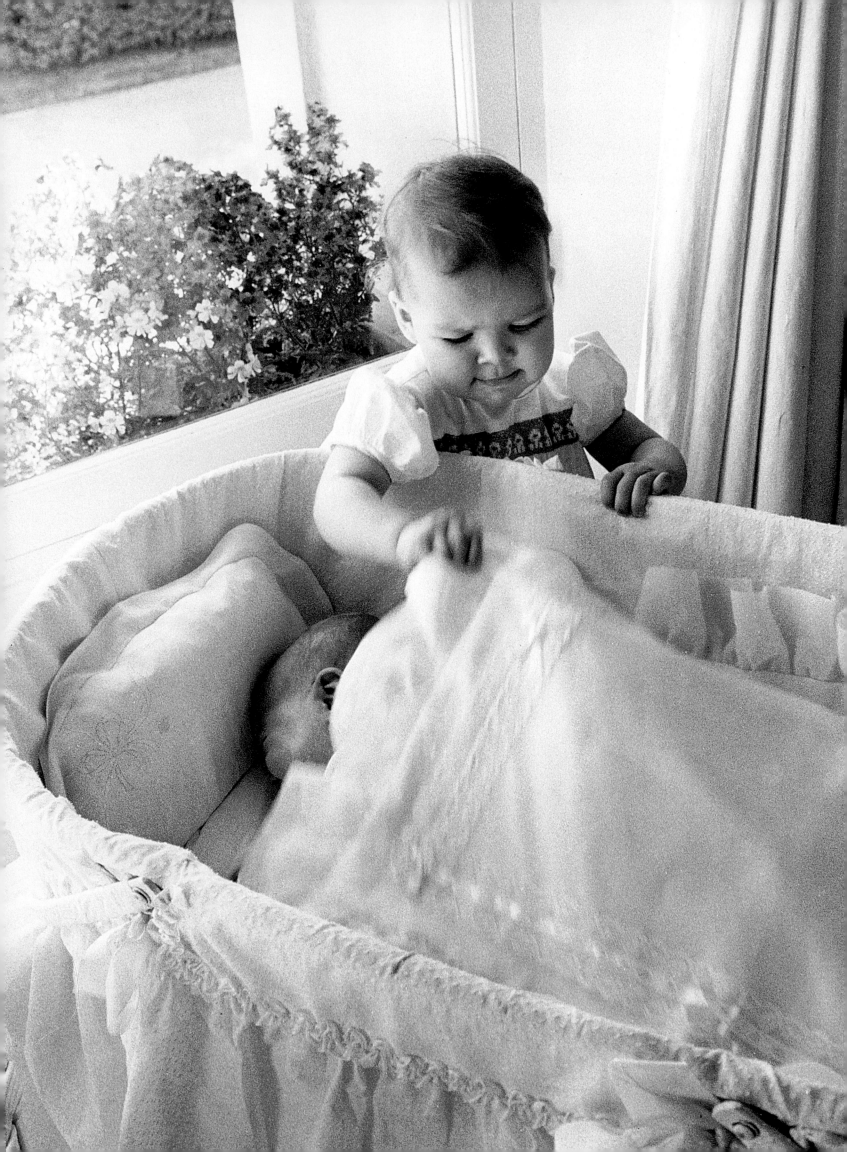

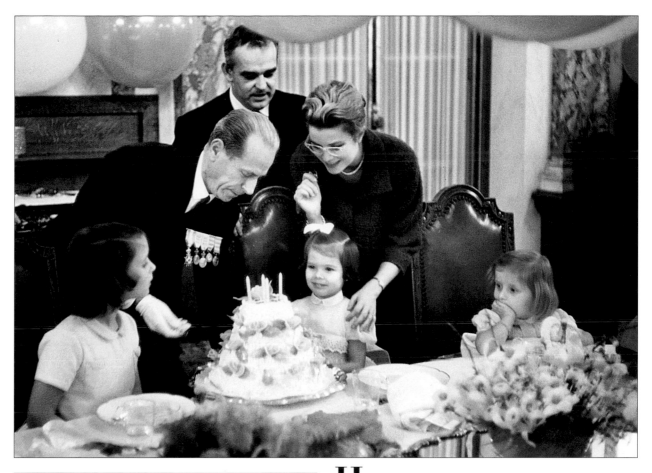

**S**oon after Albert was born in 1958, little Caroline tucked him into his bassinet.

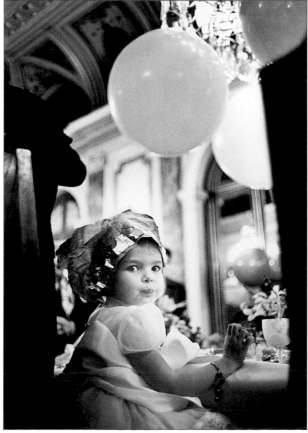

**H**er Hollywood career finished, Grace needed outlets for her theatrical skills, and she found many with the children. Birthday parties (such as Caroline's fourth, here and on the next three pages) were elaborate affairs, with games and surprises.

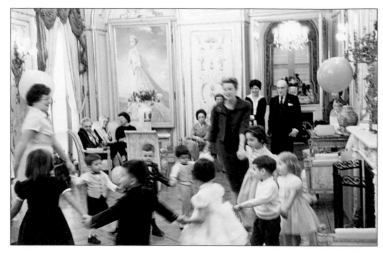

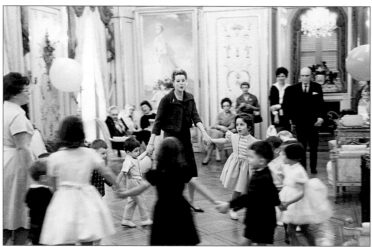

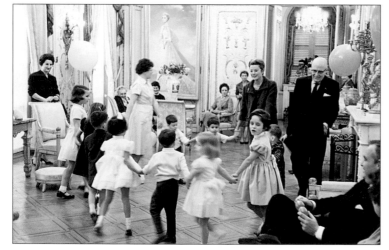

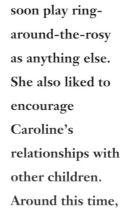

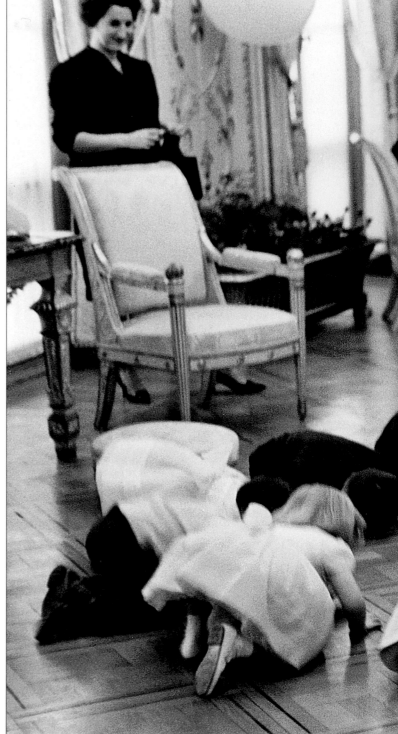

**I**t would have been very easy for Grace to stay and talk with the adults at such gatherings. But she loved games, and would just as soon play ring-around-the-rosy as anything else. She also liked to encourage Caroline's relationships with other children. Around this time, Grace arranged a palace school-room where Caroline could be taught with other Monégasque girls her age.

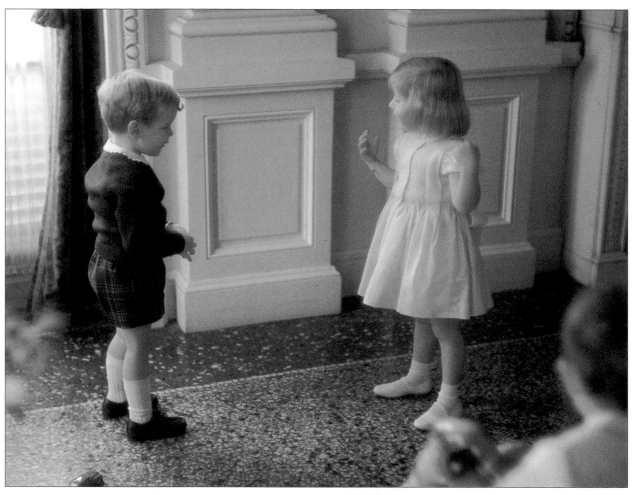

Much later, in 1965, Grace gave birth to their last child, Stephanie. Caroline took a particular interest in her new sister, right.

From the start, Rainier and Prince Pierre took it as their responsibility to train Monaco's heir apparent, above left, at the party, and below, background.

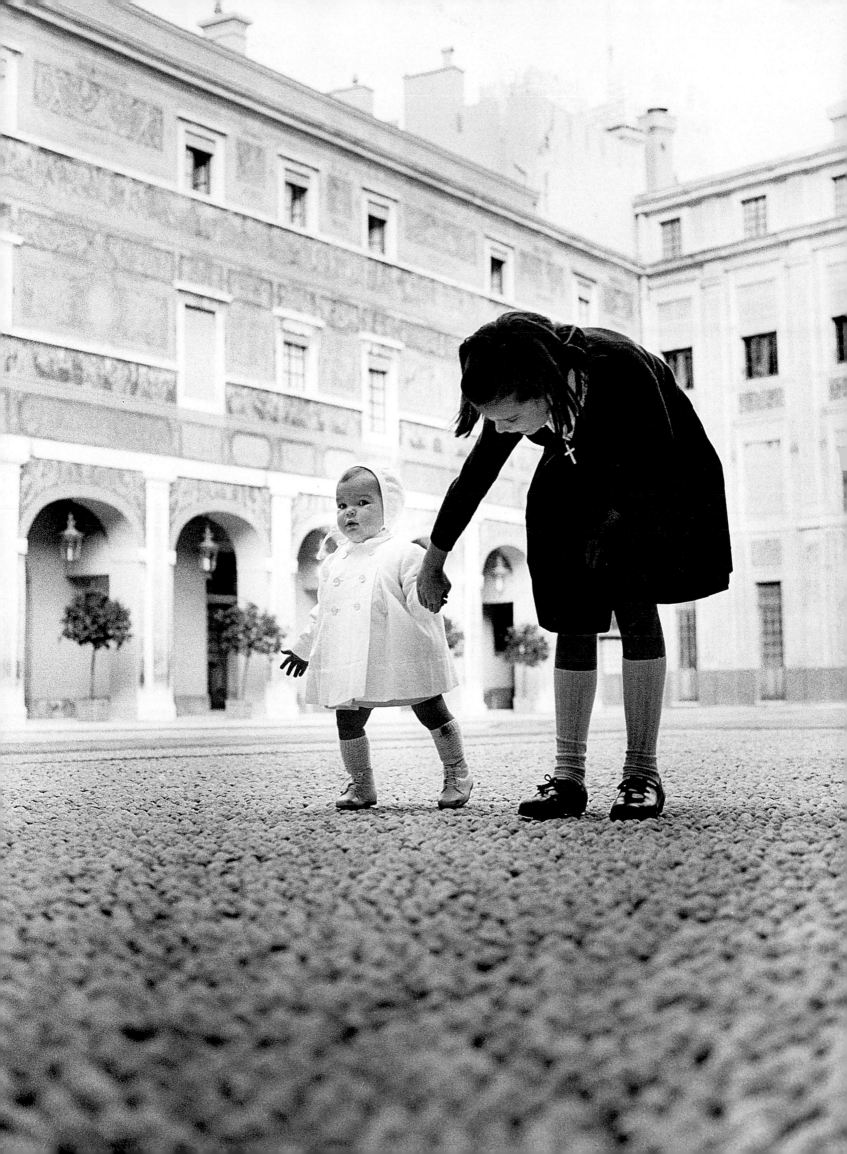

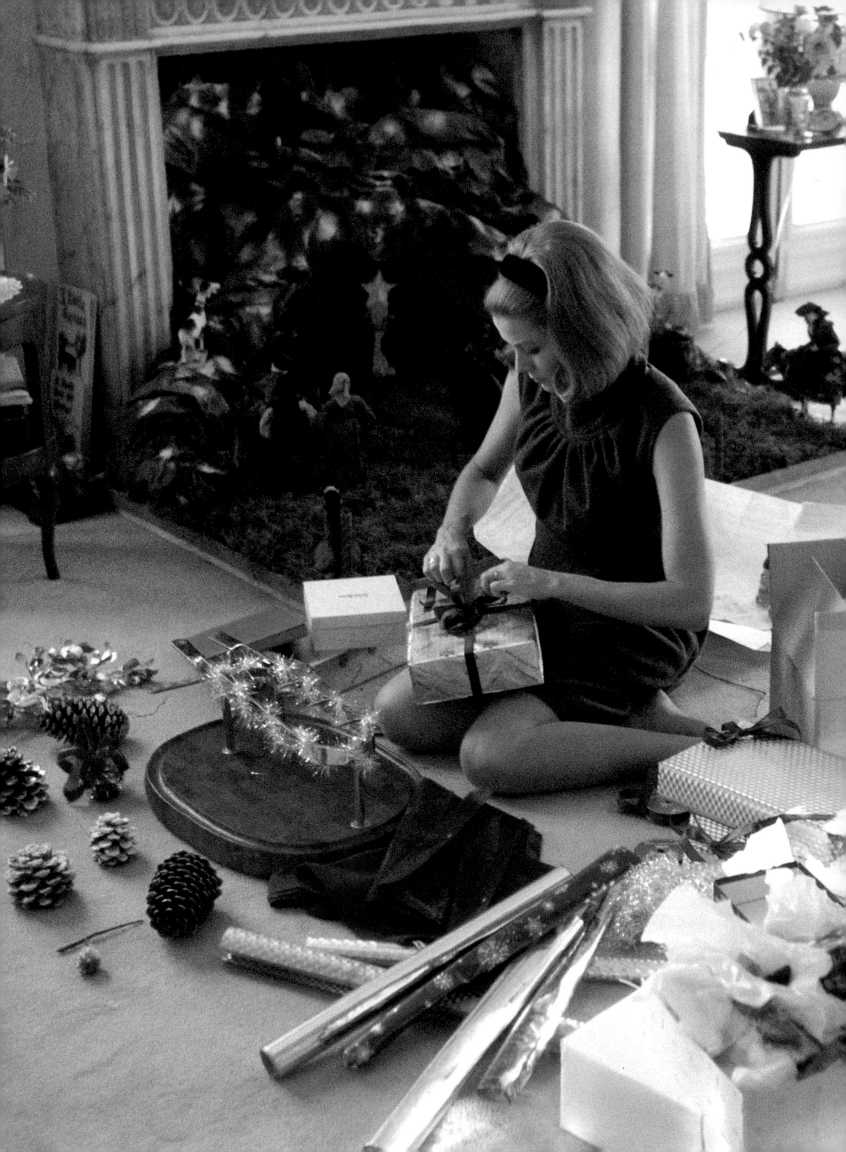

## Christmas in Monaco

**S**urrounded by ribbons and wrapping paper, Grace rushes to complete her Christmas preparations in the palace bedroom.

**G**RACE HAD ALWAYS loved Christmas as a child, and she made sure it was celebrated warmly for her own children as well. She and the family celebrated a private midnight mass in the palace chapel each year. But she was otherwise not content with the more modest Monégasque celebration of Christmas. Grace wanted the family—and the country—to enjoy a full-scale American-style Christmas. Though the palace staff sometimes shook their heads in puzzlement, she insisted on wrapping all the Christmas presents she gave, and even bought many of them herself. She wanted the family to trim the tree together—even Rainier, when she could persuade him to.

Yet it was Grace's work with the Monégasque children at Christmas that was most enriching. Each year, she would organize a party for all the children of the country, and a special party in the palace for the orphans.

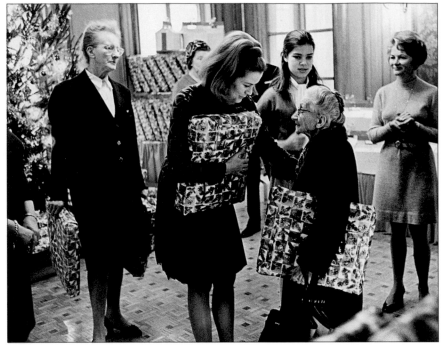

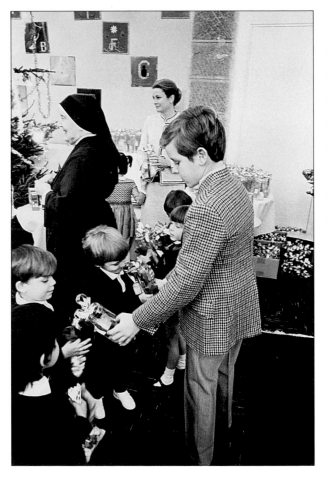

Grace had a special sympathy for Monaco's aged, ordering changes in the decor of the principality's only old-age home to make it cheerier. But the plight of Monaco's orphans touched her the most. Every year, she would hold a Christmas party for the children of the orphanage and give them all presents. Here, she and Albert listen to a thank-you speech.

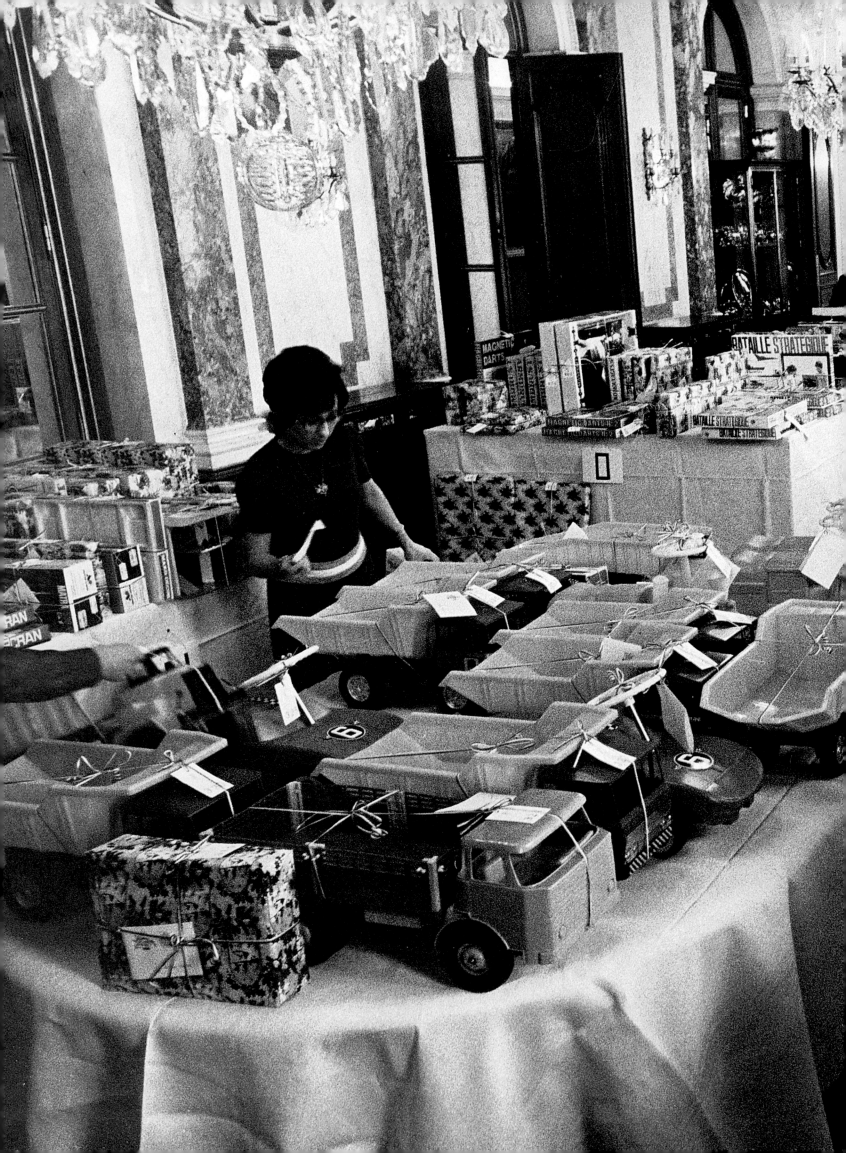

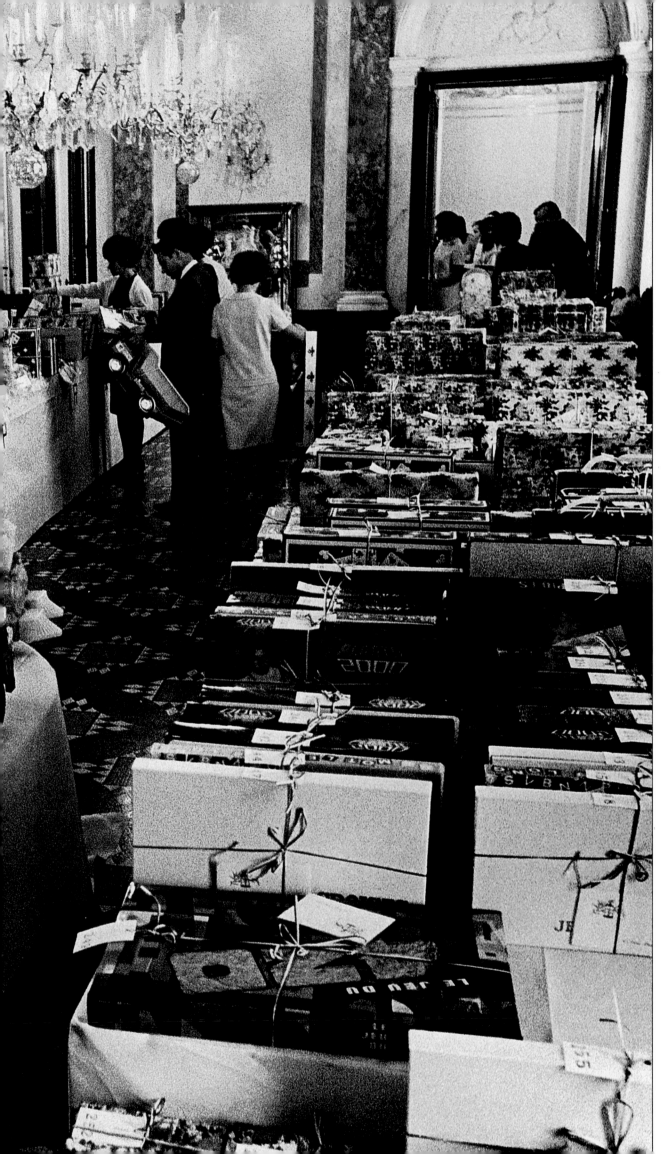

The orphans were no idle interest of hers. Visiting the orphanage frequently throughout the year, she would get to know the children. Then, at Christmas, Grace actually oversaw the choosing of each present, tagging each box with a name. The children of Monaco loved her for the attention, and bounded happily down the palace steps after their party, overleaf.

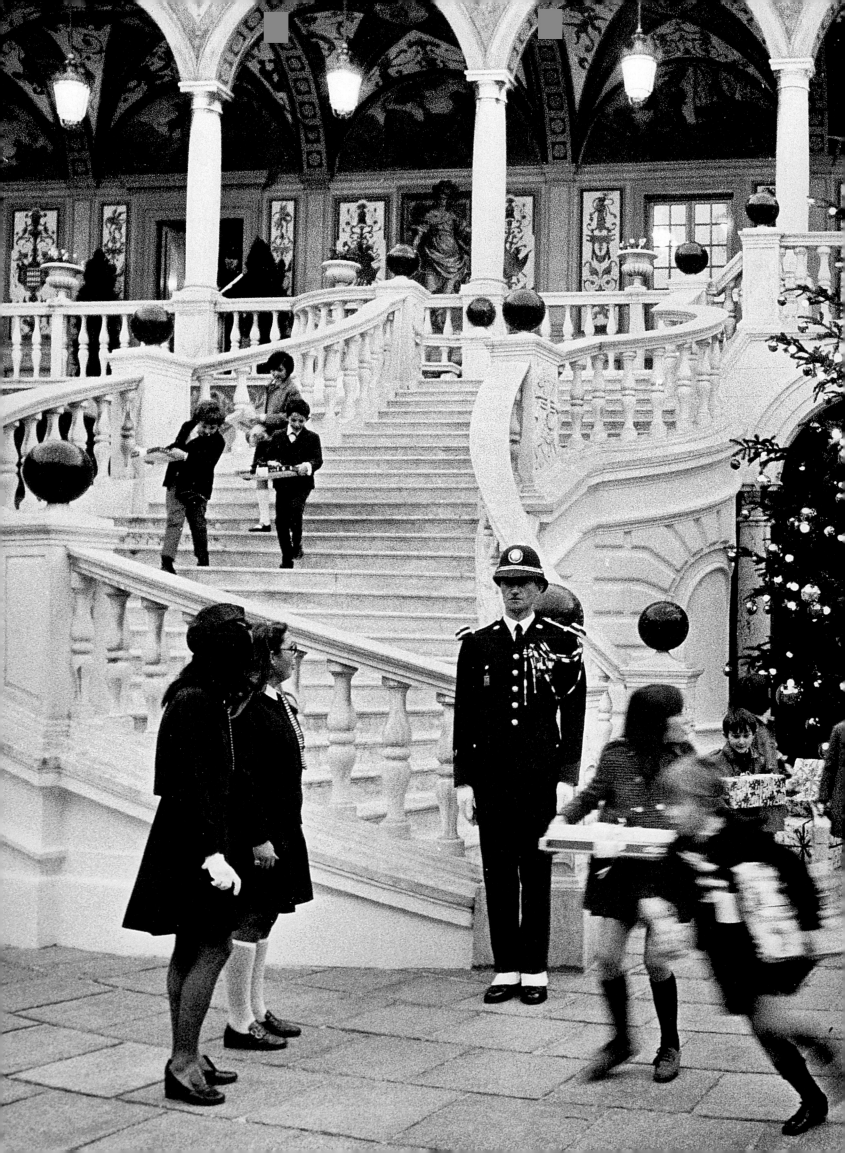

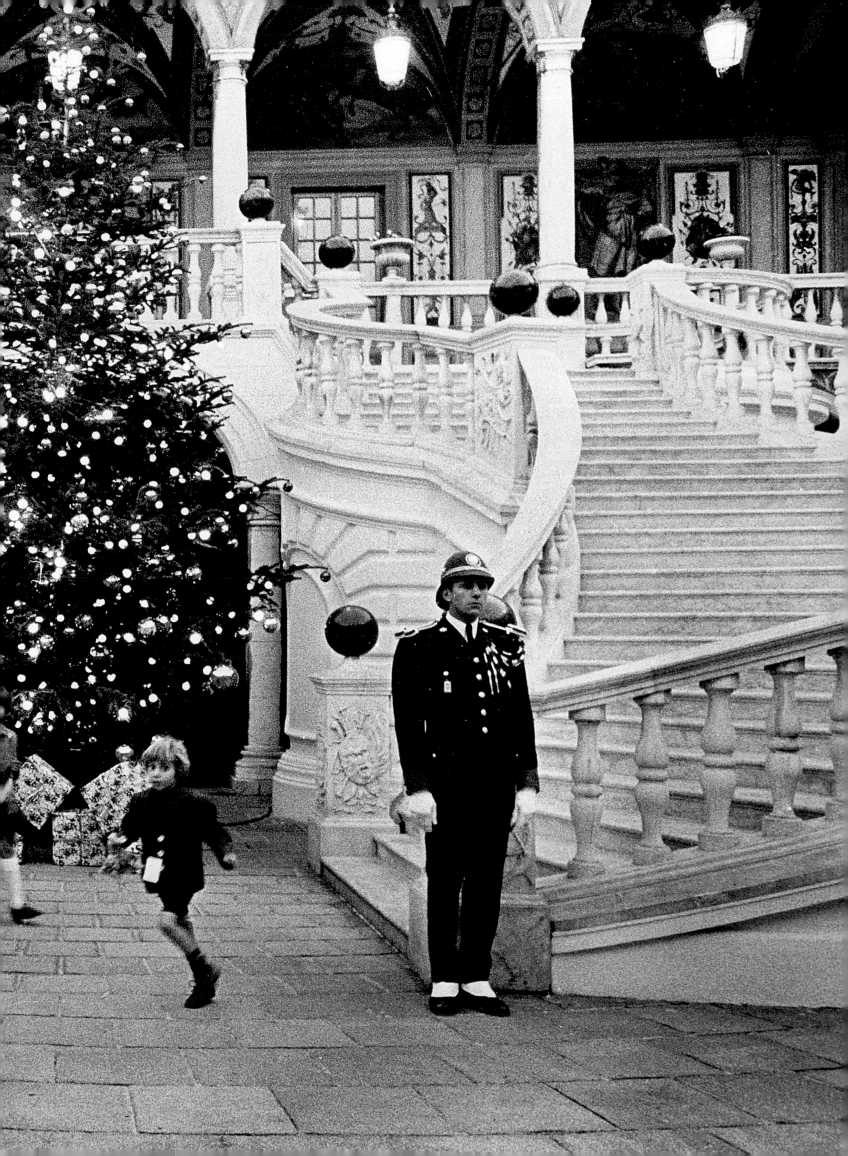

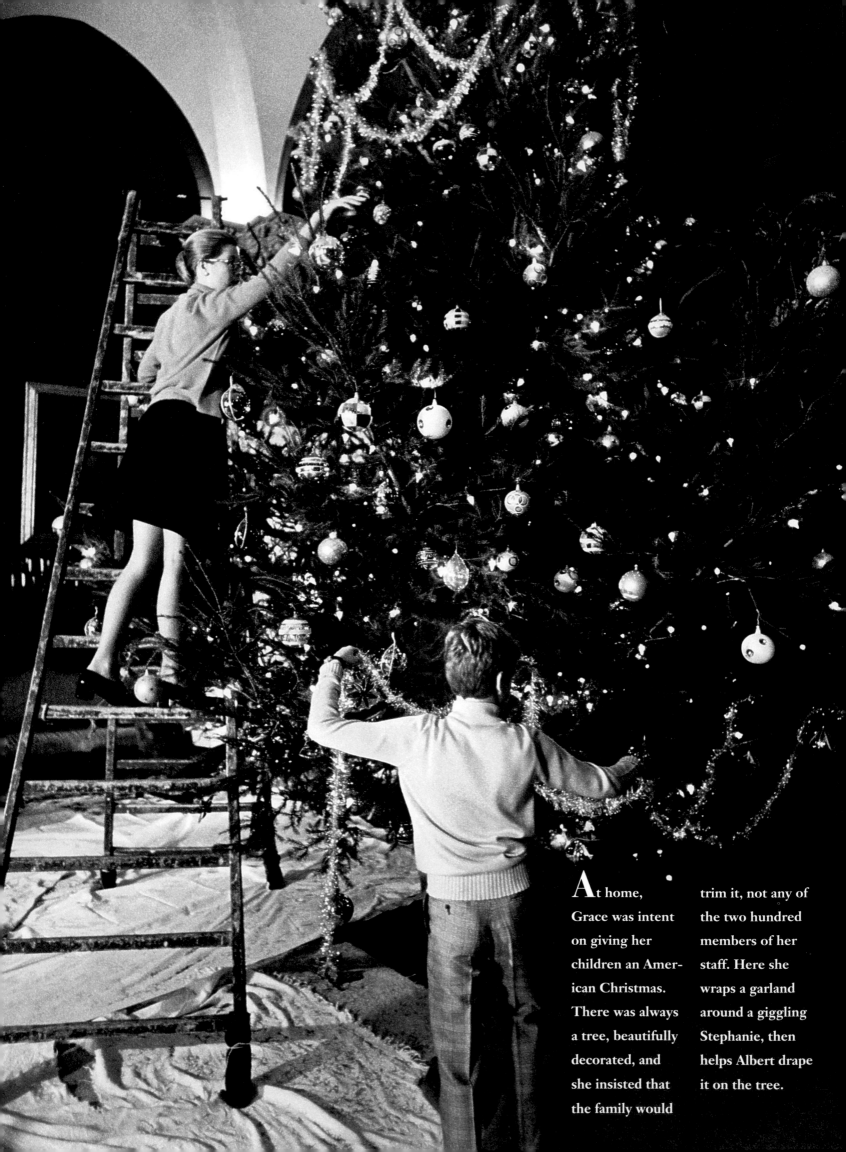

At home, Grace was intent on giving her children an American Christmas. There was always a tree, beautifully decorated, and she insisted that the family would trim it, not any of the two hundred members of her staff. Here she wraps a garland around a giggling Stephanie, then helps Albert drape it on the tree.

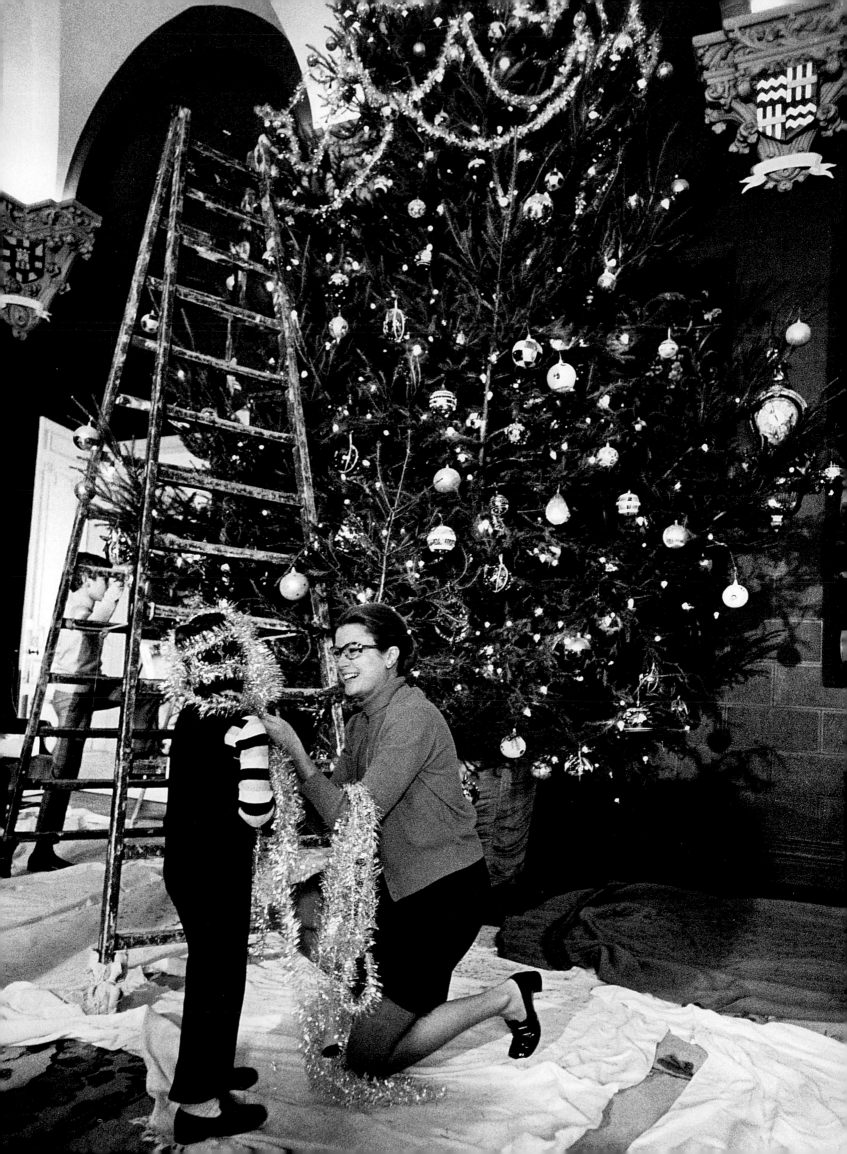

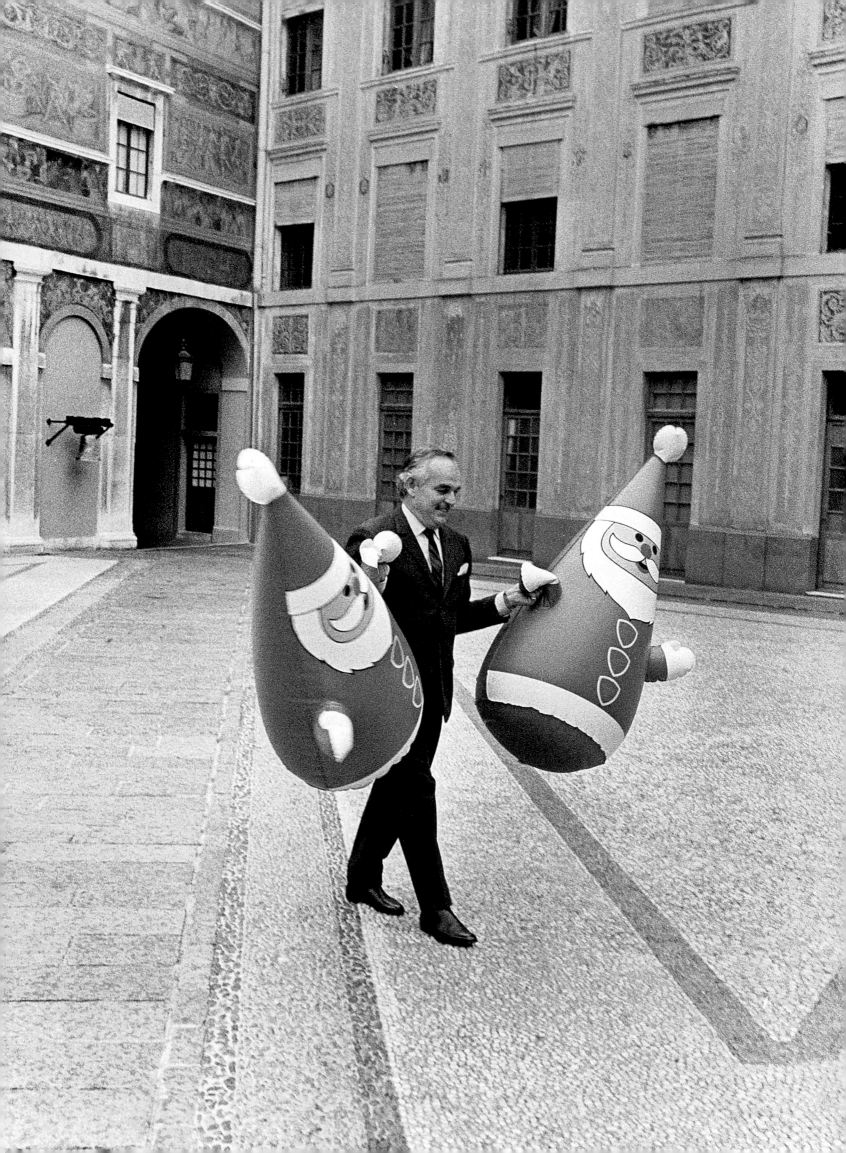

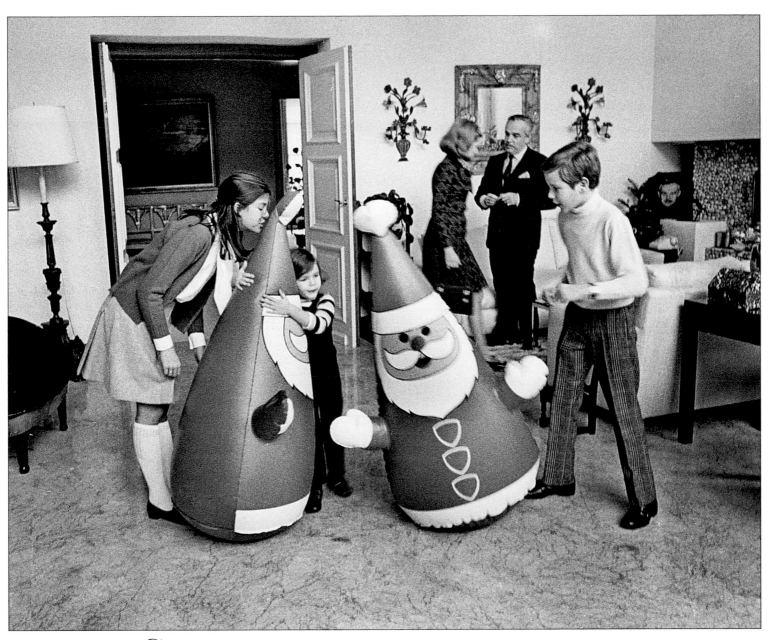

Grace seemed to engender extra Christmas spirit in Rainier. One year, he brought out some inflated Santa dolls for the kids, looking quite unprincely carrying them through the palace courtyard. But that was one thing they agreed on: they weren't going to let their high position keep them from being themselves.

# The Duties
## of a
## Princess

THE TRANSITION FROM Hollywood actress to princess of Monaco had not been an easy one for Grace. Yet once she became accustomed to her new role, she showed an eagerness to be the very best princess she could be.

She focused on several pet projects. In 1965, she established the Princess Grace Foundation as a means of supporting Monégasque artists and craftsmen. Using the foundation's small endowment, she opened a shop in town devoted entirely to selling the ceramics, jewelry, and other local crafts. Hoping to restore the principality's reputation as a center of dance, Grace brought in a respected ballet mistress, who opened a school, the Académie de Danse Classique Princesse Grace.

Prompted by Grace's public support for breast-feeding, the La Leche League of Monaco named her their honorary president, and Grace accepted the gesture with enthusiasm. She lectured on the virtues of breast-feeding, which she saw as "the giving of food and security from within our own persons." Then, in 1968, Grace started a garden club, Monaco's first, joining the other members on outings in which they would learn about the native wildflowers and plants of the region.

All of this was in addition to her other duties, among them answering the hundreds of letters she received each week (mornings were often given over simply to correspondence) and serving as president of the Red Cross Monégasque. Despite her evident joy at all her tasks, the princess invariably faced one question everywhere she went: "Do you ever dream of returning to the screen?" Grace sidestepped the subject with considerable diplomacy, but she eagerly accepted any "theatrical" opportunity that seemed appropriate to someone in her position. In 1976, she joined in a series of poetry readings in England and America celebrating the American bicentennial.

As she became more involved in her responsibilities, Grace became more of a Monégasque. The people loved it as she put her imprint on Monaco (with her foundation, garden club, and support for the local arts). At right, she and Rainier dress Caroline and Albert in traditional garb to greet the crowds on a festival day.

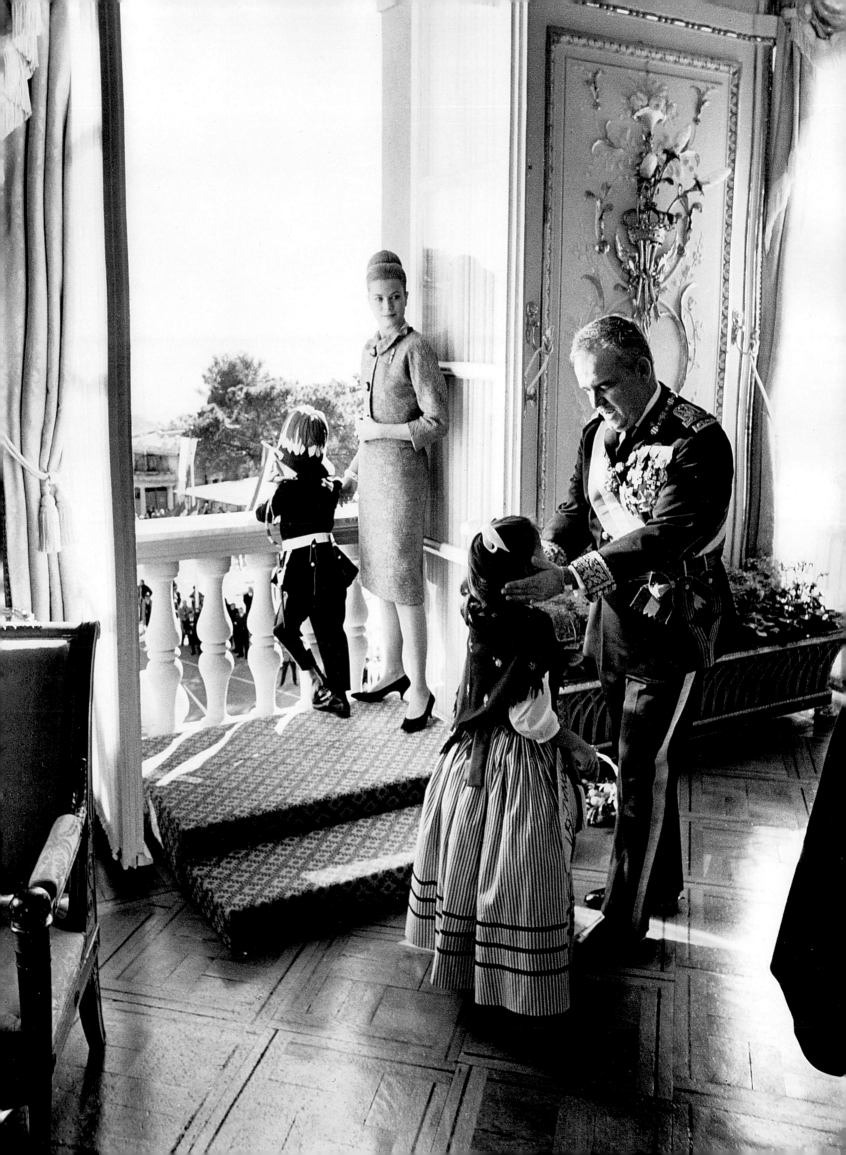

Later the same day, Grace and the children review the troops. Just as she had not wanted to be like every other actress, so now she decided that she didn't want to be like every other princess. She wanted to make a real contribution to Monaco.

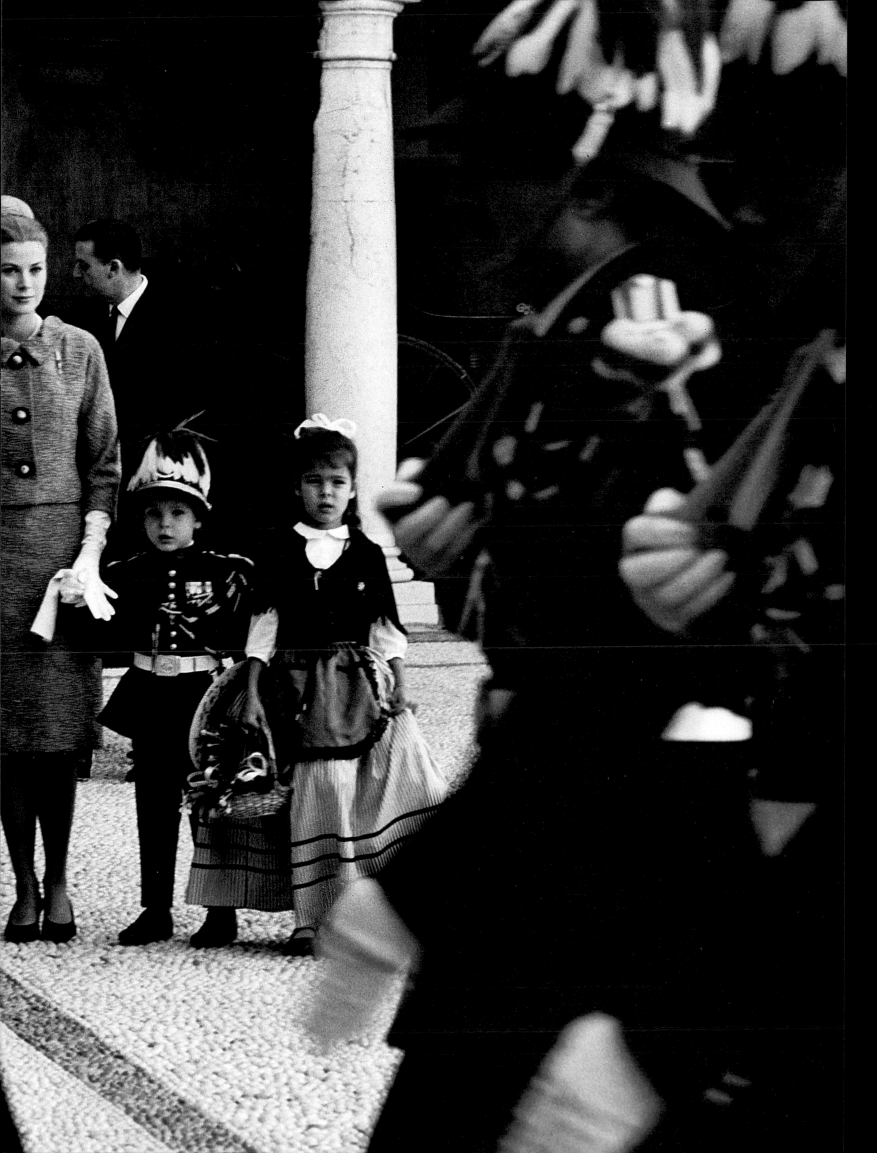

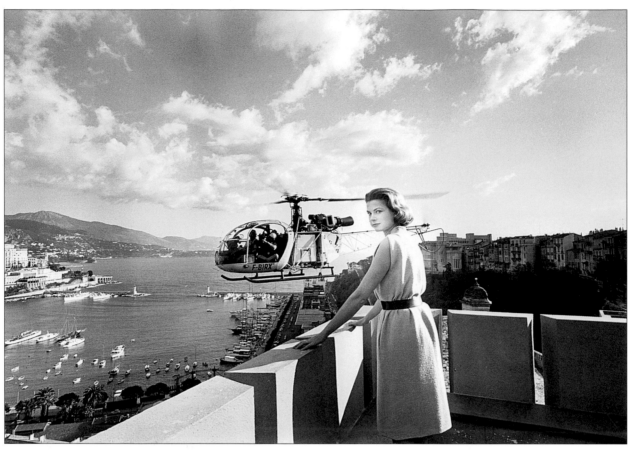

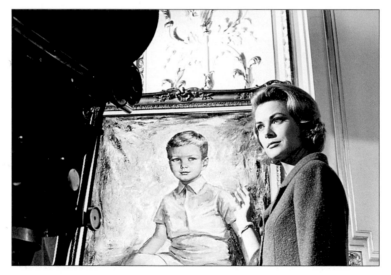

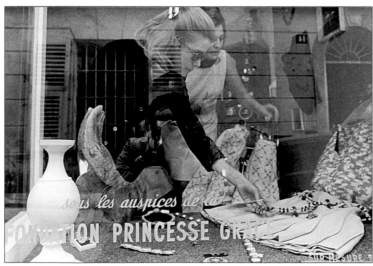

She was an extraordinary ambassador for her adopted country. Returning to the screen, albeit in a non-acting role, she made a promotional film for Monaco, showing off its beautiful rocky coast, the palace (with a painting of young Albert), and her own work at the Princess Grace Foundation.

I kept hoping to catch Grace in a pose as remarkable as the one in the water in Jamaica. The grand staircase in the palace courtyard seemed a good setting; Grace selected the dress, and we tried many poses. She was always a most cooperative subject. This was the regal result.

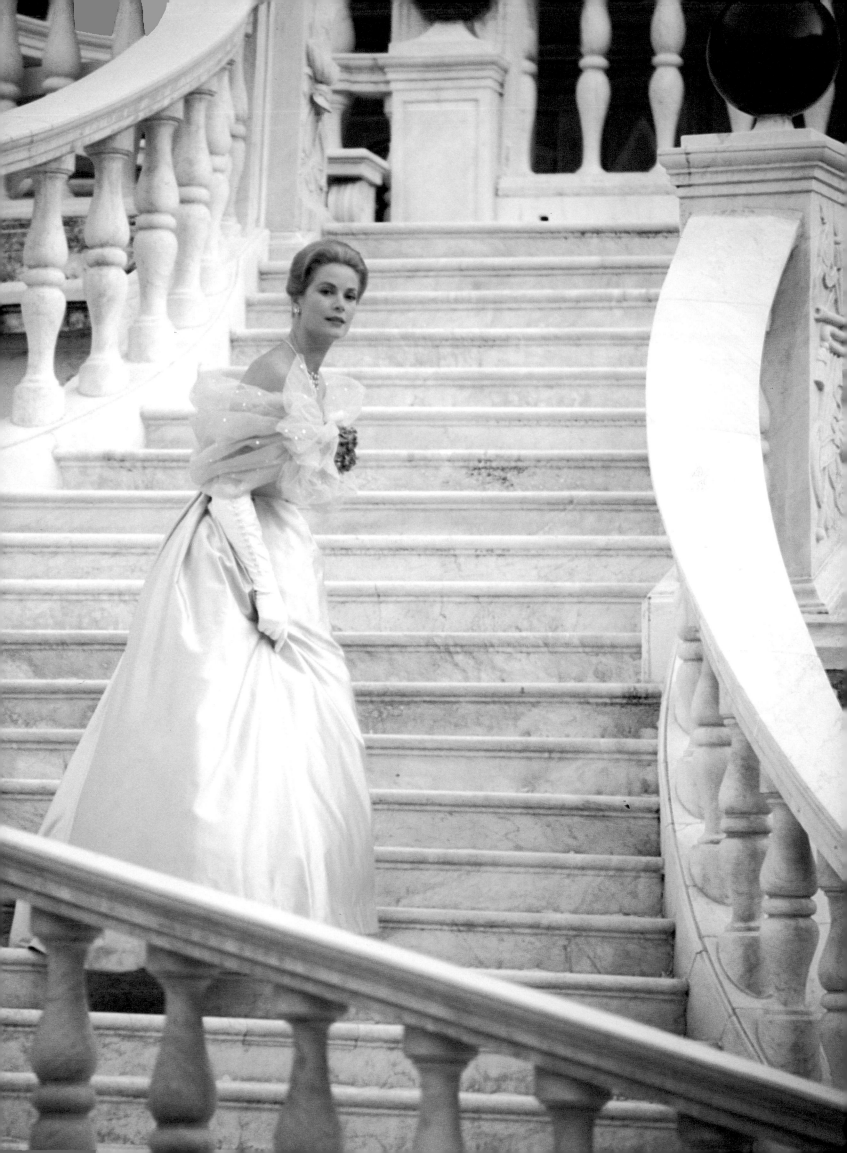

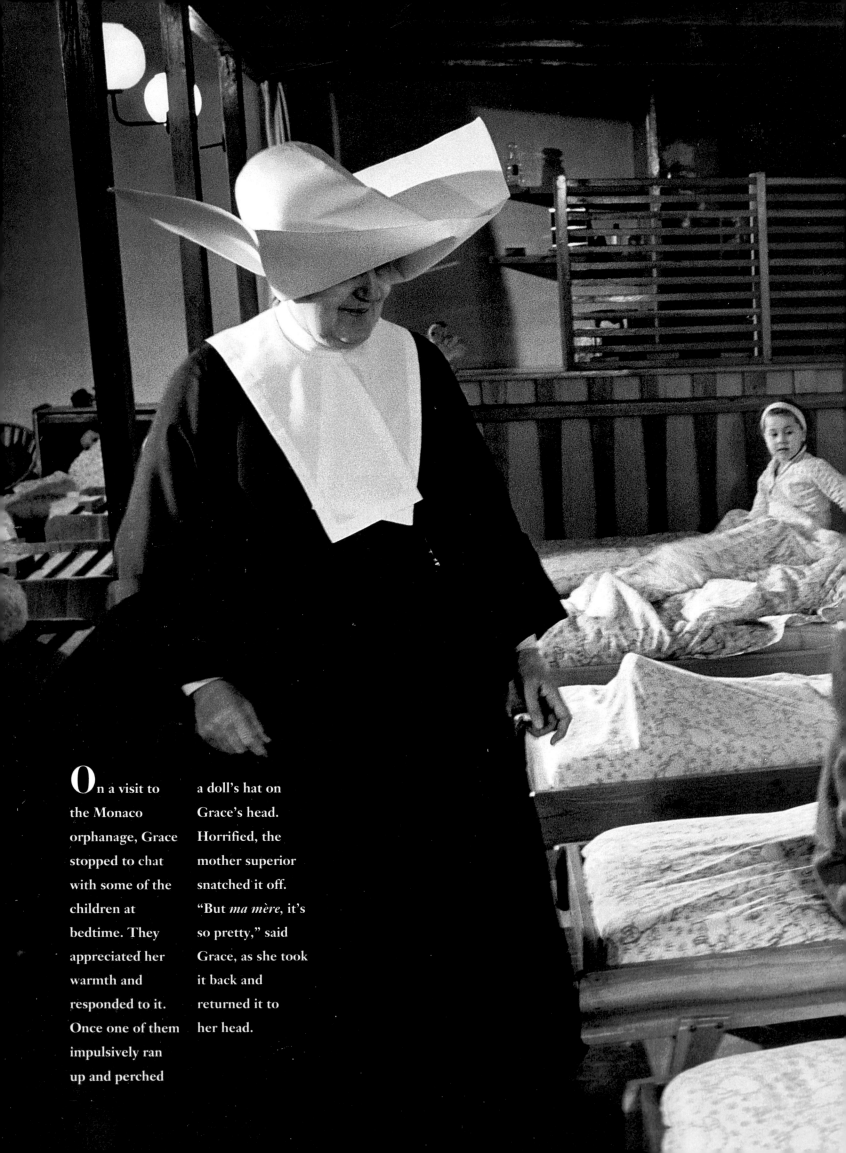

On a visit to the Monaco orphanage, Grace stopped to chat with some of the children at bedtime. They appreciated her warmth and responded to it. Once one of them impulsively ran up and perched a doll's hat on Grace's head. Horrified, the mother superior snatched it off. "But *ma mère*, it's so pretty," said Grace, as she took it back and returned it to her head.

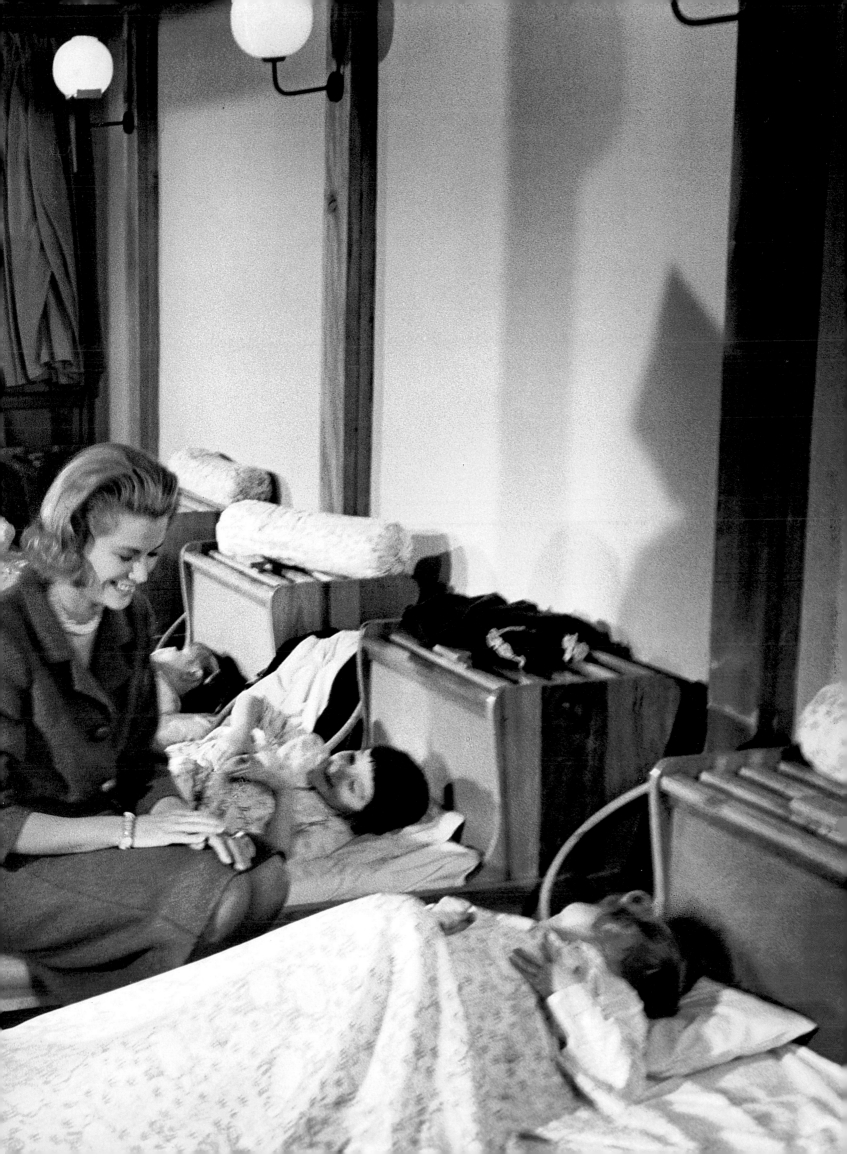

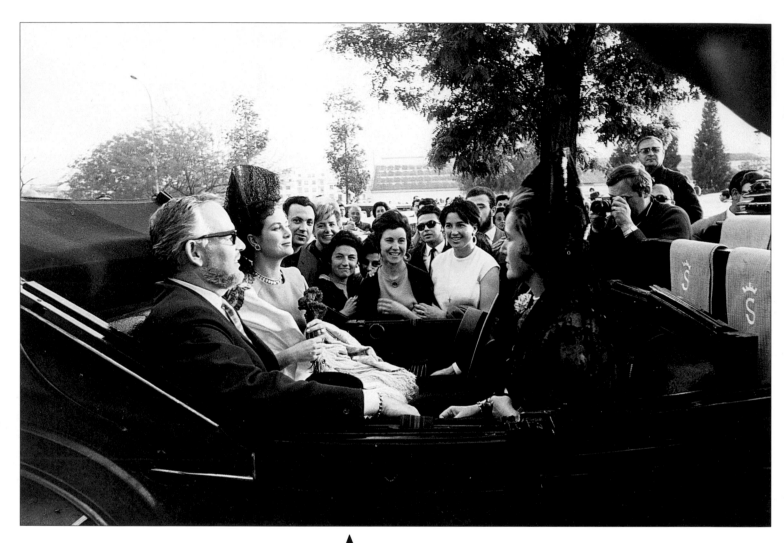

Around the time of Grace and Rainier's tenth wedding anniversary, the couple took a trip to Seville, Spain, where Grace was crowned queen of the folk festival, and dressed for the role, complete with *mantilla*. I joined them for the trip and stayed in their suite. It was the first time that they had ventured forth in public (outside of Monaco) since their marriage. Both complained about the paparazzi, who seemed to pop up everywhere with their cameras.

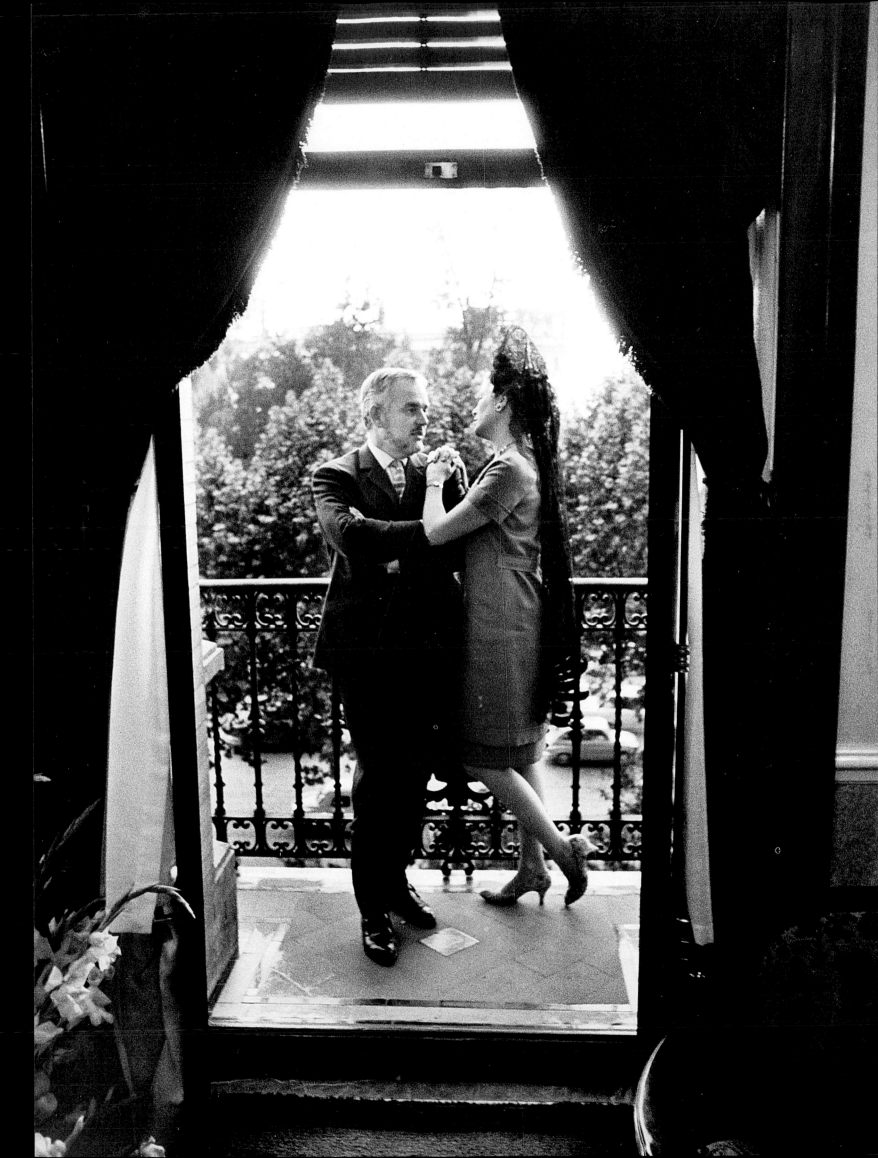

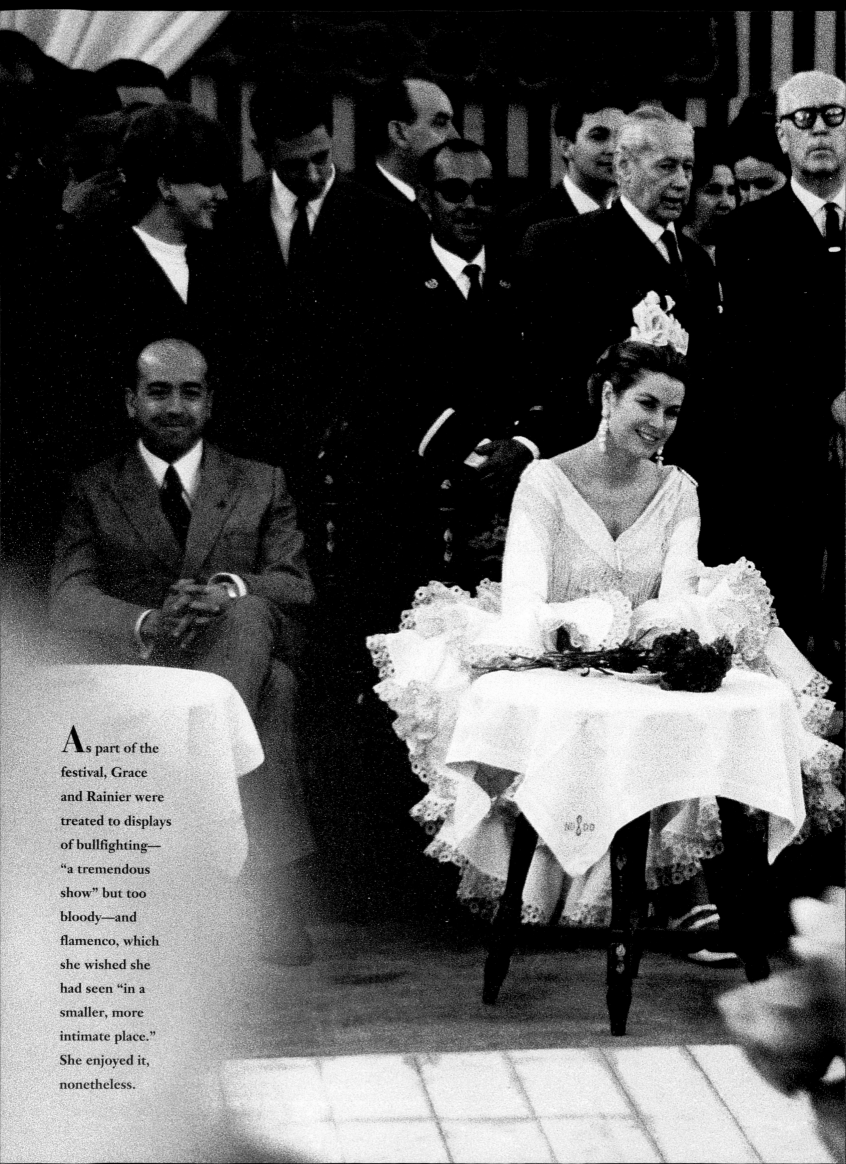

**A**s part of the festival, Grace and Rainier were treated to displays of bullfighting—"a tremendous show" but too bloody—and flamenco, which she wished she had seen "in a smaller, more intimate place." She enjoyed it, nonetheless.

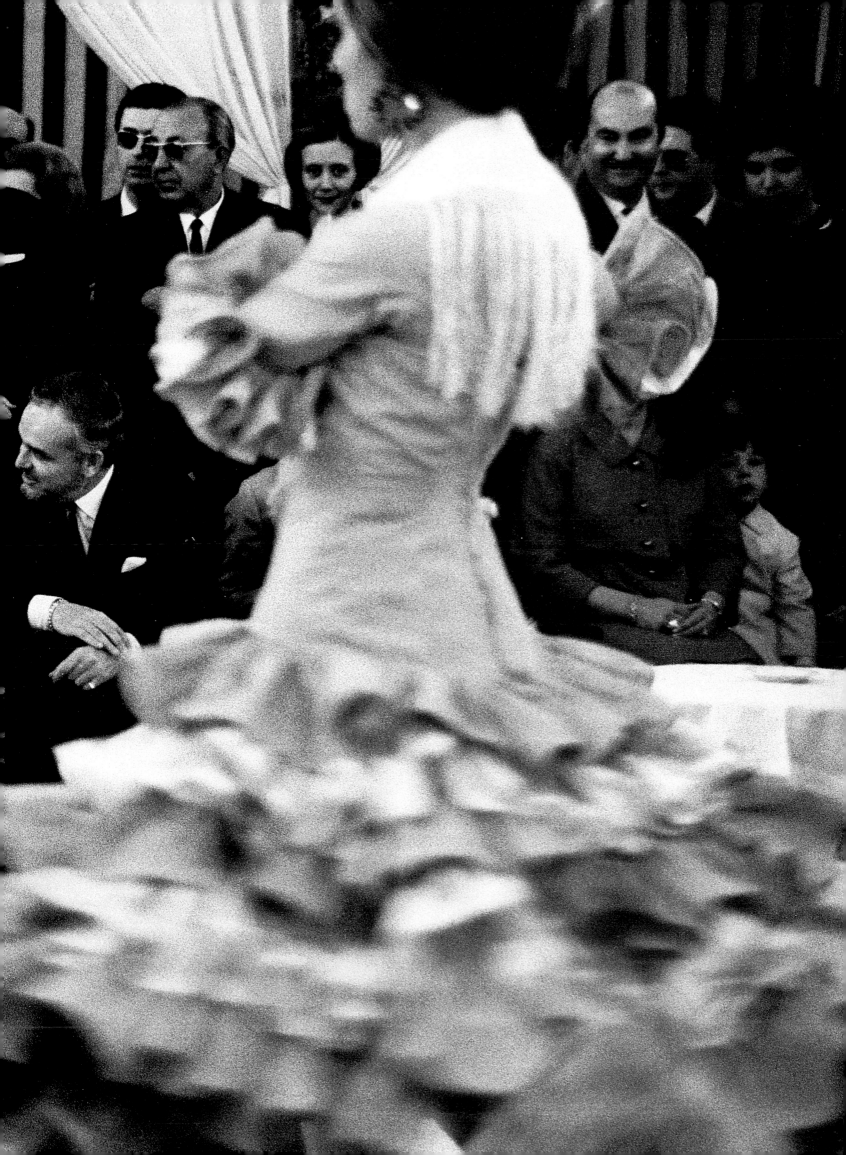

# Happy Moments
## of a
# Happy Family

SHORTLY AFTER CAROLINE was born in 1957, Grace declared to a reporter that she would not let "public life or anything else push me out of my job as a mother," and she didn't. Princess Grace of Monaco may well have been the most hands-on royal mother in recent history. As in a typical American family, she would rise and have breakfast with her young children, then see them off to school—even if the school was just another room in the palace compound. She worried about spoiling them (especially since they had at least one whole country eager for news about their every movement) and about encouraging them to develop as individuals, which she recognized would not be easy for children living the fishbowl life of a royal family.

In nearly every interview, Princess Grace was asked to deliver her philosophy on child-rearing. Though she grimaced at the headlines of many such pieces (she was often declared "the perfect mother"), she stuck to a consistent answer that stressed the building of "character." Her traditional opinions may have seemed outmoded in the middle of the 1960s movements toward liberation. Though pressures of growing up in public caused family stresses, in the late 1970s, the happy picture of family life in the Monaco palace seemed to confirm the correctness of her approach. Whether vacationing together in Atlantic City or frolicking in the rustic environs of Roc Agel, their country home, the Grimaldis offered the world an image of happiness and love.

Grace loved to read (nearly every interview with her eventually got around to the latest book she had read), but she loved to read out loud even more, since it gave full play to her acting skills. She read to the children whenever she could, in English or her unaccented French.

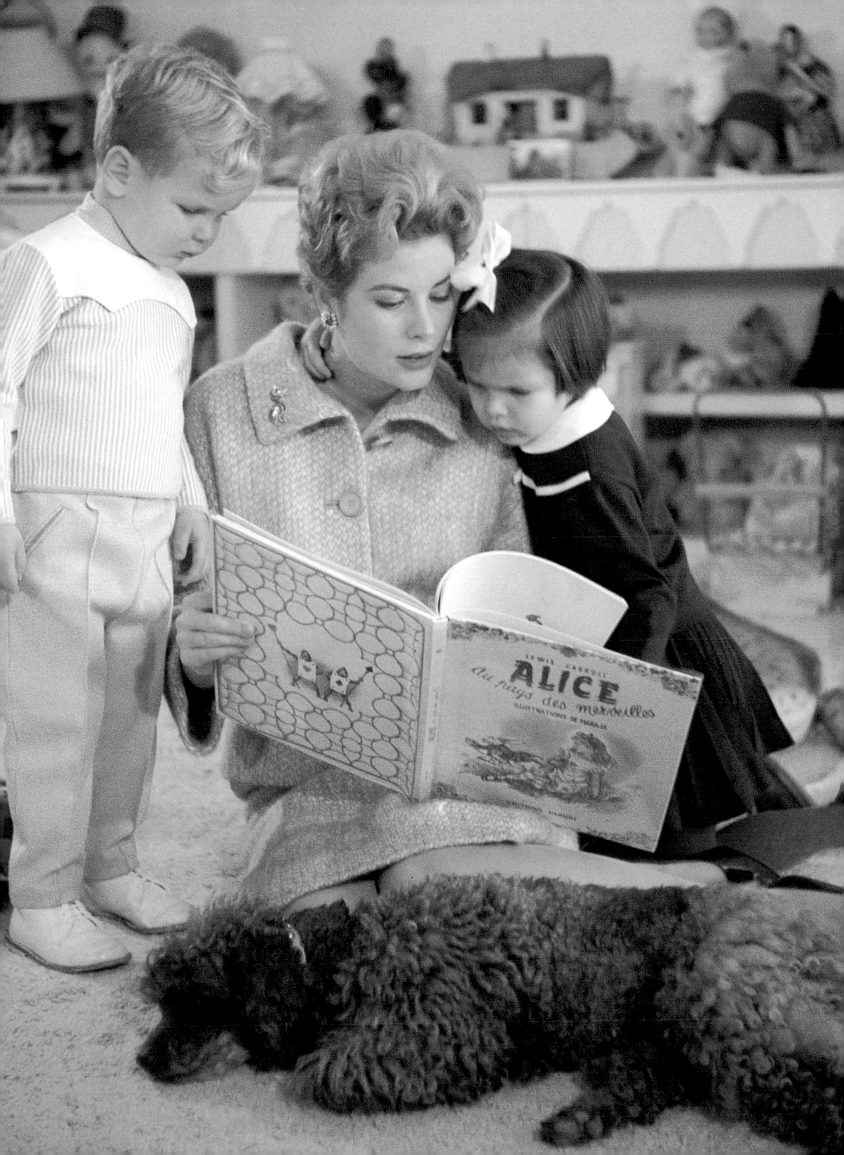

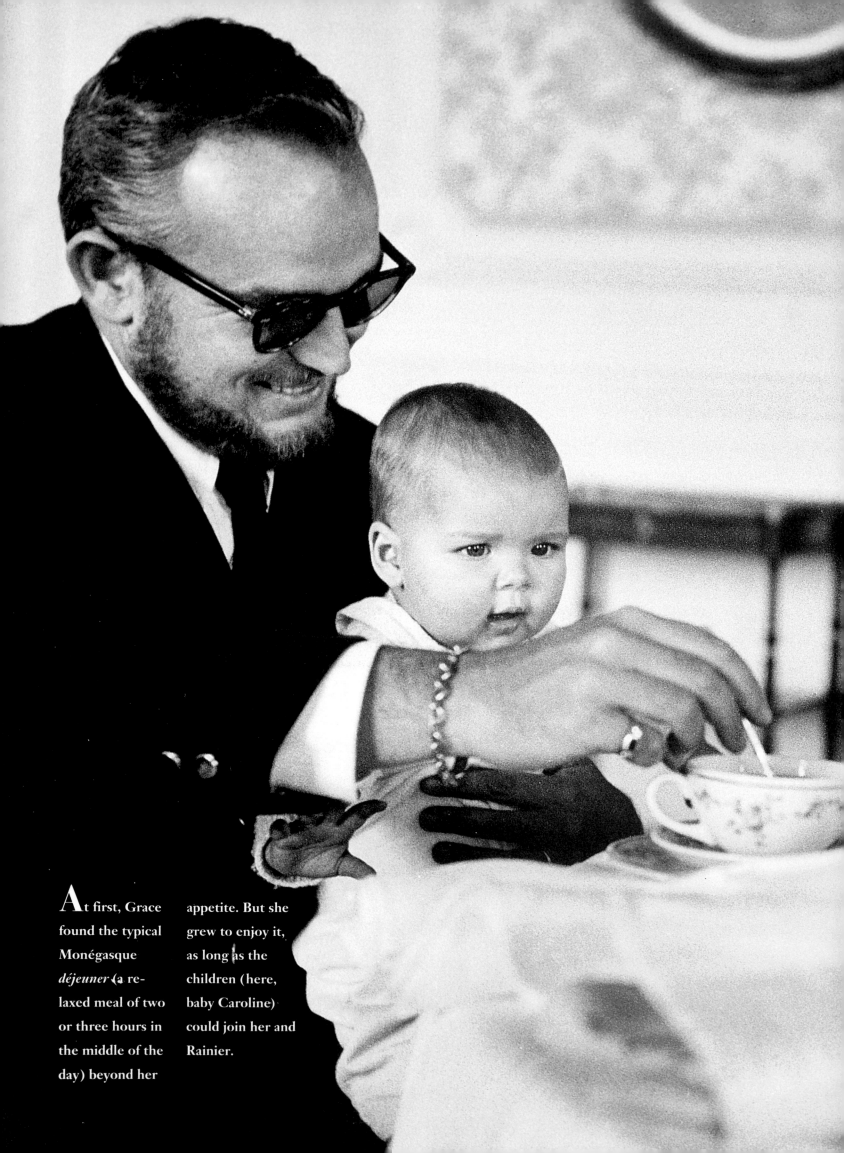

At first, Grace found the typical Monégasque *déjeuner* (a relaxed meal of two or three hours in the middle of the day) beyond her appetite. But she grew to enjoy it, as long as the children (here, baby Caroline) could join her and Rainier.

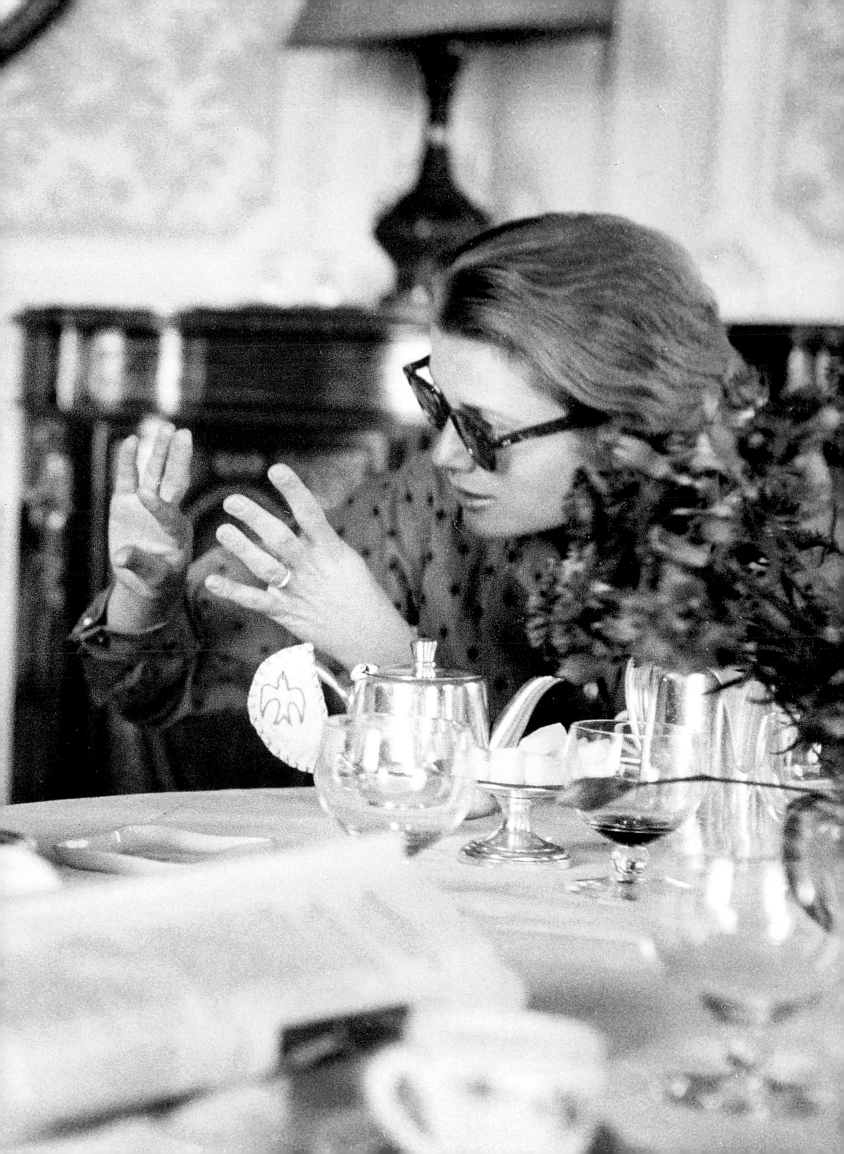

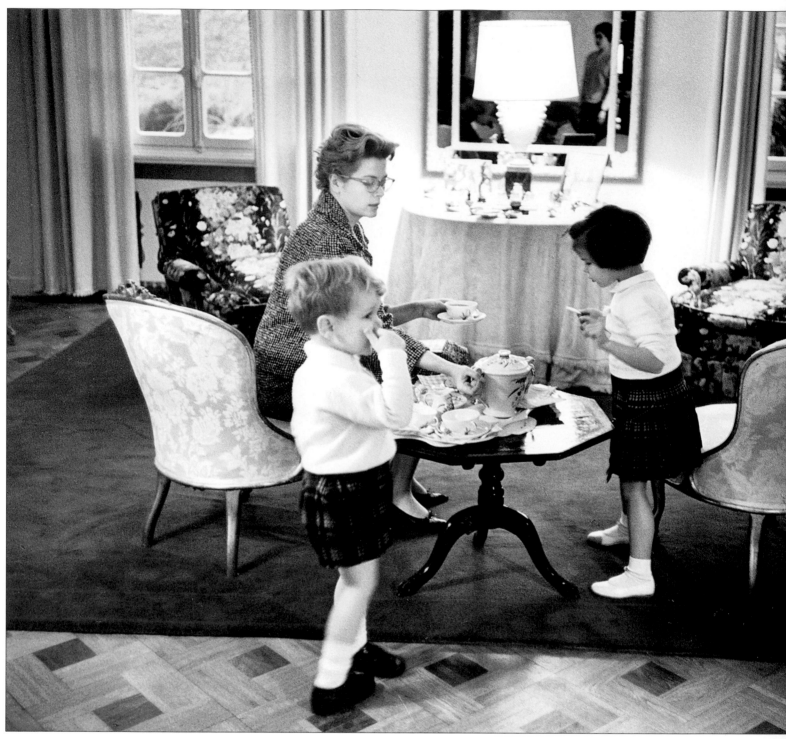

Some of the family's happiest times were at Roc Agel, the rustic summer "palace" across the border in France, atop a mountain overlooking Monaco. Nicknamed "*le Ranch*" by the locals, it was hardly ever photographed. When I took these pictures, Grace was particularly focused on the children: having a tea party, setting up a tepee, and overseeing Caroline's ballet practice.

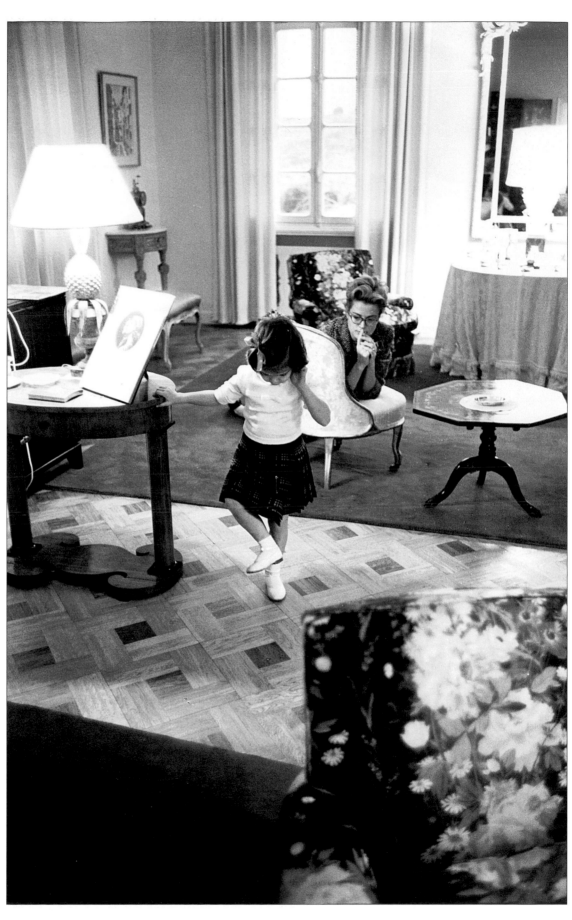

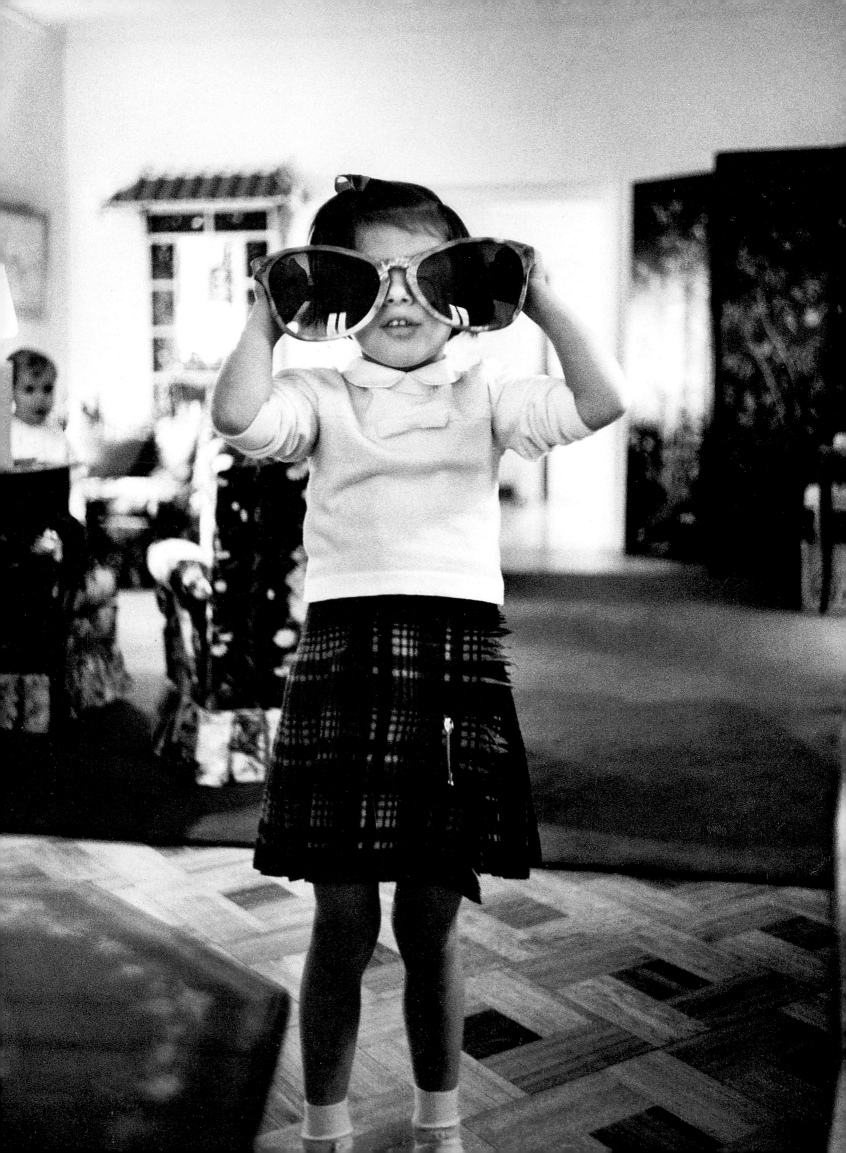

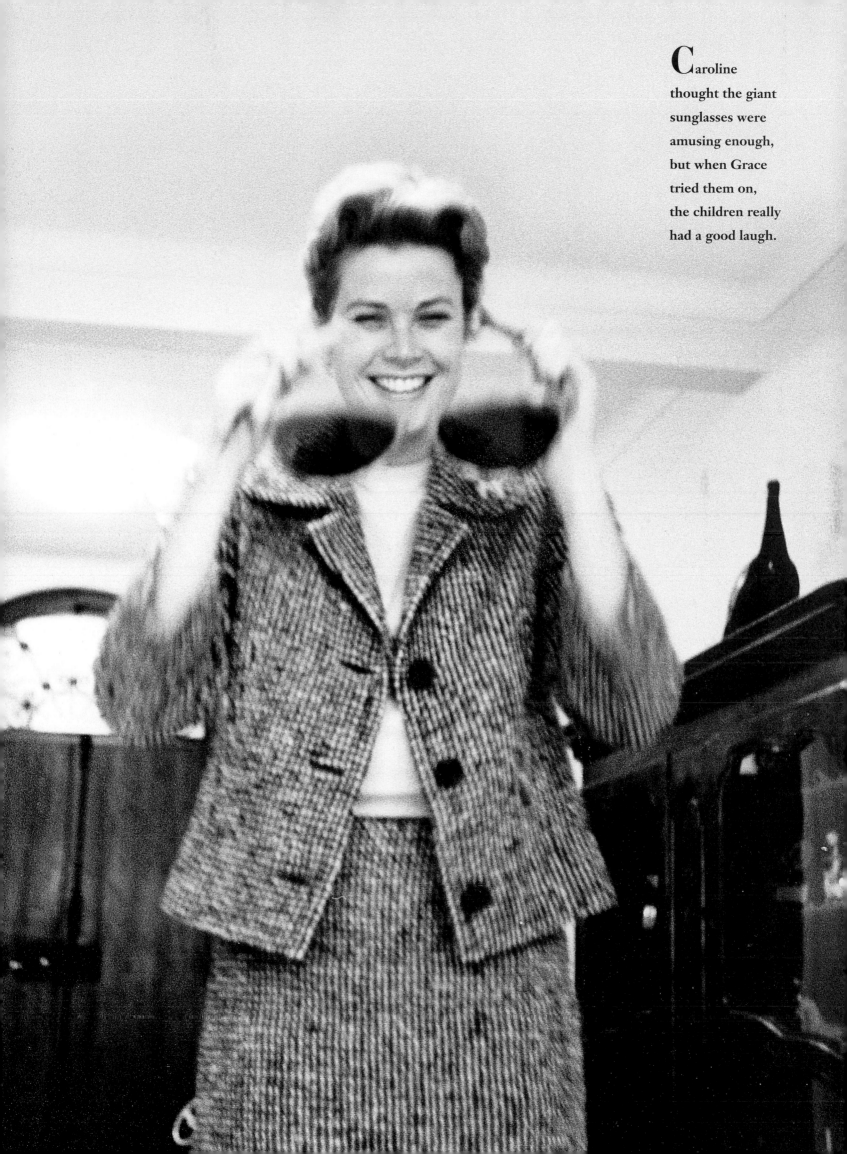

**C**aroline
thought the giant
sunglasses were
amusing enough,
but when Grace
tried them on,
the children really
had a good laugh.

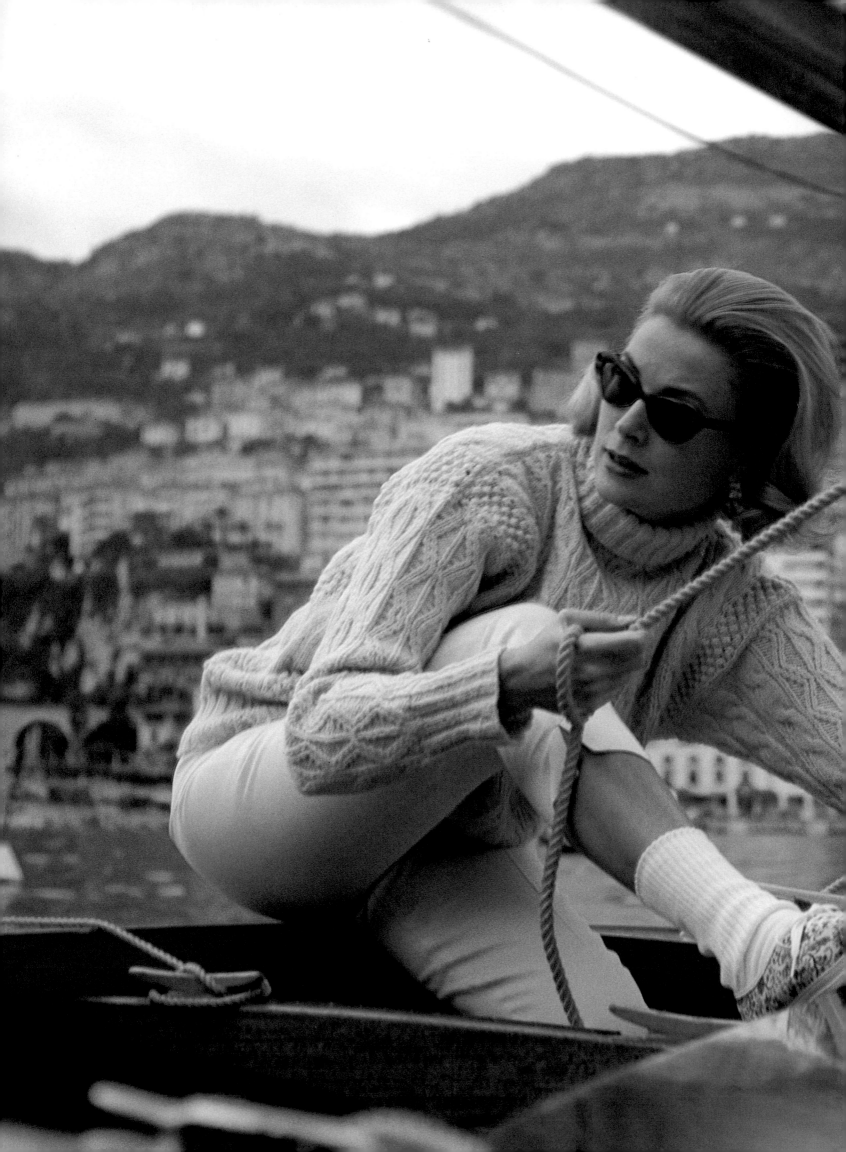

One thing Grace and Rainier didn't agree on was sailing. Though the prince had given her his yacht as a wedding present, he was the one who enjoyed taking it out. Rainier liked dangerous rides on the stormy waves, but Grace often got seasick. After a while, she left the high seas to him, and limited her own outings to navigating a small sailboat around the harbor.

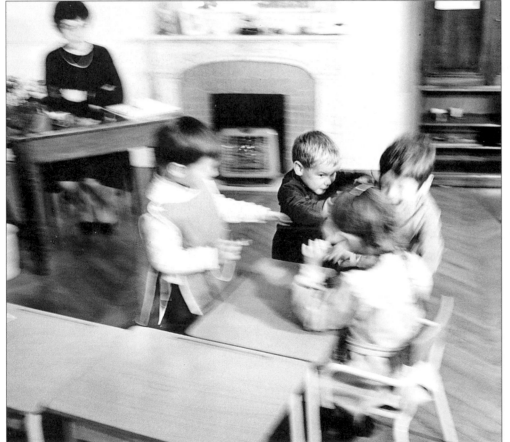

Grace had strong opinions about the education of her children. The palace school stressed the basics, as Albert learned here. And to make sure they did their homework, they were not allowed to watch television on school nights. But education, to Grace, was much more than book-learning. It was just as important to learn all the traditional skills —for the girls, cooking, sewing, and making clothes; for the boys, camping, growing food, and handling animals —and of course, sports for all.

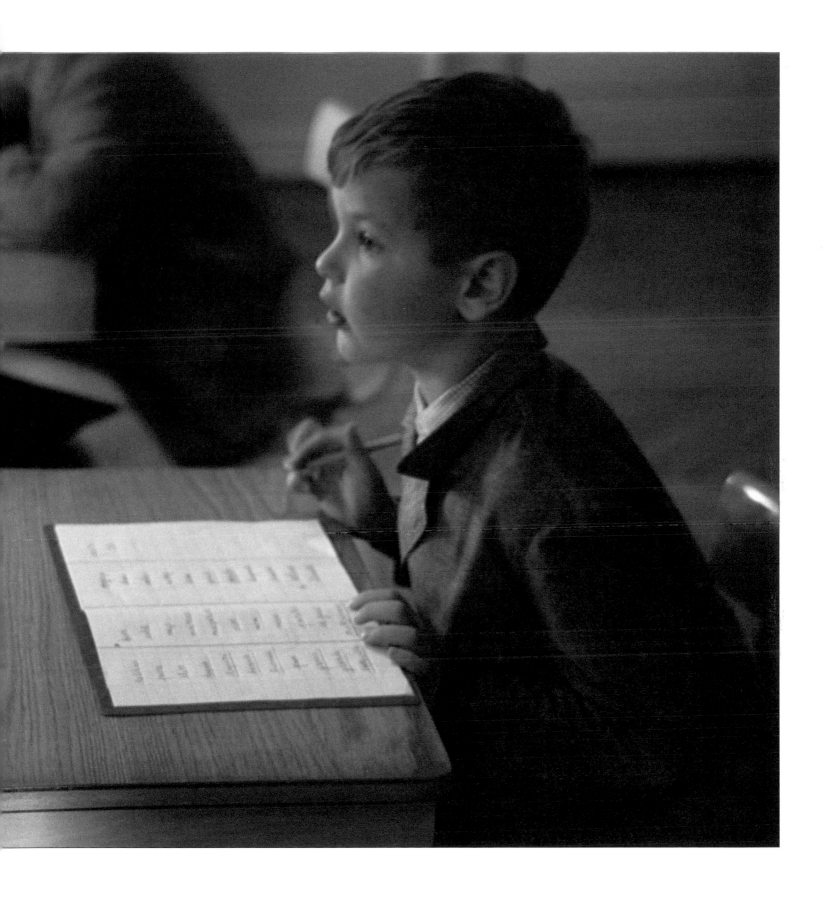

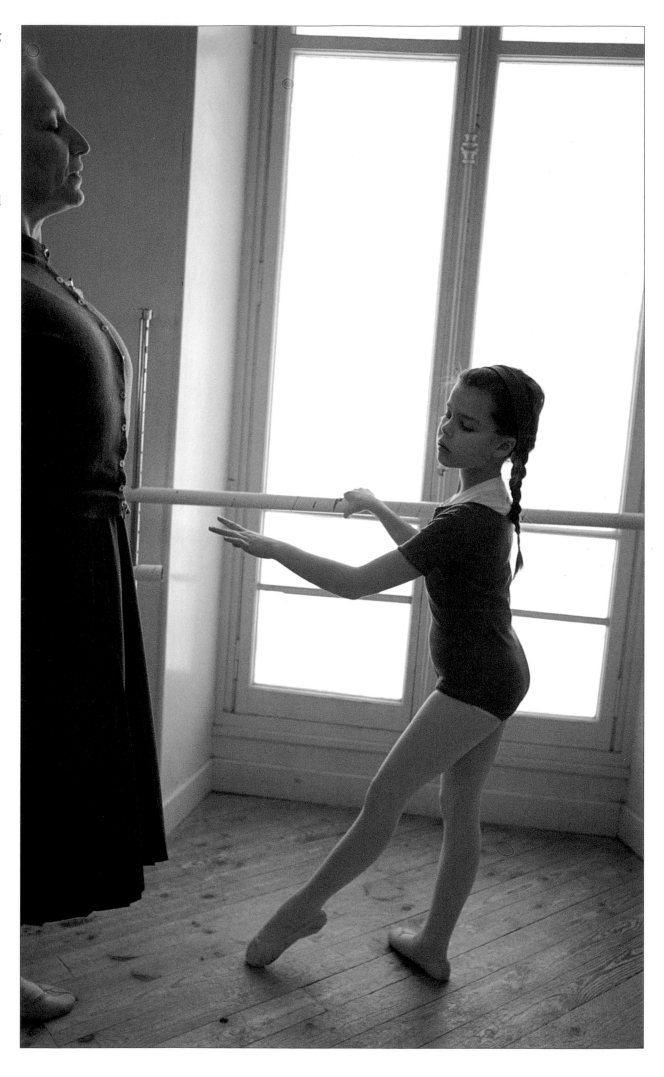

Ballet was a big part of Grace's life. Monaco, of course, was once famous for Sergei Diaghilev's Ballets Russes de Monte Carlo, and Grace hoped to make the principality a center of dance once again. She encouraged Marika Besabrasova, a well-respected Russian ballet mistress, to open a school in Monaco. Among her students was young Caroline.

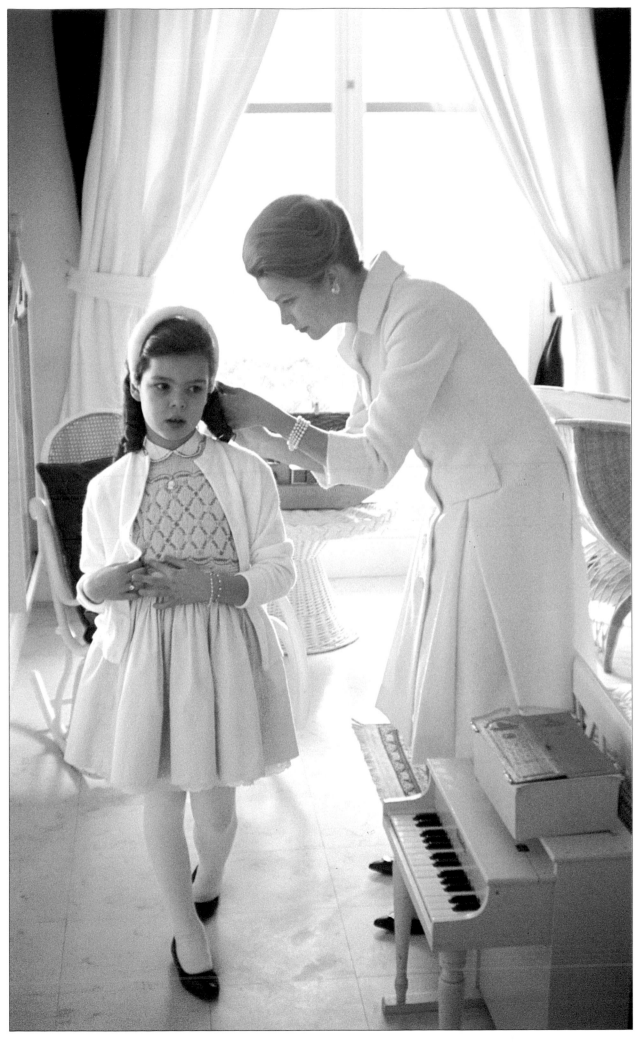

I loved photographing Grace when she was with her children, if only because she could get so involved with them that she paid little attention to me and my camera. At the moment when I snapped this photo, nothing was more important than fixing Caroline's curls.

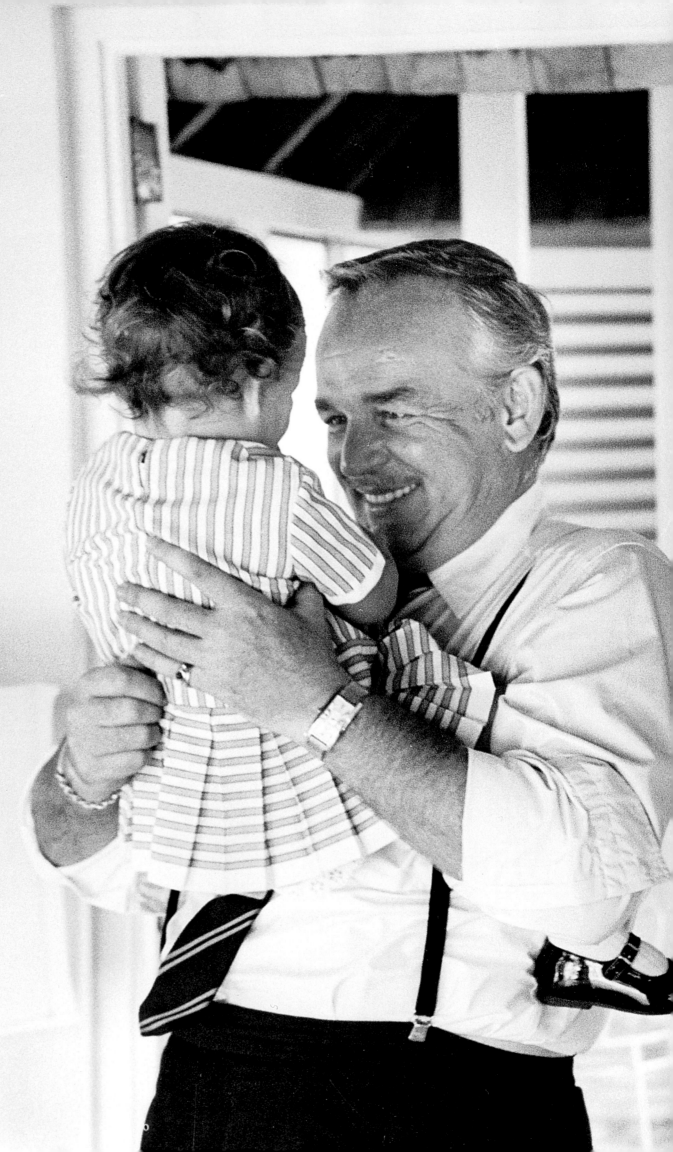

In 1967, Grace, Rainier, and the children traveled to Jamaica for a vacation, and I went with them. It was a true family event, with Stephanie, two, stealing much of the show. She sang for her parents, dressed up like a clown, and insisted on her favorite snacks: peanuts, cookies, and coffee served in a demitasse spoon by her father.

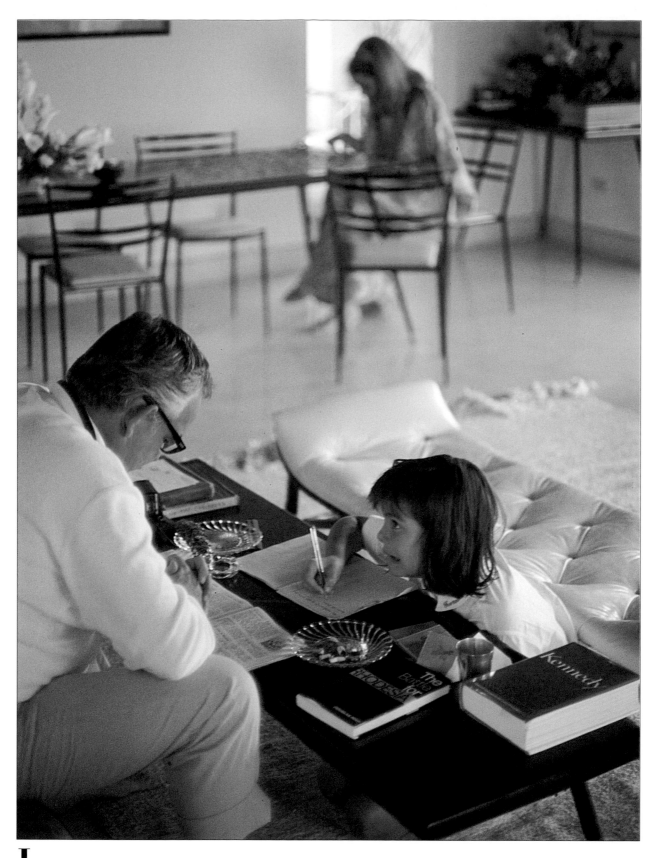

It was the first time I had been in Jamaica since I was there with Grace Kelly, Hollywood starlet, and the contrasts were overpowering. Twenty-three pieces of luggage arrived with the family, including toys, schoolbooks, and plans for a new wing of the palace. That's Caroline studying across from her father, above, while Grace works a jigsaw puzzle. The most incongruous sight was Princess Grace shopping at the open-air vegetable market. "You like the yams?" asked the seller, clearly not recognizing her.

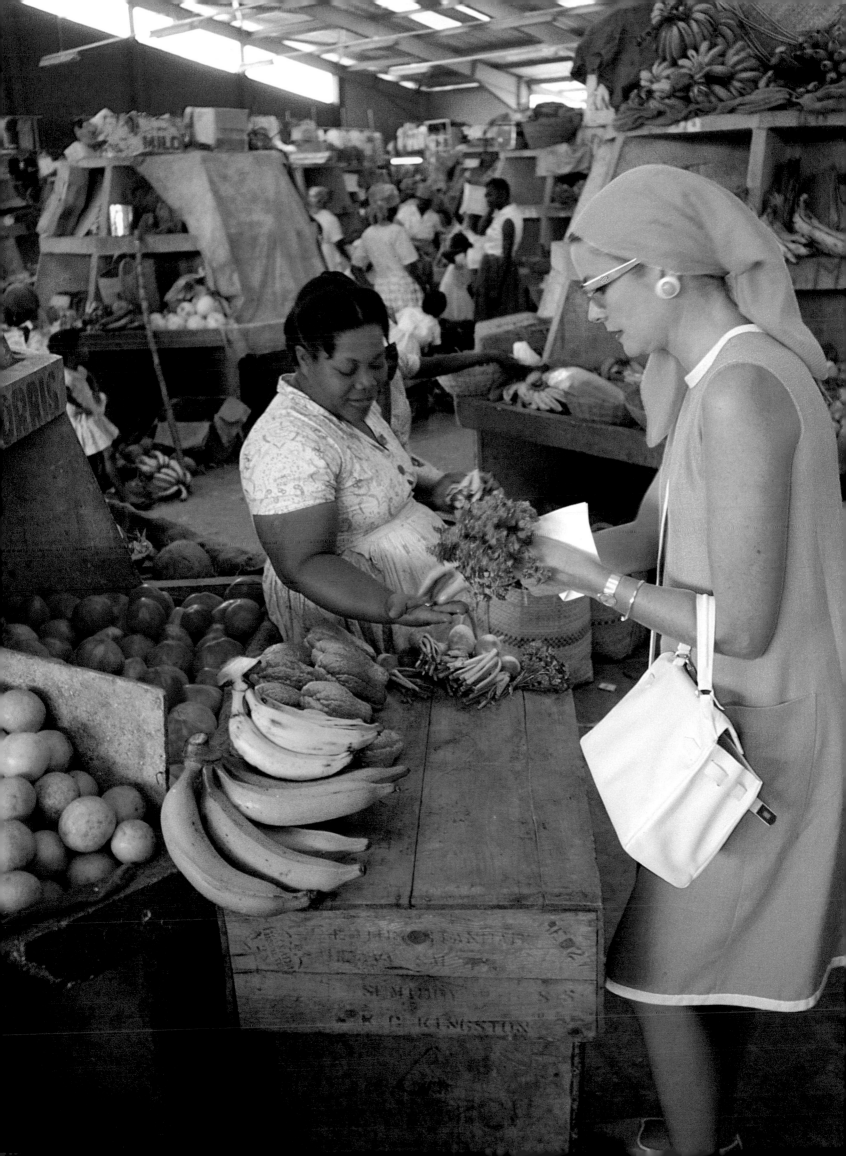

For a princess, even household chores can be a vacation. Though the family employed a Jamaican staff of seven during their two-week stay, Grace enjoyed working in the kitchen. It was a welcome break from all the polo matches and the sunbathing by the pool.

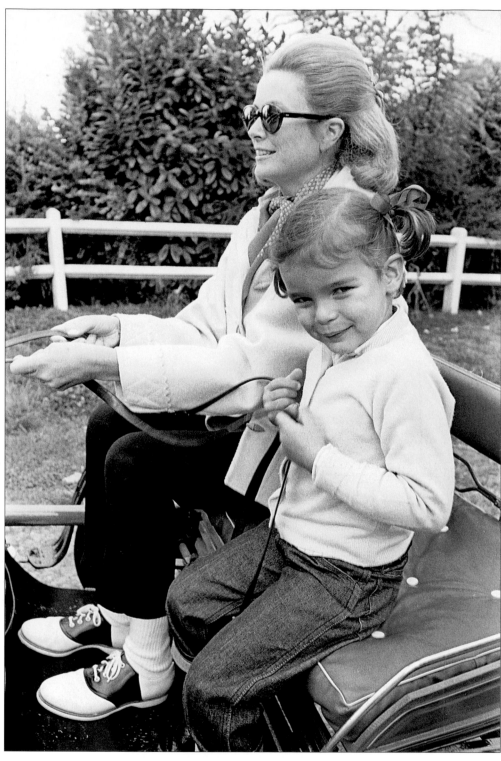

Roc Agel, though, remained Grace's favorite retreat, perhaps because it was nearby, yet so removed from the pomp and ceremony, so private and "American." She had even decorated the bathroom with stills from her Hollywood movies, which by order of the prince were never shown in Monaco. At Roc Agel, everyone pitched in doing the chores; for dinner, the family would often barbecue some hot dogs and hamburgers. The children loved it: that's Stephanie on a buggy ride with her mother and with her doll collection, and Albert, feeling like a true American cowboy. The picture at bottom left was my attempt at a different sort of family portrait: the Grimaldis in a haystack.

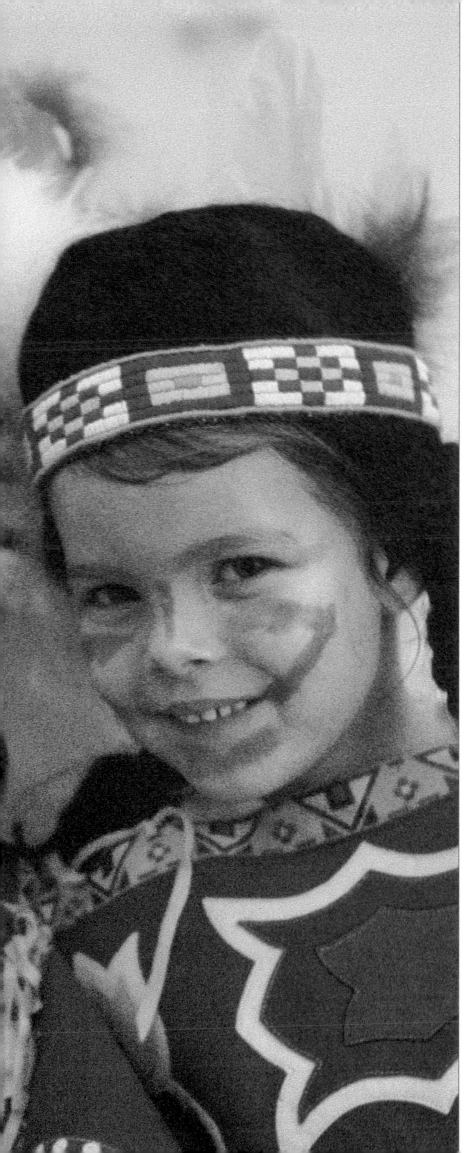

The children
were fascinated
by American
subjects, and
Grace encouraged
them to express
their interests in a
theatrical vein.
Both Albert and
Caroline—
dressed as
American Indians,
left—loved to play
with costumes.
At a much later
time, Grace
helped Albert
dress as a clown
for Monaco's
circus festival,
begun by Rainier
in 1976.

Magazines regularly reported that Grace was the disciplinarian with the children, and that Rainier was more lenient. But I never heard either of them raise their voices; the closest Grace came may have been this little altercation with Stephanie during the rehearsal for Caroline's wedding to Philippe Junot.

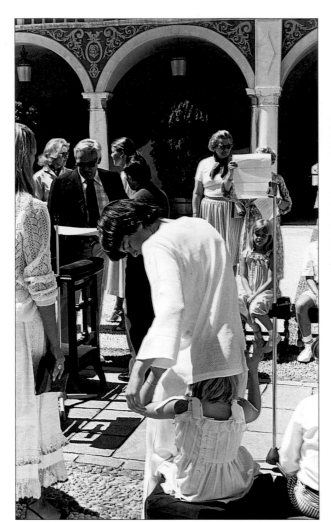 

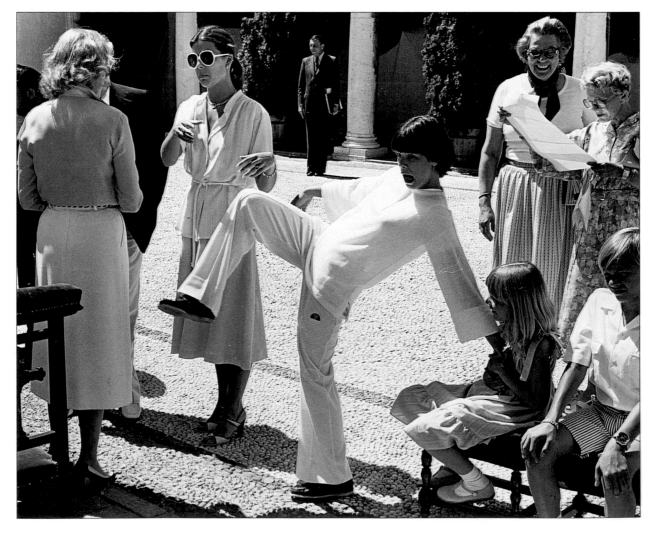

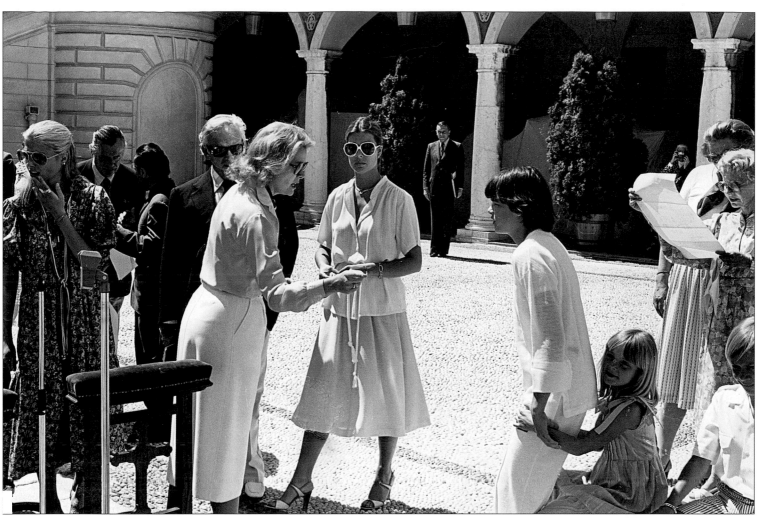

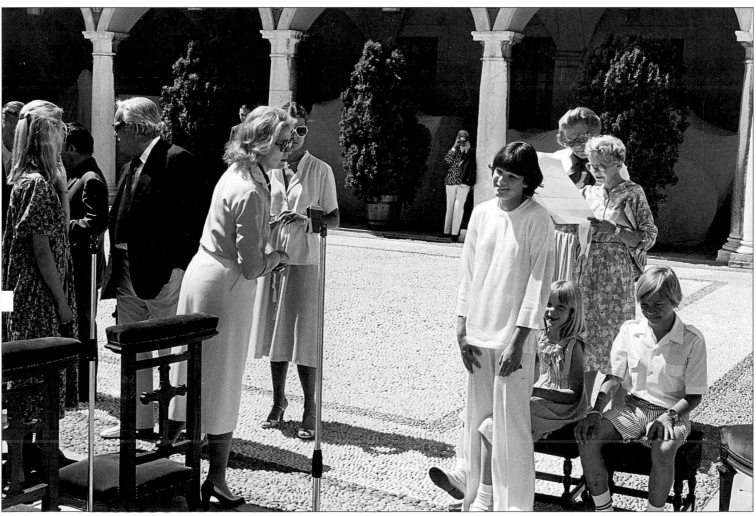

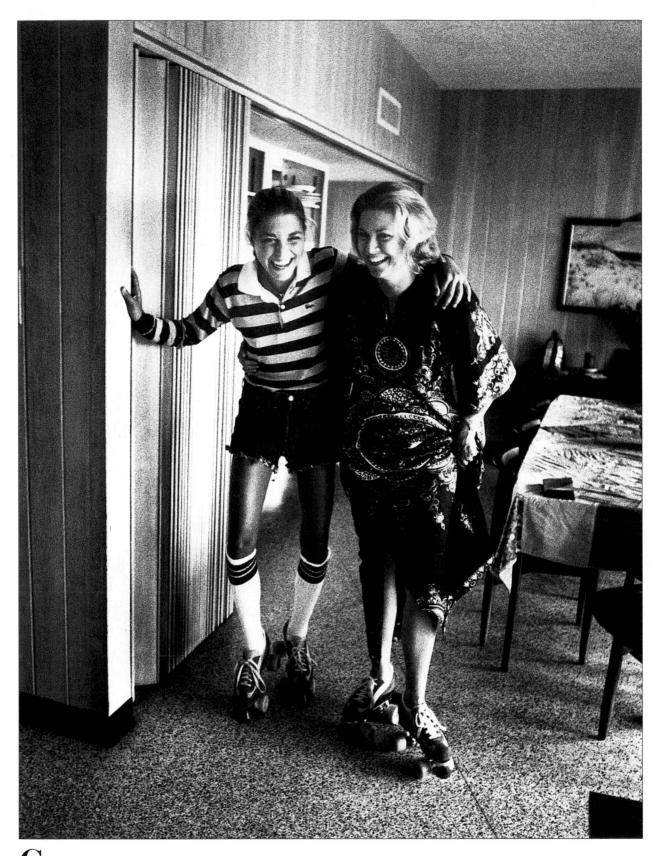

<span style="float:left;font-size:3em;line-height:0.8;padding-right:0.05em;">G</span>race always felt very close to Caroline. On a vacation trip to Atlantic City, where they stayed in a house the Kelly family had by the shore, she and Caroline tried on roller skates, above. Only a few days before the wedding, they romped on a trampoline set up for a party at Roc Agel, right.

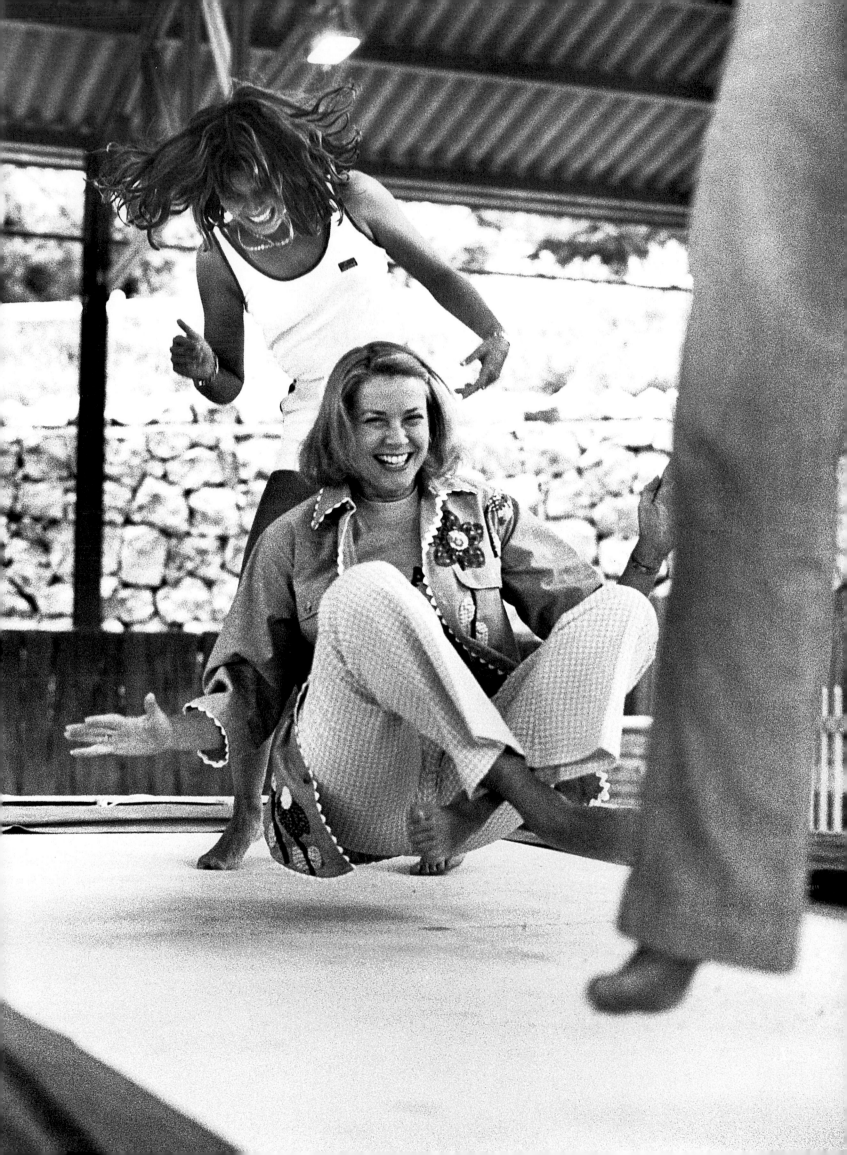

Always looking for new picture ideas, I took Rainier and the children to the top of Mont Agel for this one, hoping to show them with Monaco in the background. Thinking they would scare me, the three turned around, pointed, and shouted, "Gotcha!" But I had the last laugh. They didn't know I had the camera ready. Far from being surprised, I just clicked the shutter.

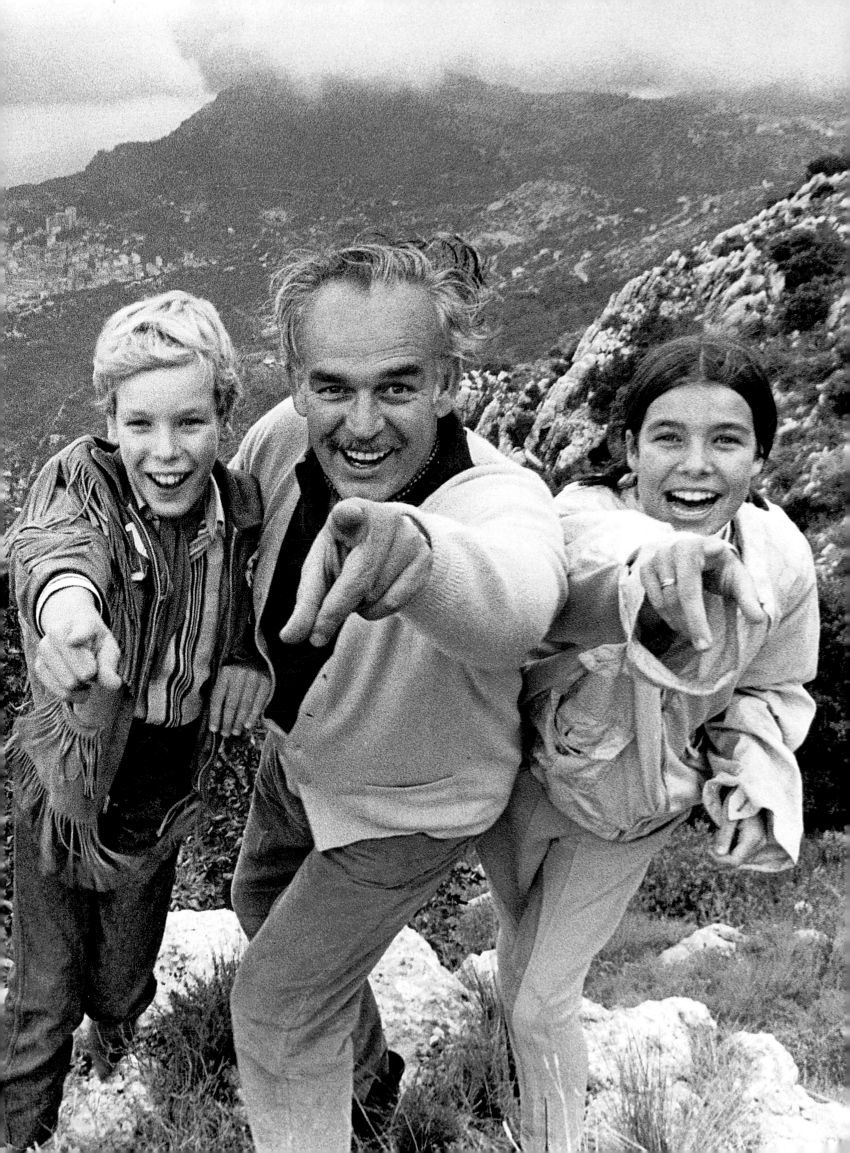

# The
# Portraits

FOR THE MOST PART HOWELL Conant's pictures of Princess Grace were taken on assignment from picture magazines, but each year he would travel to Monaco to take a formal portrait expressly for the royal family. From 1956, when the picture included just Grace and Rainier, until 1981, when they celebrated their twenty-fifth wedding anniversary in Palm Springs, Conant took the official portraits of the Monaco royal family. The photograph was sent out with the Grimaldis' Christmas card each year. Reproduced and distributed to the Monaco citizenry, it often appeared in the windows of Monégasque homes and shops. Looking at the series of pictures today, as they appear across the next few pages, affords a rare view of a family growing through the years.

Trying anything to get his kids to laugh, Rainier holds the reflector from one of my lights over my head while I take his family's portrait.

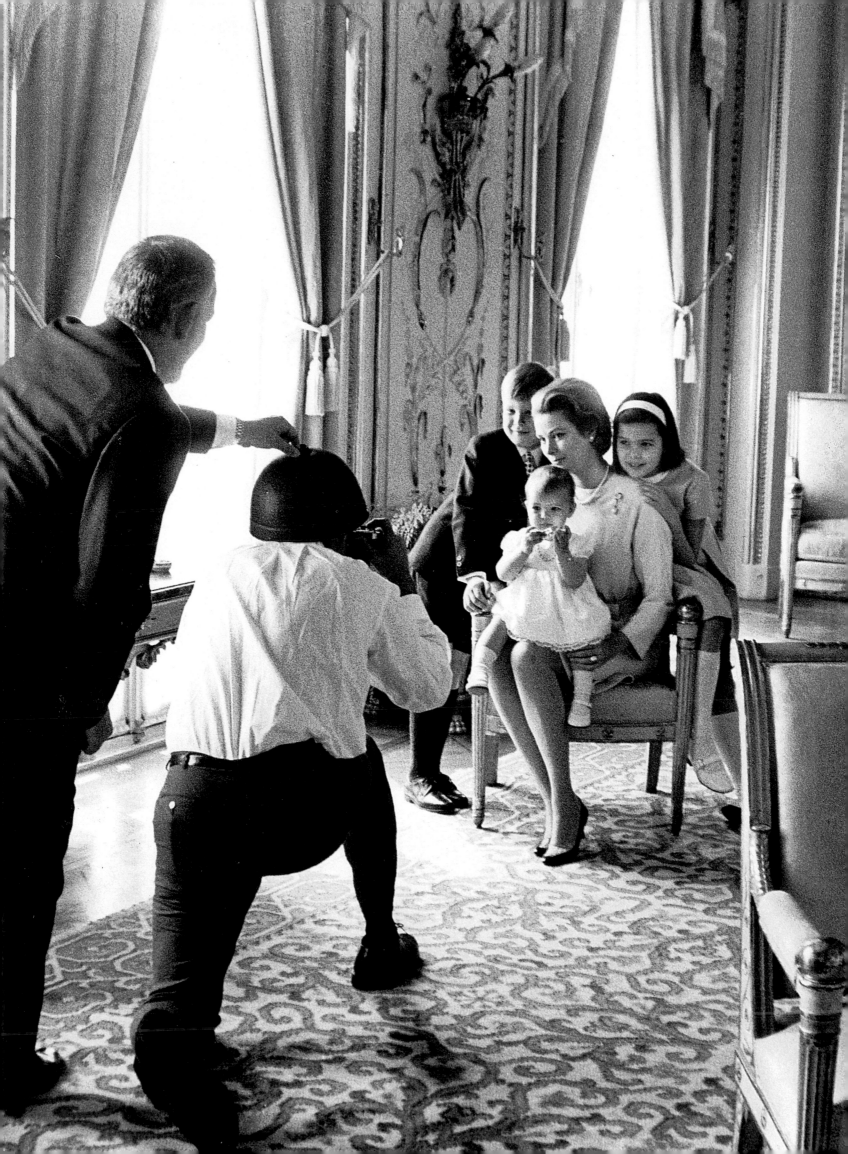

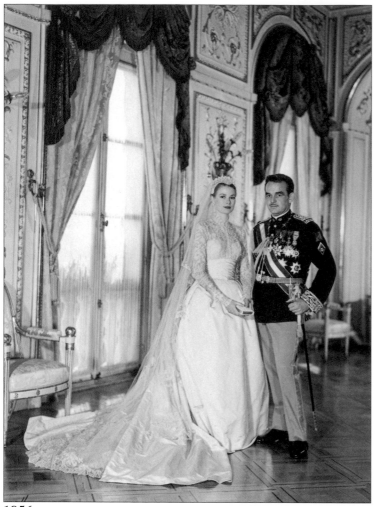

1956

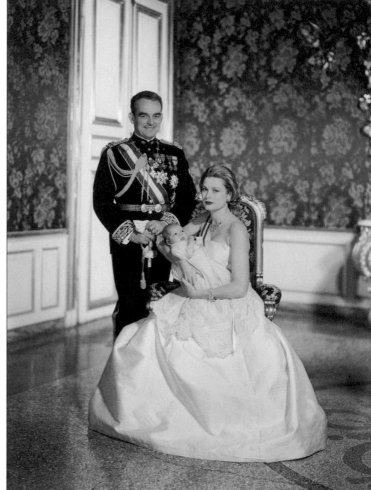

1957

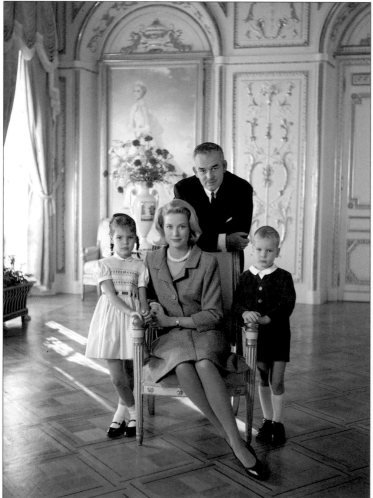

1962

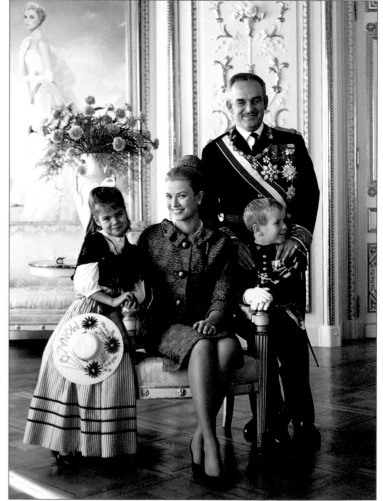

1963

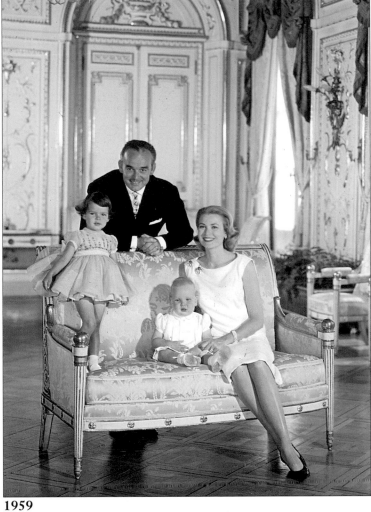

1959

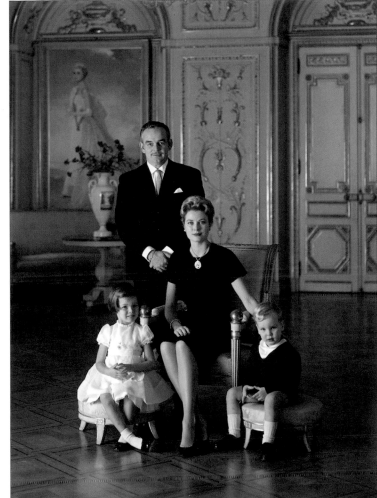

1961

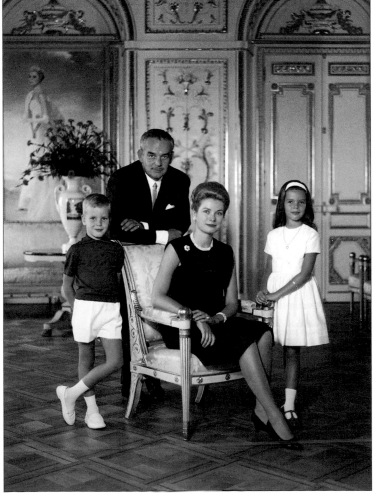

1964

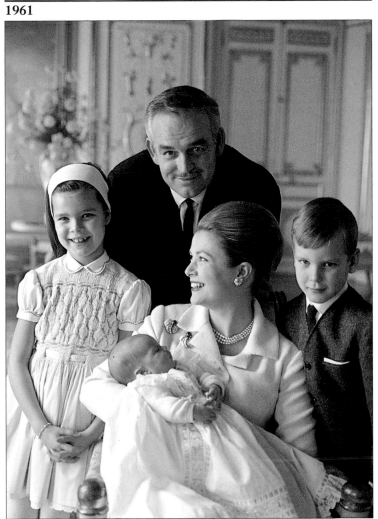

1965

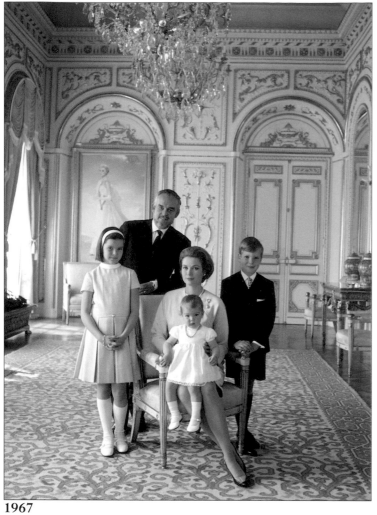

1967

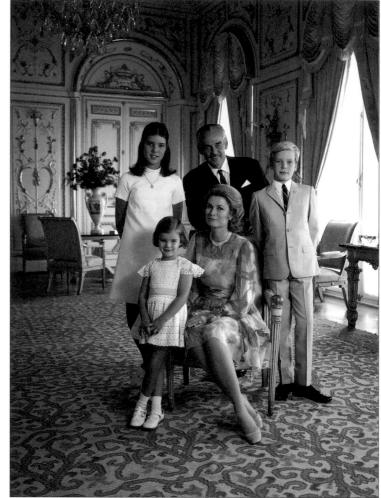

1969

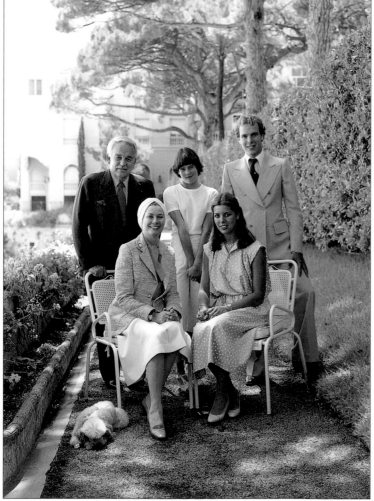

1978

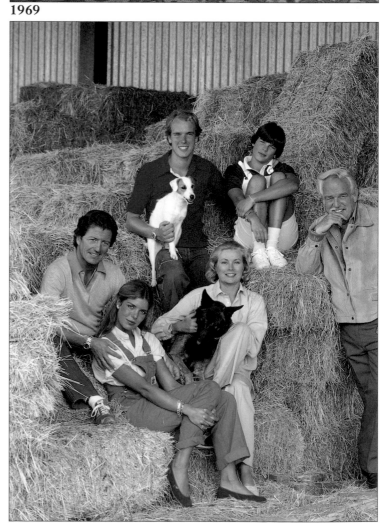

1980

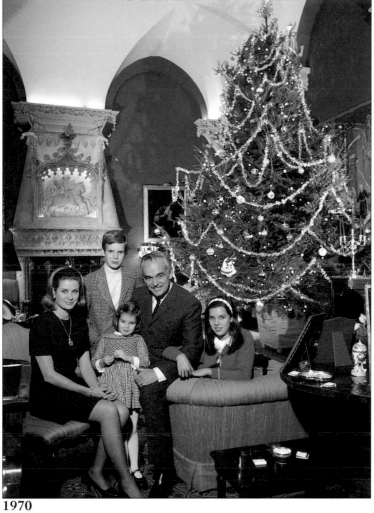

1970

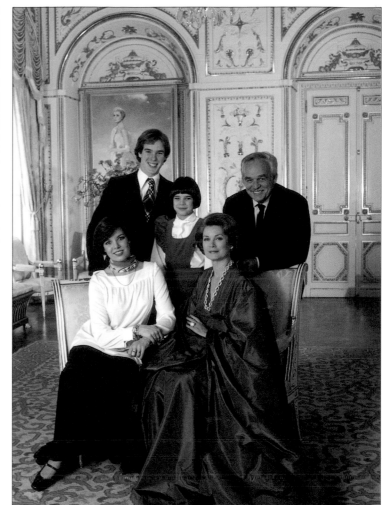

1976

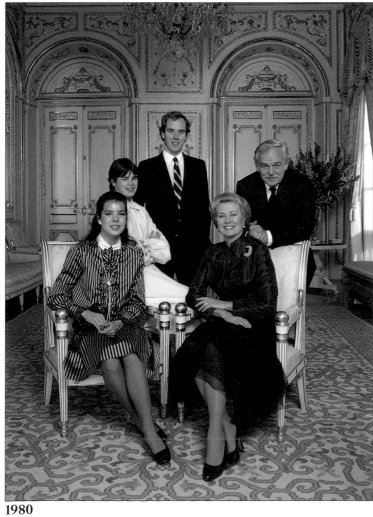

1980

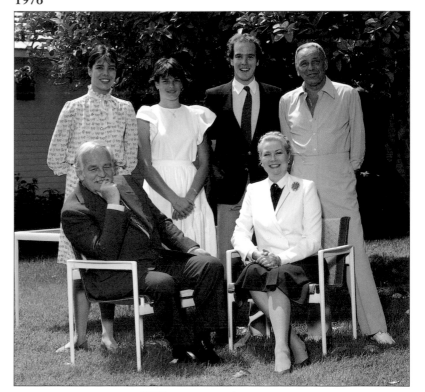

1981

These, then, are the Grimaldis. I took the last portrait the year before Grace's death, on their twenty-fifth anniversary, in Palm Springs with Frank Sinatra.

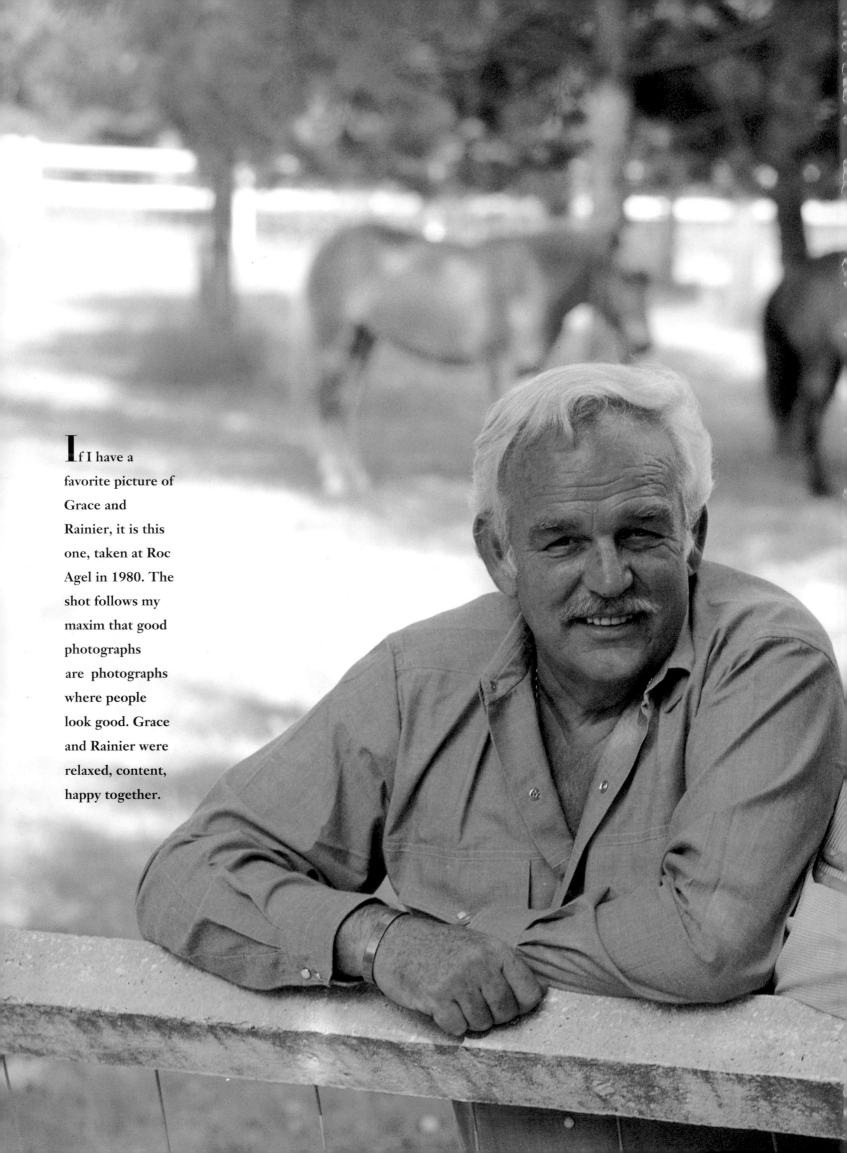

If I have a favorite picture of Grace and Rainier, it is this one, taken at Roc Agel in 1980. The shot follows my maxim that good photographs are photographs where people look good. Grace and Rainier were relaxed, content, happy together.

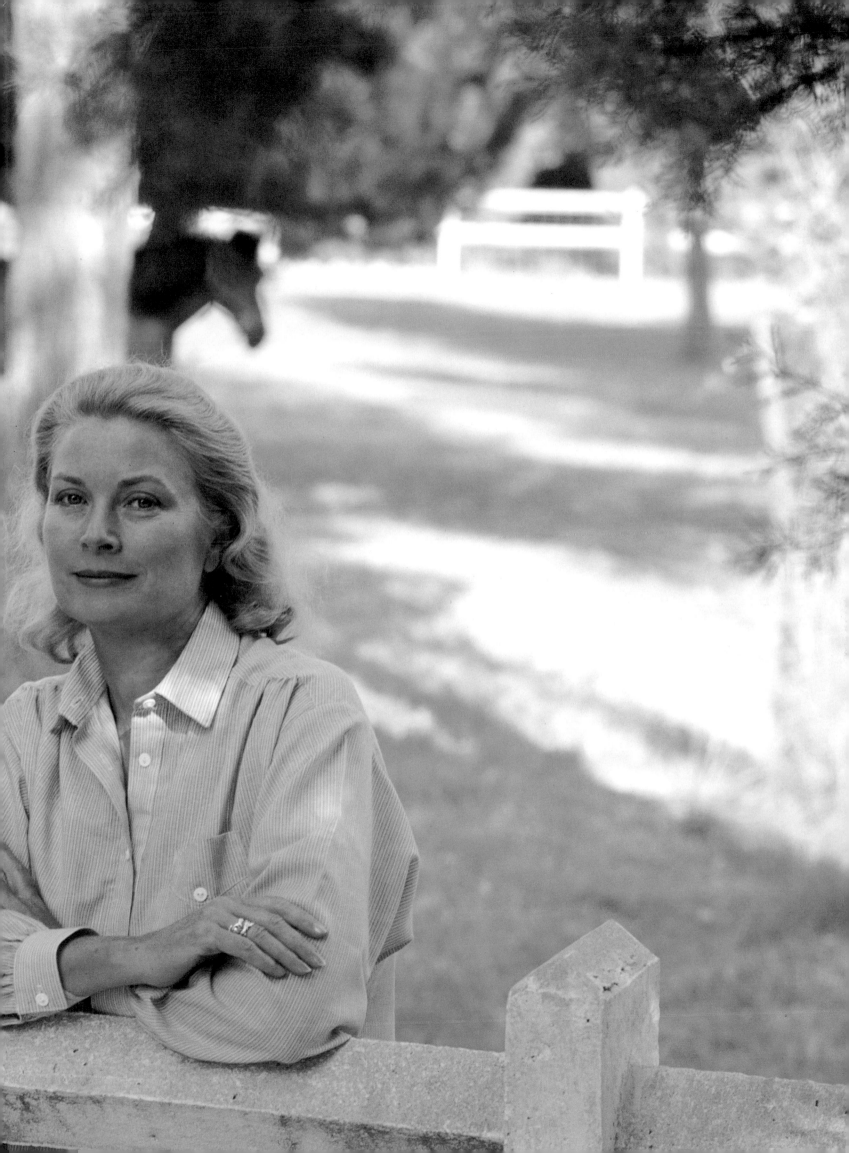

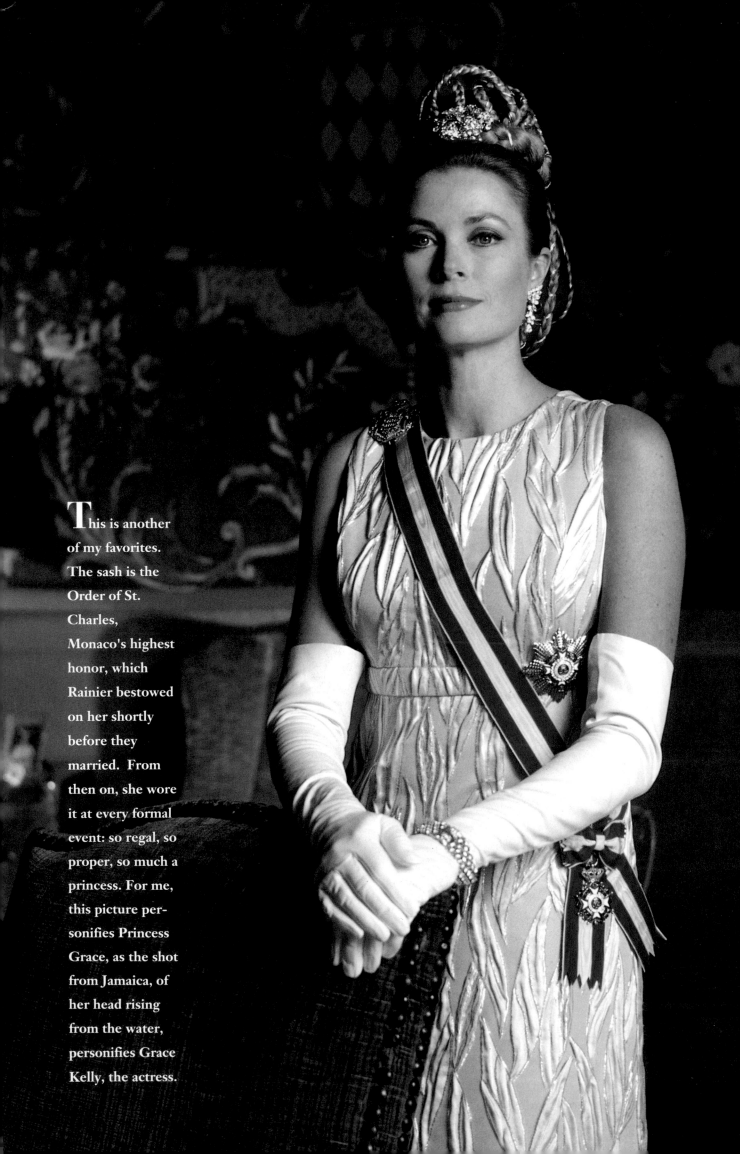

This is another of my favorites. The sash is the Order of St. Charles, Monaco's highest honor, which Rainier bestowed on her shortly before they married. From then on, she wore it at every formal event: so regal, so proper, so much a princess. For me, this picture personifies Princess Grace, as the shot from Jamaica, of her head rising from the water, personifies Grace Kelly, the actress.